ON THE

GROUND

DON'T LET THIS HAPPEN...

THE east village OTHER

VOL.2 NO.4 © 1967 by The East Village Other Inc. **JAN.15–FEB.1** 20 cents outside N.Y. **15¢**

THE STATE OF THE UNION

ON THE GROUND

GROUND

An Illustrated Anecdotal History of the Sixties Underground Press in the U.S.

Sean Stewart

Preface by Paul Buhle

PM PRESS

On the Ground
An Illustrated Anecdotal History of the Sixties Underground Press in the U.S.
edited by Sean Stewart

Copyright Sean Stewart, this edition copyright PM Press 2011.

ISBN: 978-1-60486-455-7
LCCN: 2011927951

Cover design by Simon Benjamin
Interior design by Josh MacPhee/Justseeds.org

Printed in the United States on recycled paper.

Image on page i: *Liberated Guardian*, May 1, 1970.
Image on page ii: *East Village Other*, vol. 2, no. 4 (1967).
Image on opposing page: *Rising Up Angry*, vol. 1, no. 10 (1970).

CONTENTS

RADICAL AMERICA KOMIKS

RADICAL AMERICA KOMIKS IS VOLUME III, No. 1, OF RADICAL AMERICA, A BI-MONTHLY JOURNAL OF U.S. RADICALISM. COPYRIGHT © 1969 BY RADICAL AMERICA. ADDITIONAL COPIES MAY BE ORDERED FROM 1237 SPAIGHT STREET, MADISON, WIS. 53703 (SEE ADVERTISEMENT INSIDE BACK COVER!).

PREFACE

Paul Buhle

he underground press, lacking corporate support of any kind, largely local and grassroots even in its limited advertising base, yet flourishing for a half-decade in the United States, is nevertheless one of the great wonders of modern cultural politics. The creativity of local editors, artists, writers, and others (including this writer, mainly as a hawker of underground papers on a campus mall) did as much to advance the antiwar movement as any other force. In the process, they—or rather we, including naturally the millions of longhaired readers as well—changed journalism, battled repressive laws, and had a mighty good time in the process. Looking back from forty years or so, it was the best time of our lives.

The title of this priceless collection's first chapter, "Like Mushrooms," recalls a populistic bumper-sticker slogan of uncertain political character from the eighties: "They Must Think I'm a Mushroom; They Keep Me in the Dark and Feed Me Bullshit." But perhaps the sensibility in this book better fits a popular slogan held aloft by activists in Wisconsin during the struggles of Spring 2011, against right-wing governors and legislators: "SCREW US AND WE MULTIPLY!"

The contributors and readers of the underground press may have been, as a group, the most comfortable generation materially in U.S. history, but we nevertheless felt screwed. The locked-down character of American culture, from the fifties, had not eased all that much even by the mid-sixties. Anything disliked could be called "Communist" and dismissed without a second thought, not only by segregationist rednecks in their own locales but by the *New York Times* reporters and editorial writers, whenever the subjects of a U.S. military occupation anywhere in the world did anything at all to try and end the occupation. The Beatles had appeared on the scene, following the rise and fall of early rock 'n' roll, but popular

Radical America, vol. 3, no. 1 (1969). Title page artwork by Rick Griffin. Editor Paul Buhle enlisted Gilbert Shelton as guest editor for this popular all-comics issue of the SDS "Magazine of American Radicalism."

culture was still dominated by the mostly idealized lives of the rich and powerful. Even the growing availability of the pill, altering the lives of young people, did not immediately change attitudes, especially public attitudes, toward sexual repression and the double standard.

Then something happened. Or to put it better, all hell broke loose—but (mostly, make that overwhelmingly) in a good way! Historians and memoirists are still trying to sort out the reasons, and they will not likely make a single, convincing case because no single case exists. For a little while there were overwhelming demographic contrasts between the readership—often if by no means always long-haired, committed to the acceptability of social drug usage (if not personal use) and nonmarital sex but not the acceptability of war—and the "straights" of Middle America, and in many places young versus not-so-young. So much of America—including most of the South and rural districts, not to mention religious college campuses— did *not* read the underground press, that to generalize would be suspect. But millions did, simply because the underground papers suited their interests and perceived needs. For those who were potentially to be in Viet Nam, or had a brother, lover, or friend likely to be sent there, it was also a matter of life and death to get the news and insight somewhere.

* * *

"The underground" as a term may be found in many places across several centuries, but there can be little doubt that the most widely used identification, up to the middle of the twentieth century, identified anti-Fascist forces behind enemy lines of the Second World War, in much of Central and Eastern Europe, also large parts of Asia, where resistance movements largely led by Socialists and Communists engaged in illegal acts, at the cost of torture and murder if apprehended. The underground, not quite yet identified as such, had begun after Hitler's 1933 takeover in Germany and climaxed with the defeat of the Axis.

Popular culture, especially the Hollywood film of a certain type, celebrated the courage and self-sacrifice of the resisters. Humphrey Bogart famously gave up Ingrid Bergman in *Casablanca* for the sake of the anti-Fascist cause, but hundreds of resistance fighters in other films, hundreds of others in popular fiction, made worse sacrifices, while real-life members of the underground were slaughtered by the tens of thousands. Not long after the defeat of Germans and Japanese, the Cold War mood minimized the role of the underground, insisting that Allied troops had little assistance from behind the lines, and anyway the Resistance was tainted with Communist sympathies almost everywhere (an accurate charge). "underground" in that usage seemed to fade, and its companion "resistance" was applied to movements bent on overthrowing governments unfriendly to U.S. interests. ("Suicide missions," a term of heroism in anti-Fascist and war films, popped up again decades later with the heroic suicide-missioners now mocked as fanatics: who else would consider such a thing?)

It was a bit surprising, then, to see nominally apolitical victims of

Gothic Blimp Works, no. 8 (1969). Up from under. Spain Rodriguez takes on the Comics Code.

"THAT IS NOT DEATH WHICH CAN ETERNAL LIE; AND WITH STRANGE AEONS EVEN DEATH MAY DIE"

FROM THE NECRONOMICON BY THE MAD ARAB ABDUL ALHAZRAD

WE SIT... IN PATIENCE

WAITING FOR THE DAY.....

WHEN WE SHALL REINHERIT THE EARTH

YES LESTER, THE YEARS HAVE BEEN KIND TO YOU... YOU HAVE DONE YOUR WORK AND DONE IT WELL

DR. LESTER PRONG ON HIS WAY TO WORK, REMINISCES

REMEMBER BEFORE, THE WAY THINGS USED TO BE REMEMBER HOW DISGUSTING THE PHANTOM LADY WAS

AND OH! THOSE HORRID E.C.s WHAT A RELIEF IT WAS TO DRIVE TALES FROM THE CRYPT OFF THE STANDS

AND REMEMBER HOW INSIDIOUSLY YOUNG MINDS WERE EXPOSED TO CARNAL KNOWLEDGE DISGUISED AS BATMANS ARMPIT IN REALITY A BLATANT FEMALE VAGINA

BUT THE GOOD DR. WERTHAM PUT A STOP TO IT.... AND EVER SINCE WE'VE KEPT THINGS IN LINE, OBSCURING AN OVER SUCCULENT TITTY ERASING AN OVER MOLDY CORPSE

AUTHORITY

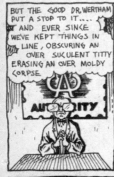

THAT NOISE! WHAT IS IT?

CODE

C A

AUTHORITY

UPTIGHT

CREEEEEK

QUEER SSEE

SPLOP

YOU THOUGHT YOU HAD RID YOURSELF OF US LESTER, BUT NOW WE'VE COME FOR YOU!

GULP!

AUTH

SLISH SPLOP

SKREE

HEH HEH SCREE S

UHAAA

SLISH

GIBBER

YAAAAAAGH!

CHUNK!

HAK

NO!...PLEASE I DIDN'T MEAN...

the McCarthy Era, almost a decade later, to declare that they had gone "underground" against the censors of *comic books*. The occasion, a removal of comics not acceptable to the "Comics Code" (policed by an agency of the Catholic Church), sent the editors of *MAD Comics* into a high dudgeon of satirical art in 1955. A strip published shortly before *MAD Comics* became *MAD Magazine* (thus a black-and-white publication, no longer "comics" and not susceptible to censorship) showed an otherworldly figure who needed to be underground, effecting escaping the likes of Joe McCarthy and the FBI. Humor, real humor, had been forced underground.

Not everyone would have noticed this decidedly vernacular gesture. The editor and prime mover of *MAD Comics*, Harvey Kurtzman, was himself about to abandon *MAD* for a series of failed experiments in more daring satire. But young readers (I count myself among them) definitely noticed. As a decade went by and the largest generation in history passed through adolescence, the itch for a different, more daring and also more intimate, publication than *Time* or *Life* or *Playboy*, became steadily more evident. John McMillian—whose history *Smoking Typewriters* is the most recent and one of the more scholarly overviews of the underground newspapers—suggests that the mimeographed publications of young radical organizations of the early sixties, along with the daring satirical magazine published by Paul Krassner, *The Realist*, led the way.

They certainly had a role. But McMillian seems to have missed several other related phenomena that also preceded the new wave and likewise made the underground press possible. The first was the satirical magazines published on campuses for generations, acquiring a new daring after the Second World War. Post–World War II GIs, and those with far more bitterness coming back from the Korean War, led or joined efforts to satirize all manner of current literature, college deans, sexual behavior, and other aspects of middle-American life seen from the campus. They gathered local advertisers, depended upon unpaid writers and artists, sold in campus bookstores or hand-to-hand. They were sexy and had names like *Shaft* (at the University of Illinois). More than a few were banned. Some, in particular the *Texas Ranger* at Austin, led directly to the explosion of the local underground paper (in this case one of the first, the most long-lasting and most influential, *Rag*).

Sampling these publications in his final magazine, *Help!*, a few years before a protégé of his helped create *Monty Python's Flying Circus* in Britain, Harvey Kurtzman made a decisive connection. The future underground press was to be, in no small part, an autocritique of existing popular and commercial culture, a critical look from within rather than the anticommercial political line of the Old Left (shared, in some ways, by the Old Right). *Help!* also popularized the *fumetti*, comics using photos with comic-style dialogue bubbles—a way to use or reuse images in a fresh way that was also rooted in the work of antiwar Dadaists two generations earlier.

Like other authors on the underground press (including a dean of the press itself and later memoirist Abe Peck), McMillian also misses the nonpolitical fanzine, invented by science fiction devotees for communications

with each other during the forties and fifties, generally produced on used Gestetner mimeograph machines with ink likely to be smeared in the process. This was amateur journalism at its most ardent, and as with the campus magazines no one actually paid. The enthusiasm met and actually created an audience of fifty to a thousand or more that wanted more personal expression than what was available in mainstream publications, commercial newspapers, or even in the fading left-wing press (once abundant and full of semiamateurs learning their trade by practicing it but down, by the end of the fifties, to a handful of monthlies, a few weeklies, and a semiweekly *Worker*, from the Communists).

What a surprise, then, when the *Los Angeles Free Press* emerged in 1964. Its editor Art Kunkin spoke to an audience of mostly young people who gathered in area nightclubs owned by middle-aged (and Jewish) ex-Communists who knew the business, had strong progressive feelings on race and other issues, and knew how to put on a show. Kunkin, who some years before had been a personal secretary to a brilliant Pan-Africanist revolutionary (and, for a time, a follower of Leon Trotsky) C.L.R. James, had the shrewdness to sell advertising suited to the needs and wishes of young people and to distribute copies by the thousands in places where those young people would willingly lay down a quarter for a different view of the world. The *Freep*, as it was popularly called, also gathered other outsiders, leftovers from the area's once-flourishing radical movements, but also avant-garde artists, hipsters, and homosexuals, all of whom found something that they missed elsewhere.

The *Village Voice* had pioneered a somewhat less scruffy, more traditional liberal constituency since the late fifties in New York, with prestige writers like Norman Mailer and rising artists like Jules Feiffer, attracting sophisticates (and not only in New York). It also had a business model from early on, thus fairly steady income to pay editorial staff and contributors. And it had deep, intimate connections to Reform Democratic clubs, even some reputed influence on liberal politicians. It was, so to speak, the overground as underground, a nonmodel that nevertheless suggested something beyond the existing commercial press could succeed. The *East Village Other*, emerging in the mid-sixties, was a different beast, almost a rebellion from the *Voice*, because the readers were a decade younger, far more likely to smoke marijuana on a regular basis, likely to be disillusioned with the Democrats, and as with the *Free Press* readers, intensely interested in the "look" as in the "read."

If we wish to see the flourishing of several hundred other weekly or monthly newspapers during the next few years as a technological phenomenon, advances allowing for short runs of tabloids made the most of the new possibilities, cutting costs to what could be covered with modest sales and no paid staff. Similarly, if we wished to see the emergence as a commercial prospect in the rising student populations around colleges and universities, the small businesses quaintly known as head shops were on hand and eager to sell black lights, handicraft jewelry, rolling papers . . . and underground newspapers. The street-corner newsstand was gone by this time, replaced by vending machines, or had scarcely existed in college towns. In its place there was a new outlet, and a new

audience of foot traffic, with a bit of money to spend so long as rents were cheap and marijuana even cheaper.

The local nature of the underground paper marks another staggering development in the nature of journalism. American newspapers emerged in business centers, but often prospered by virtue of low-cost sales (the penny press of the 1830s led the way) as well as the subsidy provided by the federal government in the nature of subsidized mailing fees. National and franchise advertisers became steadily more important, automobile sales along with local classifieds, as time went on. Reliance upon newspaper syndicates for news and funnies added to the blandness of views on many subjects, especially foreign policies, military spending and such after onset of the Cold War. The new wave of rebel papers, with hardly any business base to draw upon, created their own short-lived syndicates of news and graphics, but the flavor of the papers was distinctly local, perhaps more than any American papers had been for more than a century.

So was the talent. Never before had so many young people learned so fast and so brilliantly what it meant to do layout (in those days before software) with paste-up, decide on the all-important cover illustration, get the articles written and edited, and go to the printer, sometimes hours away due to local threats of censorship. And not to mention rallying the sales force, which made precious little money but acted with great enthusiasm, meeting friends old and new, sometimes flirting a bit, while coaxing a quarter or more from passersby in some mall or on some urban street corner.

There are two aspects of this talent that might be especially cited, because they often operated as the readers' favorites. The underground press provided real news and insight on the war in Viet Nam, events abroad, and protest movements at home that could not be published without upsetting too many advertisers and government officials in the mainstream press. The same goes for black power, Indian, Asian-American, and Latino movements given only hostile treatment within the mainstream, and after 1970 in most places, feminist, gay, and lesbian movements and personalities as well. The most popular feature of the commercial dailies had since 1900 been the "funny pages," and here, the underground press picked up where Harvey Kurtzman and *MAD Comics* had left off. Indeed, "underground comix" emerged a distinct artform, antiwar, proecology, prodope, lustily pro–free love and other libertarian-like issues. When the memory of the underground press had faded (and "comix" had become "alternative comics," losing the "x" in gaining a niche audience), the works of Robert Crumb, Art Spiegelman, Alison Bechdel, and others, but especially Gilbert Shelton of the *Furry Freak Brothers* had become an accepted part of art history, with an increasing influence upon a global audience and newer generations of comic artists.

The brilliance of this book is fully on display in the commentaries of the participants. As an oral historian knows, "orality" is an artform and a category of knowledge with its own distinct rules, not those of supposedly objective history. Oral subjects at their best, and certainly the interviewees in this volume, speak about themselves and their compatriots,

sometimes also about the police and city officials ranged against them, with great vigor. The years have not dimmed the sharpness of their memories, or the importance of these participants of such varied natures. Some had greater success than others, some managed to make straight careers while others disappeared from sight. All are valuable.

The brilliance of this volume is likewise on display but in a different key, in the reproductions of images from the papers. The imprint of Dada is clearly present, and some of Surrealism as well, but perhaps what is most striking to this participant-observer is the relentlessness and courage of opposition to the mainstream, and at the same time the manipulation of mainstream materials: once more, but with thousands of creative participants, an immanent critique of civilization tipping toward barbarism.

There may never again be a journalism as intimately connected with its readers, removed so little by money, neighborhood, hair styles, or marijuana possession. It is difficult to imagine any readers and cultural creators so much further distant from each other than those connecting on the web. Then again, the underground press, in its pursuit of freedoms, has left a mark or sign of hope to all future writers and artists, in every possible format. For these reasons, the undergrounds will not be forgotten. For many readers, the current volume is the best introduction and will long remain on the shelf for casual contemplation.

Open City, no. 25 (1967).

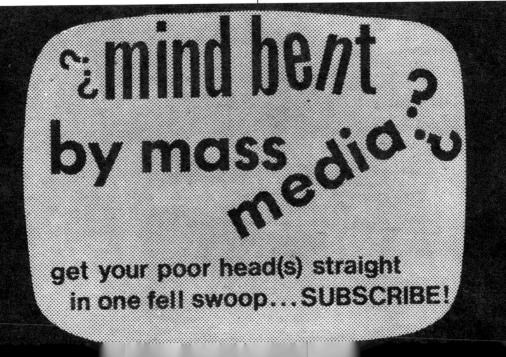

INTRODUCTION

Sean Stewart

I n 2009 I curated and hosted an exhibition of underground newspapers at my old bookstore and gallery, Babylon Falling, in San Francisco. On opening night, Billy X Jennings and Emory Douglas both gave speeches about working in the underground press, and we were all treated to an impromptu speech from John Wilcock, who drove up from Ojai. That night, and over the life of the exhibit, I met and had conversations with former members of the underground press as well as a number of students—some of them having never before seen or even heard of the underground press—who were absolutely blown away by the exhibit. In many ways the book grew out of that exhibit and the response it received. *On the Ground* mimics that experience of simultaneously seeing the vibrance contained within the pages of the papers themselves and hearing veterans of the period tell the stories and anecdotes that are so evocative of the spirit of the time.

Though my focus is strictly on the atmospherics—trying to get a handle on what things were like day-to-day in the underground press—I've edited the book so that it remains faithful to the established historical narrative. The underground press was a part of a vast and amorphous scene and any attempt on my part to be comprehensive would have been folly. I've included voices and artwork from some groups that traditionally haven't gotten much ink in the histories, but I've also, inevitably, neglected to include others. So it goes. There are a number of wonderful histories of the underground press out there (many no longer in print, but all still available used) without which this book could never have been put together: *Our Time Is Now: Notes from the High School Underground* by John Birmingham; *Outlaws of America: The Underground Press and Its Context* by Roger Lewis; *Smoking Typewriters: The Sixties Underground Press and the Rise of Alternative Media in America* by John McMillian; *The Paper Revolutionaries* by Laurence Leamer; *Rebel Visions: The Underground Comix Revolution* by Patrick Rosenkranz; *The Underground Press in America* by Robert

Glessing; and *Uncovering the Sixties: The Life and Times of the Underground Press* by Abe Peck were all indispensable guides as I waded through the piles of underground newspapers. In addition, I consulted numerous histories of the decade, an interminable list of memoirs, and a few great underground press anthologies.

Half of the interviews were conducted in person and half over the phone, with the lone exception being the contribution from John Wilcock, which is transcribed, with his permission, from the speech he gave at Babylon Falling in 2009. The overwhelming majority of the scans in the book come from my own collection of underground newspapers and comix, but it could never have been complete without Billy X Jennings, who opened up his It's About Time archives and allowed me to scan early issues of *The Black Panther* and *Basta Ya!*; Howard Swerdloff, who reached out to his network; Jeffrey Hurwitz, who responded immediately and trusted me with his crispy copies of the ridiculously rare New York City high school underground newspapers; and Robert Newman, who has generously given me a number of key newspapers in the past. Also big thanks to Emory Douglas, who gave me permission to use the scans of his artwork from the pages of *The Black Panther*. Way back in 2007 before there was even talk about doing a book, we picked out some images of his artwork for a limited-edition t-shirt line, and as dope as the first (and only) t-shirt we put out was, I think the images have found a better home here in the book. Please note that all artwork by Emory Douglas in this book is © 2011 Emory Douglas/ Artists Rights Society (ARS) NY.

Thanks to everyone who participated in the book for being so accessible and for tolerating my gaffes. Thanks to Paul Buhle for the wonderful preface. The historical context is crucial. John McMillian, I fully appreciate you reaching out to support this project and specifically for putting me in touch with Allen Young. Johnny Ace, much respect for linking me up with John Sinclair. Thorne Dreyer for going above and beyond in getting me connected with a number of people. Jeff Shero Nightbyrd for allowing me to tag along with you for a full day and for introducing me to Michael Kleinman. Michael Kleinman for showing me your copies of *The New York Herald Tribune* and for the spur-of-the-moment interview. Gregory Nipper for copy editing the manuscript and for your patience with my unorthodox and often abstract notions of style conventions. Josh MacPhee for providing the internal design of the book, tackling the layout, and for getting me in touch with Ben Morea. The long-time homie, Simon Benjamin, for the great cover design. Ramsey, Craig, and the whole PM Press crew—I'm mad proud to be on the roster. Lara, Scott, and Wayne for your considered criticism of the manuscript. Chris and Liz (,,!,,) for letting me and my scanner crash on your couch. The whole Babylon Falling crew. Kensey for everything, but especially for patiently editing my chicken-scratch transcriptions and for generally enabling my life as a functional illiterate.

Hope you dig it.

Sean Stewart
Brooklyn, N.Y.

and don't forget to smash the state.

HEADLINES

Word that Scotland's Lochless Monster has been sighted by scientists after 300 year search. A rumored resemblance to the Old Bitch at Gem Spa. Heads still flipped out from all that free dope given out at the be-in.

POT
Ounces of good grass going for $15 or $20. Pounds are about $150.

HASH
Good black African hash can be found for $90 per ounce.

ACID
Rainbow tabs and purple tabs still best in town. $5 or $6 for a good 2-trip tab. Quantities very cheap.

Spring breeding sandals and bare chests. Watch out on the streets. Pigs coming down very heavy. Defend yourselves.

THE RAG

Vol III No 6 Nov 18, 68

20¢

25¢
OUTSIDE OF
AUSTIN
HOUSTON

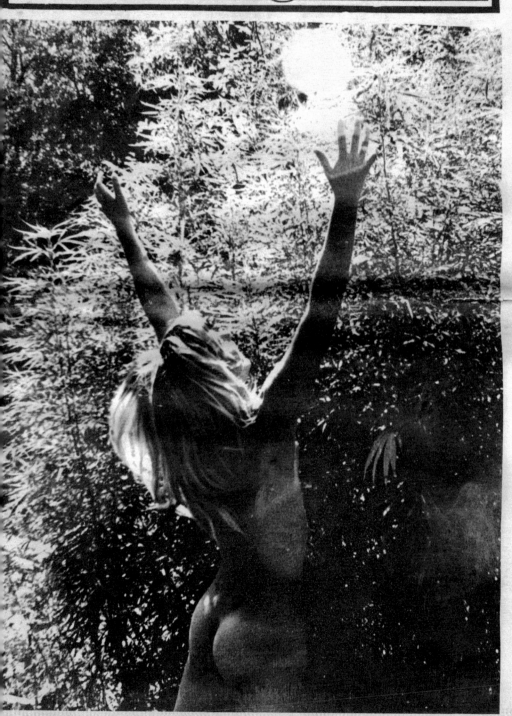

LIKE MUSHROOMS

Points of Entry and the
Birth of the Underground Press

T*he birth of the underground press took place at the intersection of a period of rapid evolution in printing technology and the beginnings of what would become the greatest youth movement in U.S. history. By the late fifties and early sixties, not only was it possible to afford the printing bill for thousands of copies of your own tabloid-sized newspaper, chances were you would find a community of sympathetic souls to actually buy the thing.*

Originally reflective of the regional character of the communities and scenes from which they sprang, the newspapers that would comprise the underground press grew to cover and sponsor sit-ins, be-ins, love-ins, yip-ins, Black Panthers, third-world liberation, women's liberation, gay liberation, grease power, red power, black power, brown power, student power, people power, abortion, crash pads, communes, comix, SDS, Weatherman, peace, love, self-defense, Viet Cong, Motherfuckers, hippies, Yippies, Diggers, dope, rock 'n' roll, and fucking in the streets.

Unified on some fronts and divided on others, the one thing that prevailed above all else was an atmosphere of inclusion. Attendance was the price of admission, and the points of entry were as many as they were varied.

Rag, vol. 3, no. 6 (1968).

JOHN WILCOCK
Village Voice, East Village Other,
Los Angeles Free Press,
Other Scenes

I was one of the five people who started the *Village Voice*. After five years, a guy called Walter Bowart, in the East Village, figured the *Voice* was kind of passé, so he started the *East Village Other*. I went and became the first editor of that, and while we were sitting around in the office of the *East Village Other*, we realized that there were five papers by then which were basically alternative papers—which were really the first alternative papers. Up to that time, any paper that wasn't a regular weekly paper just covered the Mother's Institute or, you know, boring things. The five

original papers were: the *Los Angeles Free Press*, with Art Kunkin; Max Scherr's *Berkeley Barb*; the *Fifth Estate*; *The Paper*, in [East] Lansing, Michigan; and our own paper, the *East Village Other*. And as a result of that, we put together the Underground Press Syndicate [UPS]. Any underground paper anywhere in the world was allowed to join on one condition: they had to send a copy of the paper to every other paper in the UPS. And the way we initially made money was to sell subscriptions to *Time* magazine, but that didn't bring in much. Then this guy Tom Forcade turned up (he later started *High Times*

after a dope run). He took over UPS and sold the rights to Bell & Howell to microfilm all the underground papers. So that's what initially financed the underground papers. And there were six hundred papers at one time, all over the world. Everywhere I went in the world I was interviewed because people were interested in this phenomenon, these American underground papers. And every underground paper I ever went to believed in two things: they wanted to end the Viet Nam War and to legalize marijuana.

PAUL KRASSNER
The Realist

I was working for Lyle Stuart (I started in 1953, and it was in 1958 when I started *The Realist*), who edited a paper called *The Independent*. It was the precursor to the underground press and was essentially against censorship, but it was in the tradition of *I.F. Stone's Weekly* and George Seldes's *In Fact* and, you know, there was a whole tradition, in that time, of publications going back to Tom Paine. I started out just filling envelopes with issues of *The Independent*, mailing them out—and I ended up as their managing editor. That's where I got my journalistic apprenticeship. At that point our office was a tiny, tiny office on Forty-Second Street in New York right off, I think it was, Sixth Avenue. Lyle was a big fan of *MAD Comics* and

Rat Subterranean News, vol. 2, no. 14 (1969). Wilcock surveys the scene.
Opposing page: *East Village Other*, vol. 2, no. 5 (1967). "Roll up, roll up . . . Ladies and gentlemen take your seats for the greatest show in America since Joe McCarthy did his famous TV pratfall, It's the Angry Arts Festival and it's all over New York City—now!" —Lead paragraph in Dick Preston's cover story on Angry Arts Week.

INSIDE : FREE CUTOUT MANIFESTO

THE east village OTHER

VOL.2 NO.5 © 1967 by The East Village Other Inc. **FEB.1-15** 20 cents outside N.Y. **15¢**

THE ANGRY ARTS

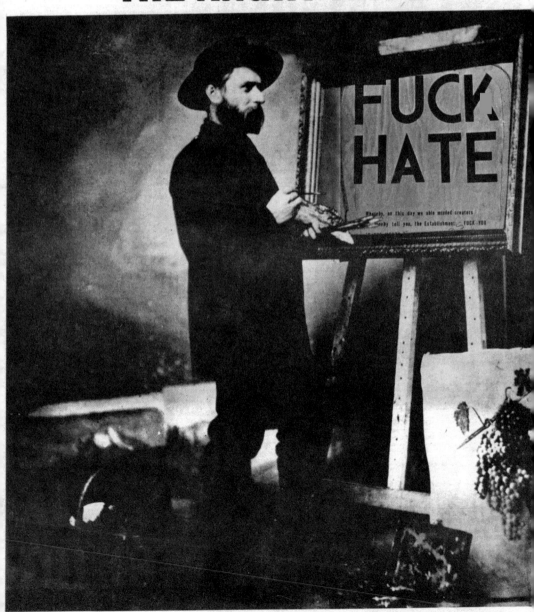

FUCK
HATE

social-political-religious criticism and satire

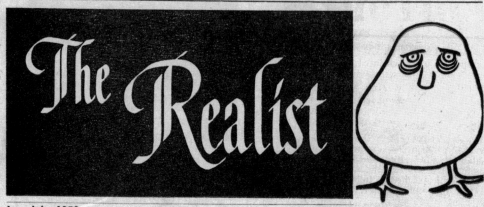

June-July, 1958 35c No. 1

An Angry Young Magazine . . .

"RUB HIS TUMMY in the morning before breakfast, and make a wish," says an ad that epitomizes all ads, "and Ho-Toi, the gleeful Chinese god of happiness, will throw his weight around for you in the land where dreams come true. Hand-carved, of teakwood. He's about 4 inches high, and men love him. We know because our husband swiped ours . . ."

And there you see a copywriter who has gone and tripped over her own editorial we. Unless, of course, the husband made a wish for an alternate wife, and the little idol actually *did* throw its weight around. We mustn't be too dogmatic about these things.

In any case, this editorial will be written in first person singular, as a sort of symbolic gesture toward a society where conformity has replaced the weather as that which everybody talks about, but which nobody does anything about.

However, I am neither for conformity *nor* for non-conformity. I am for individuality. If one's individuality is *in effect* non-conformity, then so be it. But basically, one's individuality consists of conformity—to oneself.

* * *

The purpose of the *Realist* is twofold.

First, it is devoted to the reporting and analysis of timely and significant conflicts that are ignored or treated only superficially by the general press.

Much of the material, therefore, will be critical of specific social and political activities of organized religion. As a recent editorial in the *Christian Century* states, "religion needs as much to

(Continued on Page 2)

sent a subscription to it. Bill Gaines, the publisher of *MAD*, wrote back to Lyle and said he was a big fan of *The Independent*, and he signed the letter, "In awe." So they became friends and Lyle [eventually] became the general manager of EC Comics. When Lyle Stuart became the general manager we moved our office to 225 Lafayette Street, which was known as the MAD building. We got an office on the same floor, in fact, and I would sometimes do stuff for *MAD*, like take a bag of stuff to the post office (which I could then put on my resume that I was in direct mail).

It was a very exciting place to be and my friends were jealous of me. By the time *MAD Comics* was out, I was in my late teens, and so I was probably older than their usual readers, which were teenagers and preteens. But I was charmed by it—just the imagery of Superman going into a telephone booth to change his costume, but he can't because Billy Batson is changing into Captain Marvel there and he'd have to wait. It was mostly about comic books then, but, you know, it did leak out into other areas of the mainstream culture that *MAD* would parody. Anyway it was in, I think, 1955 when I sold my first article to *MAD*. It was just a script called, "If Comic Book Characters Answered Those Little Ads in the Magazines." So it would be like Dick Tracy getting a nose job or Little Orphan Annie getting Maybelline because she had these empty oval eyes. They assigned the articles to an artist, and in this case it was to Wally Wood, and when they bought that from me, I told Lyle, "I'm floating."

Then I wrote this thing for *MAD* called "Guilt Without Sex"—it was a handbook for adolescents. They said it

was too grownup for *MAD*, but I did sell it to *Playboy*. It was the first thing that I sold to *Playboy*. There again was another floating experience. So, anyway, I said to Bill Gaines, "A million and a quarter circulation, I guess that's why you're keeping the magazine aimed at teenagers. I guess you don't want to change horses in midstream." And he said, "Not when the horse has a rocket up its ass." It had nothing to do with my article; it had to do with their circulation. It was the essence of my awareness that there was no satirical magazine for adults. This was before *National Lampoon* and *Spy* and before comic strips like *Doonesbury* and before TV shows like *Saturday Night Live*. All of the things that concerned me, all of the injustices and contradictions in the culture, there was really no satirical outlet for that. So in combining *MAD Magazine* and *The Independent*, the process [with *The Realist*] was to try to communicate without compromise, and the goal was to eventually put myself out of business—this was the fantasy—by liberating communication. The mission statement was, in effect, a combination of entertainment and the First Amendment.

The Realist, no. 1 (1958). "For the first four or five years, I was living at home with my parents. I was working out of Lyle Stuart's office, and he was only charging me like ten dollars a month, and I had a top-flight lawyer who was charging me fifteen dollars a month as a retainer. I was doing the editing and the delivery and whatever there was to do—it was a lone-person thing." —Paul Krassner.

ART KUNKIN
Los Angeles Free Press

I became a tool and die maker, a master machinist, and I worked in the fifties at General Motors and Ford as part of the whole radical thing that I was involved in then. At one point the union wanted me to become a union executive and the company wanted me to go into management. I had been five years at GM and I didn't want either one, so I went back to school to become a history professor. This was in 1962–1963, and I was going to school nights and working in machine shops during the day. While I was in school there was somebody from the Socialist Party who was teaching a class there, and he had been approached by some Mexican-Americans who wanted to start a paper. He didn't have the time and [asked whether] I wouldn't be interested in doing that with them. So while I was going to school I began connecting with this Mexican-American group, and they were putting out a little eight-page paper once a month called *East L.A. Almanac*. I was the political editor, listed on the masthead as Arturo, and I'm writing about garbage collections in East Los Angeles.

A couple months go by, we're putting this paper out and it's being sponsored by a lawyer—you know five thousand copies, eight pages, once a month—and we get word that Vice President Johnson was coming to town to meet with the Mexican-American leaders. So the day before he was to come, the *L.A. Times* announced that he wasn't coming. The next day, he came anyway, and it was a terrible conference—he knew a great deal about the blacks but he knew nothing about Mexican-Americans. So

I'm writing this story up for this little paper and somebody calls me from City Hall, a Mexican-American, and he's got the story of why Johnson almost didn't come. It seemed that Johnson's trip was being backed by a group called the California Democratic Council [CDC], which was a group kind of at the fringe of the Democratic Party—very progressive, liberal people. Jesse Unruh, who was state treasurer of the California [Democratic] Party, and Roz Wyman, who was on the city council, decided they didn't want the CDC to get the credit for a visit by the vice president. So they began a campaign of phone calls and telegrams to Washington to stop Johnson from coming, saying he was going to be picketed and it was going to very unpleasant. Johnson came anyway (after having announced that he wasn't coming), and I wrote this up. To protect my informant at city hall, I wrote the article as if I were drawing on Sacramento and Washington—the other end of these telegrams. So this story appears in this little tiny paper and the following day it gets picked up by the *Wall Street Journal* and *The New York Times*. I become a hero in the Mexican-American community for a few days, then I go back to writing about garbage collections again.

Two weeks before Kennedy was assassinated, Johnson was again in L.A. as the vice president. There was a conference of Mexican-Americans at the Ambassador Hotel, and we were distributing our paper in the lobby. One of the guys, Alex Porras, was approached by two well-dressed Anglo guys who said they were on Johnson's staff and [that] Johnson didn't like our article last August and he thought we were a bunch

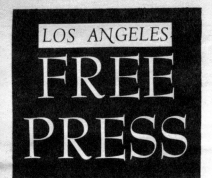

Los Angeles FREE PRESS

THE D.A. vs. "OBSCENITY" - Part Three

CUMMINGS COMMENTS on CITY CHARTER

LIPTON BATTLES GOLDWALLACE

THE JAZZ OF JOHN BANISTER

CALENDAR OF EVENTS——SEE PAGE 8

A NEW HIP WEEKLY 10¢

VOL. I, No. 9 | THURSDAY, SEPTEMBER 17, 1964 | 10¢ (15¢ outside of Los Angeles)

RACISTS IN GLENDALE *SEE PAGE 3*

FROM THE BOSTON GLOBE

THE L. A. COFFEE HOUSE SCENE

By HARVEY SIDERS

LOS ANGELES—While the folk music boom continues to reverberate around Boston, the City of Angels comes nowhere near duplicating the action back East: an amazing fact considering the 50-odd coffeehouses that flourished hereabouts at the beginning of this decade.

But that difference is merely quantitative. Qualitatively, Los Angeles espresso emporia are unique, serving as a lively sounding board for the intelligentsia or the pseudo-intellectuals, as well as an unpressured outlet for professional and amateur folk performers.

Nothing like them exists in the Hub. Bostonians are accustomed to the nightclub type of atmosphere at their coffeehouses where name talent—local or national—is booked to appear on a regular basis.

Self-Entertainment

Here in Los Angeles, the coffeehouse is essentially a club, rather than a night club. Each is a market place and melting pot where the philosophy and the music are as strongly flavored as the Cafe Wein, Darjeeling tea or Dutch cocoa.

The patrons would rather entertain than BE entertained. Which means that a great many customers bring their own guitars or banjos to the coffeehouses, and literally swap notes. For those who can't afford their own instruments, there are some coffeehouses that rent guitars. Practically all clubs rent chess sets, and a few even rent Scrabble sets.

In the clubs where professional entertainment is featured, the management not only allows but encourages the do-it-yourself-between-sets activity.

One such coffeehouse is the Garret, presided over by a statuesque blonde contralto named Terrea Lea. Miss Lea—who owns half interest in the coffeehouse and has been performing there since 1958—is a magnificent entertainer, interspersing a wide range of folk material and some pop tunes with warmth, wit and whimsy.

Too Many Imitators

"I'm not too concerned about the ethnic," she confessed. "I dig Belafonte, The Limeliters, Bud and Travis, Joe Mapes, even The Womenfolk who started right here at The Garret. All types of folk music appeal to me. But I am concerned about the example set for our young folk singers by Bob Dylan. The image he sets is that of being unkempt and slovenly. But he certainly knows how to write."

Another view of the current folkways came from Al Mitchell, entrepreneur of the rambling Fifth Estate on Sunset Blvd.

"There's much artificiality on the folk scene today— too many imitators," observed Mitchell. "There are urban blues singers trying to sound like refugees from a chain gang, and equally ludicrous are all those do-gooders protesting just for the sake of protesting."

And yet Mitchell's Fifth Estate—open every night from 7 p.m. to 6 a.m.—constitutes an elaborate protest in itself. "This is my answer to the blatant hustling, the pressures, above all, the lack of graciousness out there," he explained, pointing vaguely to the outside world. "People come in here, and as long as they buy one item, they can stay all night. I won't bug them. I believe a coffeehouse should be an extension of a university."

Reinforcing this concept were his art gallery, a display of arts and crafts, his "conference room," where "some of the most stimulating discussions have been engendered," and the two main rooms where the patrons were playing rented instruments, listening to piped-in FM classical music, or meditating over their rented chess boards.

Country Revival

At another club, named simply. The Coffeehouse where it seemed every table sported a chess game and a juke box was alternating from Miles Davis to Joan Baez to Van Cliburn, a young performer-customer talked excitedly about "Easterners like Dave Van Ronk, John Koerner and Eric van Schmidt."

Flailing his 12-string Harmony guitar Laury Weiss claimed he could identify with their city blues: "I can relate directly to their style because I find it easy to slip into Negro dialect. It's natural to emulate the Negro—after all, we're carrying the white man's burden."

With considerably less ambiguity, Laurie suggested the Ash Grove for the "other end of the folk spectrum." As he put it, "They're ethnic as all hell."

Ash Grove is indeed the hotbed of traditionalism in Los Angeles. Operated by Ed Pearl—a young, wiry, energetic, loquacious intellectual who runs the well-attended UCLA Folk Festival each year—Ash Grove not only features name performers, but houses the School of Traditional Music.

Ed's single-minded devotion to the "public poetry aspect of folk music and the oral tradition of rural society" has resulted in a conspicuous revival of country music in the Los Angeles area.

"I've booked many Eastern folk artists, but I prefer the West Coast performers," Ed remarked. "You have a crazy world back there. Your folk singers are too commercial, too attracted by glitter. They're all recording too early, and so many of them are trying to sound black or trying to imitate the Scruggs style of picking.

"We don't push our folk musicians too fast out here. They learn slower, but more thoroughly. And here at Ash Grove, they're given a solid background in traditionalism. That's why I find the Kentucky Colonels musically superior to your Charles River Valley Boys."

And so it goes as in any art form, controversy as healthy as it is insoluble. But one thing is certain. The coffeehouses here are more stimulating because they encourage more direct participation.

Reprinted by Permission from

The Boston Globe
Friday, August 28, 1964

EDITOR'S NOTE

The Free Press is planning in coming issues to carry a complete Coffee House and Folk Music Cabaret Directory. The addresses of the places mentioned in the Boston Globe article are:

The Fifth Estate, 8226 Sunset Blvd., L.A. 46. (Free Press offices are below in Suite 3).
The Coffee House (Mother Neptune's), 4319 Melrose, L.A.
The Garret, 925 N. Fairfax, L.A.
The Ashgrove, 8162 Melrose, LA.

of Communists, and they walk away laughing. So I wrote this one up and this article appeared in December of 1963 when Johnson was already president. The first week of January 1964, everybody at the paper gets visited by the FBI (including the lawyer who is backing the paper), and everybody freaks.

The FBI came to visit me. I had always been told never to speak to the FBI without an attorney, but I'm not doing anything now, I'm writing in this little Mexican newspaper. These two FBI guys showed me their credentials and stuff, one was a tough guy and one was a nice guy. I kept them on the porch where I had some control over the conversation. They ask me if I'm a Communist, and I say, "No, I'm not a Communist. If you've looked into me, you know I have a program on KPFK speaking for the Socialist Party." Through the Socialist Party I was working closely with Norman Thomas and Erich Fromm, the famous psychologist. I wrote some resolutions with Erich Fromm against the Democratic Party drift of the Socialist Party. So anyway, they say, "Thank you for telling us you're not a Communist." I felt like a shit for having spoken to them. Next thing they do is they give me a dozen names and they say, "Do you know these people? Would you like to talk about them?" And I said, "Well, I'll talk about myself, but I'm not going to tell you anything about these people." I knew every one of the twelve—they were all radicals. Dorothy Healey, the head of the Communist Party in Southern California was on there (I was Southern California chairman of the Socialist Party when I was doing this program for KPFK). So I said, "No I'm not going to tell you

anything about these people." They walked away thanking me, and I felt stupid for having spoken to them. The next day I go to my machine shop job in East L.A. and they gave me my walking papers. I had been there exactly a year; they had to give me a vacation check. The owners locked themselves up in their office while the foreman told me I was fired and wouldn't give me a reason. The next day I spoke to people at the shop, and indeed the FBI had been there. So in January 1964 I'm out of work. I was really angry. I mean, I had been in the radical movement for years at this point and this was the first time that I had ever gotten singled out. As a matter of fact, when the FBI came to my door it was kind of flattering almost—somebody was paying attention for once. So I was, and still am, a skilled machinist and I could've gone out and got a job, but I went on unemployment insurance and started planning the *Free Press*.

I met a guy at *FM* (*Fine Arts Magazine*) Hal Marienthal, and he told me that he would help me get some money. He thought I needed $10,000, and he would help me get the money if I could put together a staff of writers who could produce something equivalent to the *Village Voice* of New York. So I went back to KPFK, and I was going through the Rolodex of all the people doing radio programming and picking out people that I thought might be good writers. While I'm sitting there the program director of the station comes yelling through the halls, I mean literally at the top of his voice, "Somebody hasn't showed up for a program! Does anyone want to get on the air?" I raised my hand, and, of course, he knew me. So I go into this little booth and for an

hour I do a program off the top of my head, "What I Would Like to Do with a Newspaper in Los Angeles." I spoke about the *Village Voice* and about all the different communities in Los Angeles. I didn't know who I was speaking to. I may have been speaking to hundreds of people; I may have been speaking to twelve people or two people. When you're sitting in a radio studio you have no idea who's listening.

The radio station was going to have a fundraiser, a Renaissance fair, in two weeks. I was active in the station and I knew that hundreds and hundreds of liberals would be there and, you know, it's kind of a kooky event. I knew the person who was doing it, Phyllis Patterson. So after I leave the radio booth and I've been speaking for an hour about the paper, I called her up and told her my idea. I said to her, "Could I have a table there and put out a leaflet about what I'd like to do?" And she says to me, "Well, I was going to do a paper for the fair, but I didn't have the time to get it together. Maybe you'd like to do a paper for the fair." So I went down to meet her the next day. I got dressed up in a suit and I go out there to meet with her and talk to her about the idea. She later told me she never thought I'd do anything. In the first week, talking to the KPFK advertisers, we collected $200 in advertising, and it was possible in that time to print an eight-page paper for $125 (five thousand copies). Part of the story is that after I had left the machine shop I started a little print shop in Maywood, California, and I had sold it to go back to school and study. So I went back to my old print shop, to the owners, and they let me use the layout equipment.

In the second week we began putting this paper together, and by the time of the fair, we had the *Faire Free Press* printed. It was called F-A-I-R-E *Free Press* on the front cover, and there were little tiny articles with headlines about Shakespeare getting arrested for obscenity and students having ban-the-crossbow demonstrations; an art review of the opening of the Mona Lisa painting; and a little article about Sir Walter Raleigh bringing tobacco back to England and the health problems that were created. In other words, all kinds of contemporary issues under the guise of medieval issues. This was on the cover, and we sold it for a buck a piece at the fair. You opened it up and inside was a statement about what I wanted to do to start a paper like the *Village Voice*. The main article was a feature on a bust at the Cinema Theater of a Kenneth Anger film on homosexuality. Then my ex-wife wrote a piece on nursery schools, and I had a piece about Joan Baez and a tax refusal, and I got a couple of music reviews. So inside was the *Los Angeles Free Press*. After the fair I had a couple thousand copies left, and I refolded the paper and put the [*Los Angeles*] *Free Press* pages on the outside and the *Faire Free Press* on the inside. It's kind of a remarkable little project. In the first week of doing this we raised $200 through advertising. At the end of the fair, I had $1,000. I gave KPFK some money—there was an agreed-upon percentage because I had a little booth there and so forth.

Al Mitchell at the Fifth Estate [coffee house] gave me a basement office (I had gone over there with copies of the paper, the first *Faire* issue), and I spent the next month writing a business plan and trying to raise my $10,000. I succeeded in raising $600 from two friends: $200 from one friend and $400

from another. I started the paper with that, and we came out for the next ten years without a single break, sometimes with great difficulty.

BEN MOREA
Black Mask, The Family
(Up Against the Wall/Motherfucker)

I had been involved with jazz during my drug addiction days. I was a musician and every time I got out of jail I went back around the jazz world and got readdicted. I was in prison several times, but when I finally kicked for the last time, I was in jail and I got very sick, so they put me in the prison hospital, which was one ward in Roosevelt Hospital in Manhattan. In that prison hospital (which was some transition between prison and hospital; it was not a prison atmosphere, but yet it was segregated from the rest of the hospital) there was an occupational therapist that befriended me, a woman. She, for some reason, sensed that I had more potential than I had been utilizing, so she took it upon herself to really try to set me in a different direction, really help me to educate myself, give me the tools. She was an art therapist so I started painting. Besides studying different art movements

and philosophies, I became aware of a lot of the European art movements. After leaving the prison hospital (and I had vowed that I wasn't going to go back to drugs), I stayed away from the jazz world and, being a creative person, sought art as my artistic outlet.

Then I got involved with an art group. The person that originated this group, his name was Aldo Tambellini. One of his motivations was to bring art into the vernacular. We used to talk about primitive art. Primitive art was a total part of the life. So, in other words, they made masks as part of their spiritual world and carved their spoons, which were utilitarian items, but they were really artfully done. Their houses were really artfully done. Art was a total part of your life and culture, but in the west art became removed from life, and so one of his ideas was that we should break from that. Aldo developed these multimedia shows; they were the first multimedia shows done in America. He was a painter and sculptor, so he starting painting on slides and he would project those slides so the paintings were projected on the wall. While it was projected, we had a black poet that participated with us, Calvin Hernton, we had a jazz musician playing, and we had a dancer on occasion (modern dance like in the Twyla Tharp tradition). I created these sound machines out of everyday items, like saws and grinders, but I made them into musical entities. I became more interested in Surrealism and Dada, and I started to see the need for the written and verbal attack on western culture, à la Surrealism and Dada. Ron Hahne, this other artist who was part of

Los Angeles Free Press, vol. 2, no. 34 (1965). "At the Fifth Estate I was doing the paper, and people would come down almost every night from the coffee house to visit me." —Art Kunkin

BLACK MASK

No. 9 JAN.-FEB. 1968 5 Cents

"These smut sheets, are today's Molotov cocktails thrown at respectability and decency in our nation. . . . They encourage depravity and irresponsibility, and they nurture a breakdown in the continued capacity of the government to conduct an orderly and constitutional society."
Rep. Joe Pool (House Un-American Activities Comm.

Black Mask, no. 9 (1968).

Aldo's group, agreed with me—so him and I started *Black Mask*.

Ron and I agreed: not only did we want to follow the direction of Surrealism and Dada, but we made it even more political. He and I more or less removed ourselves from Aldo's multimedia shows. It wasn't a hostile break . . . it was just, we evolved. So Ron and I did *Black Mask*. He and I worked on the layout and the visual. I was really the main editor and writer, but Ron went over everything with me, gave me his opinions. He and I worked on the covers, and we thought of the cover being very important, almost like a painting. We saw the cover as an artform.

At that time we worked in his apartment. Obviously he had a kitchen table, so we used that and would [do] layout [on it]. First we would sketch an idea, or I would suggest something and he would either agree or disagree and we would go further in our discussion. We did everything together. I would never say, "This is what we're doing." And he would never say, "This is what we're doing." We were also interested in Constructivism, and really interested in all the art movements of the modern twentieth century. We saw the layout as being an important tool, equal to the words. So we continued that for ten issues.

JOHN SINCLAIR
Work, Change, whe're, Fifth Estate, Warren Forest Sun, Ann Arbor Sun, Guerrilla

Detroit was what you would call a cultural backwater of the United States at that time. Nothing was happening, and it had no connection to the outside world, everything was all hidebound. So you got your inspirations from reading an underground paper. Well, before the underground papers, the small poetry presses (that's where I came out of) had an underground system of communications and a lot of that was through mimeograph publications (but [there were] also people who could pay for printers). This was really outside the mainstream and it was just poetry and maybe a little bit of arts coverage on the edges, but it was the same paradigm as far as independent producers of literature banding together, sending each other their stuff. That's how you found out what they were doing in San Francisco, Los Angeles, Chicago, Atlanta, and Vancouver. Then when the papers sprang up, they were even more au courant because they had news of what people were doing in several areas against the war, against the draft, for the civil rights movement, all that kind of stuff.

Harvey Ovshinsky was a high school student when I met him. He had started

The Paper, vol. 2, no. 2 (1967). The Spike Drivers perform at a benefit for Harvey Ovshinsky's *Fifth Estate* newspaper.
Opposing page: *Berkeley Barb*, vol. 5, no. 5 (1967). The power of the Underground Press Syndicate. This photo was part of a full-page reprint in the *Berkeley Barb* of *Fifth Estate*'s coverage of Detroit's Twelfth Street riots in the summer of 1967. Caption reads: "*Fifth Estate* co-editors Ovshinsky & Werbe interview looters as they window-shop at a cleaners at the corner of Trumbull and Forest. Photo by C.T. Walker."

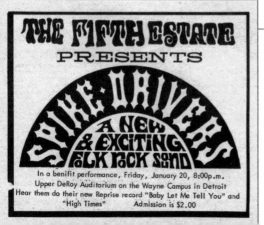

THE FIFTH ESTATE
PRESENTS

SPIKE DRIVERS
A NEW & EXCITING FOLK ROCK SOUND

In a benifit performance, Friday, January 20, 8:00p.m.
Upper DeRoy Auditorium on the Wayne Campus in Detroit
Hear them do their new Reprise record "Baby Let Me Tell You" and
"High Times" Admission is $2.00

Detroit's first underground tabloid called the *Fifth Estate*. My wife Leni and I, my first wife, we saw this first issue of *Fifth Estate* and it was appallingly ugly. At the same time, we were thrilled because we were part of an arts community centered on a place called the Detroit Artists' Workshop, and we were proponents of the mimeograph revolution advanced by Edward Sanders here in New York City at the Fuck You Press. So we learned from him that you could publish off a mimeograph without it costing you very much money, especially if you could steal the paper and ink. We published books of our own poetry and other writings. We published a poetry magazine, an avant-garde jazz magazine—we did all this with mimeograph. It was a very grueling process, but you could do all the work yourself so you didn't have to pay a printer—that was prohibitive. We would have never published one book had we had to hire a printer. We didn't have any money at all. So we became very proficient with this, but it was a strenuous process. Then all of a sudden here's this paper . . . in Detroit. We said, "Wow, a tabloid. Why didn't we think of that?" So we sought out Harvey Ovshinsky and told him we were thrilled by what he was trying to do, and if he needed help we wanted to help. We knew how to do this. We knew how to write; we knew how to do layout. We knew all this stuff and we wanted to be a part of it. By the second issue I wrote a column for him, which was an arts column called The Coatpuller. It was about music, poetry, plays, other kinds of arts activity around Detroit from an underground perspective. Leni did the photography and helped with the layout, and then Gary Grimshaw came in and he did the layout. So I was intimately involved with them from the second issue.

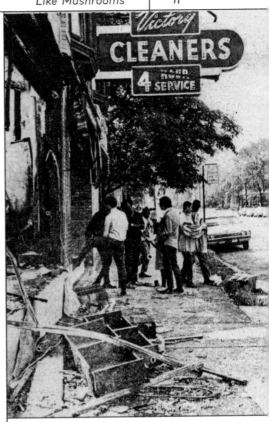

HARVEY WASSERMAN
Liberation News Service

When I grew up in Columbus, Ohio, I was in a Jewish youth organization, and our organization had conferences. Our region included Colorado, and when I was in high school I met this guy, Marshall Bloom, from Denver, who was a year older than me. We became friends, but I lost track of him over the years. In the spring of 1966 I opened *The New York Times* and there on the front page was my friend Marshall, who I hadn't seen in years, and he was leading a walk-out of the student body at Amherst College at the graduation because they had Robert McNamara as the speaker.

So when I graduated University of Michigan in 1967 I went that summer

to Europe and I found Marshall. I ran into him on the street, actually, in London, and he was leading protests against the London School of Economics. The lead editorial in the Sunday *London Times* was, "Bloom Go Home." He was really a big troublemaker. I stayed with him at his apartment, a place called Montague Mews. He had then been appointed to become the head of the Collegiate Press Service, which supplied articles to college newspapers around the country, and so he asked me (I had a Woodrow Wilson fellowship to go to the University of Chicago) to be the Chicago correspondent, and I said sure.

He went back to the U.S., and I went traveling around Europe. When I got back in September, I found that he had been thrown out of the Collegiate Press Service for being too radical. When he was thrown out of the Collegiate Press Service, he and Raymond Mungo, Veranda Porche, and a couple others had been riding around the country trying to raise money to start what Marshall called the Liberation News Service. The Liberation News Service was to supply articles, not to the collegiate press, but to the underground papers (of which there were hundreds that had started at the peak of the antiwar movement in the late sixties, in 1967 actually). So I came to see Marshall thinking I was going to be the Chicago correspondent of the Collegiate Press Service, and he said I would just be the Chicago correspondent of the Liberation News Service, and I said, "OK, that's fine." And so I went back to Chicago in September and Marshall was doing what he was doing trying to get the news service going.

On October 19, I came back to Washington because the big march on

the Pentagon was going to be on the twenty-first. Unfortunately for me, I got beat up in a rally so I wasn't in very good shape when I got to Washington. Marshall was there and we were all packed into this house on Church Street, on the northwest side right near Dupont Circle, which was kind of the hip area of D.C. On the twentieth, the next day, we had a meeting in a loft, somewhere on the northwest side, of all these editors who had come for the march, and Marshall put on his Sgt. Pepper outfit that he had gotten in London and convened this meeting. He said, "OK, this is the Liberation News Service." And it was just a really wild scene. Everybody's yelling, there's actually a fistfight or two—it was just really wild. Everyone was all decked out in their hippie costumes, all ready for the big march on the Pentagon, the war was at its peak, it was an amazing time. That was the founding of the news service.

THORNE DREYER
Rag, Space City!,
Liberation News Service

I grew up in Houston. I graduated from high school in 1963. That was a period of time when things were just starting to happen, where there was this sense of possibility, this sense of history. You already felt it back then. And so I was primed, I was ready to do something when I came to Austin. I also grew up in an environment . . . my father was a writer, a fiction writer, and was a reporter and editor at the *Houston Chronicle*; my mother was a pretty famous artist, art teacher and gallery owner, Margaret Webb Dreyer, in Houston. She also became a major peace activist. She was

one of these larger-than-life figures, and I got a lot of my sensibility, a lot of my sense of the sacredness of human life (the basis for antiwar sentiments), from my parents, and especially from my mother. Their art gallery, Dreyer Galleries, was always the center of this kind of literary and progressive community in Houston. My mother always pulled people together, and that was the great ability that I've always had—to be a focal point, to pull people with lots of skills together to make things happen. So I came already with that sense, and Austin was just, you know, you'd walk around and you'd see these weird-looking people and you'd get this sense that things were happening, and obviously the drug culture was just starting to really explode.

In the early days it was mostly the coastal papers that were recognized—the *East Village Other*, the *Berkeley Barb* and the *Los Angeles Free Press*. The stuff that happened in the middle of the country the people weren't aware of, but I think that what we did was really very unique and seminal. *Rag* was incredibly influential. What happened at *Rag* was repeated, or affected what happened, in a lot of other places. Austin was unique. Austin was the perfect setting for it [*Rag*] because Austin already had that incredible tradition, that literary tradition, the cultural tradition, and had always been a center for progressive politics and for radical politics.

We were the sixth member of the Underground Press Syndicate. Unlike LNS, which was a real organization that fed packets of intense copy and photography and art to all the papers twice a week, the Underground Press Syndicate was primarily a commitment: One, that every paper would run the list of the underground papers in every issue; and two, that there was free reprint rights. All these underground papers suddenly had connections to each other. There wasn't an organization, it wasn't a thing— it was more a concept. We sent papers to everybody. We put everybody on our subscription list . . . we would get fifty papers a week, or something like that. We had tables and racks and everybody would come in and read the papers from everywhere. It was amazing because it started out being five or six underground newspapers and eventually there were hundreds all over the world. They just started popping up like mushrooms all over the country out of totally different kinds of communities, psychedelic drug communities (like the [*San Francisco*] *Oracle*) . . . some of them were very political, very radical, some of them were just kind of leftish student newspapers. They all had kind of different looks, a different feel, but they all had a sense of community with each other.

Austin was really tied into what was going on other places. I had met a guy named Michael Kindman who had a paper called *The Paper* in East Lansing [Michigan]. It was one of the original underground papers, and it was on a campus [Michigan State University]. I talked to Max Scheer, to a few people. There were several things that inspired *Rag*. We knew some of the people. They

THE UNDERGROUND PRESS SYNDICATE is an informal association of publications in the "alternative press" and exists to facilitate communication between such papers and the public at large. Members of UPS are free to use each other's material. A current list of all UPS papers and advertising rate cards for individual papers are available by sending a stamped, self-addressed envelope to UPS, BOX 26, GREENWICH VILLAGE POST OFFICE, NEW YORK 10014. A sample packet of about a dozen UPS papers is available from the same address for $4 and a Library Subscription to all UPS papers (about 50) costs $50 for the remainder of 1968.

Open City, no. 47 (1968).

The City of Saint Francis

The City of Saint Francis

VOLUME ONE, NUMBER NINE

25
in state

35
out of state

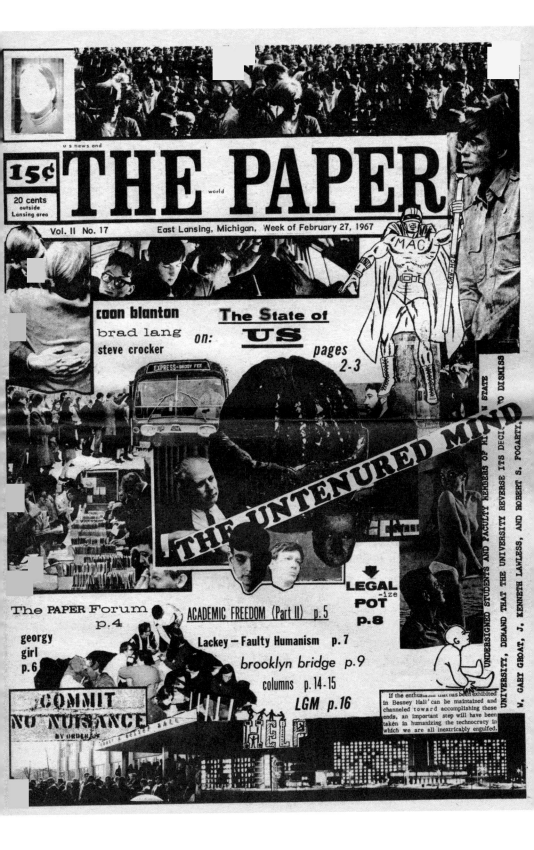

u s news and

THE PAPER

world

15¢

20 cents
outside
Lansing area

Vol. II No. 17 East Lansing, Michigan, Week of February 27, 1967

coon blanton
brad lang
steve crocker

on:

The State of US

pages 2-3

THE UNTENURED MIND

LEGAL -ize POT p.8

The PAPER Forum p.4

georgy girl p.6

ACADEMIC FREEDOM (Part II) p.5

Lackey — Faulty Humanism p.7

brooklyn bridge p.9

columns p.14-15

LGM p.16

COMMIT NO NUISANCE BY ORDER OF

HELP

UNDERSIGHED STUDENTS AND FACULTY MEMBERS OF MICHIGAN STATE UNIVERSITY, DEMAND THAT THE UNIVERSITY REVERSE ITS DECISION TO DISMISS

W. GARY GROAT, J. KENNETH LAMLESS, AND ROBERT S. FOGARTY.

If the enthusiasm that has been exhibited in Bessey Hall can be maintained and channeled toward accomplishing these ends, an important step will have been taken in humanizing the technocracy in which we are all inextricably engulfed.

didn't know us, but we made contacts with them. The movement in Austin was really tied to the movement in other places. Austin SDS [Students for a Democratic Society] was one of the biggest and most important SDS groups in the country and was very influential in terms of the national SDS. It was kind of the Prairie Power, the anarchist wing, in many ways, of SDS nationally. A number of people from Austin ended up becoming national officers. All the key people who worked on *Rag* were also involved with SDS—there was incredible overlap, it was really the same people.

One of the things about the Austin New Left was that there was this amazing sense of community. We were all very tight. Not just tight in a closed sense, but it was always growing. Somehow *Rag* was just the next evolutionary step in that community. It was the voice of that community and it pulled the community together—it played both of those roles.

We were mostly on the west side of the campus, within ten or twenty blocks of the University of Texas all the way around. The University of Texas was very, very different then—the student union was really a center; the west mall was a big open space so people could have rallies; the Chuck Wagon, which was the coffee shop in the student union, was the center of an incredible amount of subversive activity. Back then we worked out of the student union. SDS was a student organization, even though half of us weren't students most of the time. Times were different. You could be a student and drop out, go back, drop out, go back, drop out, go back. You could find places to live for seventy-five dollars. It was much easier to live. It was much easier to function. It was much easier to

go to school, to be around campus.

There was a place called The Ghetto. The Ghetto was an old Army barracks on the west side of campus and it was the center for a latter-day beatnik, early bohemian kind of scene—[there were] the *Texas Ranger* people, like Gilbert Shelton, who started the *Fabulous Furry Freak Brothers* in *Rag*; Janis Joplin; Billy Lee Brammer, the author who wrote *The Gay Place*. There were all these different groups. There were motorcycle groups that were kind of lefty, there were the spelunkers, there would be a table of the old Socialists. In the Chuck Wagon all these people would gather around, you know, and what *Rag* did was it gave all these people a place to come. When the paper would come out it would be a big event.

ALICE EMBREE
Rag, NACLA,
Rat Subterranean News

My dad was a professor at UT, so I grew up in Austin. They had fairly liberal ideas about integration. I had been in a couple of situations in high school that kind of changed me. Getting tossed out of a restaurant with a black girl on our marching squad . . . you know, that kind of thing. We had gone from Austin High down to Corpus Christi, and they got us all out of this bus (it was this stupid marching thing) and then had us standing around and no one would tell us what was going on. Then finally we get back in the bus, we go to another place, we all sit down. I was with another woman named Glodeen, who is the only African-American on the marching squad, and this waitress came over to our table and said, and you know this is so

Southern, "I'm sorry, sweetheart, we just can't serve you here." So polite, and she probably didn't want to be doing it; she was told to do it. I got up and said, "They won't serve Glodeen. We need to leave." And everybody else goes, "But we just ordered, Alice." It was just one of those markers in your life where you realize what other people will do and what you will do, and what it really meant to the person I was sitting with. So at least three of us stomped off to Woolworth's and we ate, because Woolworth's was integrated at the time (it was 1963).

Then when I was a freshman at UT in 1963 I got involved in civil rights stuff because dorms were segregated, and some movie theaters, and some restaurants, and the football team was segregated. I try to explain particularly to younger people that we had the civil rights movement as the example of moral courage and direct action. It was like, you can do things and change things. That was the first thing, and then I slowly got involved in [the] university freedom movement. Then Kennedy gets assassinated, and none of us were enamored of Johnson (some of us might have been enamored of Kennedy at the time), so I got involved with SDS in the spring of 1964 and then got involved in antiwar stuff.

I think it was like finding a place where you belong, you know. It was really before the draft kicked in very heavily and so, you know, anybody who was different, we were all mushed together by the other people and we all kind of hung together in certain ways, whether you were politically left or culturally left. There was, I think, a bigger overlap in Austin than in a lot of places that way. I think it's the weird atmosphere of Texas, it kind of throws you to the extremes. You can't hide; we stood out.

I dropped out and went campus traveling with Jeff [Shero] for SDS. (I think that was 1965 that we were doing that, spring of 1965.) We would show up in a town with a list from *New Left Notes*, cold, and start trying to find people. [We were] talking to people and then having meetings on what the issues were, organizing chapters and stuff. We went west in a station wagon called Butterscotch. We went all the way up to Laramie, Wyoming, and organized, I think, the last state to have an SDS chapter. We were in Utah—I mean, good Lord! Some very desolate places.

I think I do stand out, probably, as one of the women who found my voice through the women's movement. When *Rag* started I was certainly . . . I think if you ask a lot of people [they'll say], "Oh, Alice, you know, spoke up at meetings. Alice got put on disciplinary probation. Alice was a leader." But I didn't really see myself as a writer. I typed. That's what I did, I typed. I worked at this place, a Peace Corps training place, and I would take the [IBM] Selectric out at night. I didn't even think of it as marginally wrong, I was like, "Well, it's not being used." But I did not see myself as a writer and I didn't really write anything until, I guess it's not that much longer, it was

Previous page spread, left: *San Francisco Oracle*, vol. 1, no. 9 (1967). Cover artwork by Bruce Conner. Founded by Allen Cohen and initially funded by brothers Ron and Jay Thelin (coowners of the Psychedelic Shop, which was located in the heart of the Haight-Ashbury district), the *San Francisco Oracle* started publishing on September 20, 1966, and lasted for twelve issues. Highlights of this issue include: a report on LSD by Tim Leary and Ralph Metzner; an antiwar poem by Michael McClure; psychedelic art by John Thompson; an analysis of Buddhist thought by Dane Rudhyar, illustrated with a drawing by Michael X; and an article by Allen Cohen on the murders of two local drug dealers.
Previous pagespread, right: *The Paper*, vol. 2, no. 17 (1967).

the fall of 1967. I was in New York by then and I had been on a Chile exchange program that had been cancelled and [of which] Frank Irwin, who was the chair of the Board of Regents, said, "Well, we cancelled it because of the Embree girl." And that was the first thing that I wrote, a long piece about the Chile exchange program, for *Rag*. It kind of came out of total anger.

PETER SIMON
Cambridge Phoenix, Real Paper

I grew up with my father being an amateur photographer. I followed in his footsteps wherever he went. He taught me early on how to use the darkroom, and then he died when I was only twelve and I inherited all his equipment. I actually started a group and a, sort of, photo magazine, a student-run magazine, that I would distribute to students. This was when I was fourteen, fifteen, sixteen, seventeen, and I was photo editor of the student newspaper and the yearbook and would also work for a local paper in my hometown, which

was called Riverdale, right outside New York. I worked for *Riverdale Press* and earned ten dollars a photo.

Ray Mungo and I became friends while he was the editor of *BU News*, which was the campus newspaper for Boston University. He led a lot of left-wing causes. He barraged kids with left-wing propaganda, which I wasn't familiar with when I first got there because I was slightly apolitical. It wasn't long before he convinced me to go out and demonstrate against the war. He was a very charismatic figure and he got a lot of students behind him. It was about the time when it was becoming obvious that we could be drafted for this war that we didn't really care about, so there was a wave of enthusiasm that swept over the BU campus and across the country (but it first started with BU and Columbia). He turned the *BU News*—which he was the editor of and which was a student-run but university-funded newspaper—into a left-wing radical newspaper for which he was the editor and spokesman. The administration was horrified about this, but because it was student-run, they couldn't really do very much about it. The campus got very divided between the ROTC, fraternity-loving, beer-drinking right wing versus the hipster left-wing, sex, drugs, and rock-'n'-roll types that grew in numbers as the years went by. Thanks to Ray, somewhat, it became a very politicized, polarized campus. There were be-ins, sit-ins and shutdowns, civil disobediences, and marches. It was one thing after another. He started with the war, but then it was pro-pot and after pro-pot it was pro-abortion, after pro-abortion it was against Dow Chemical. It was on

Cambridge Phoenix, vol. 1, no. 9 (1969). Peter Simon shoots the Rolling Stones at Boston Garden.

and on and on—there was a parade of different causes that he championed. It was really fun to be a student at BU in the late sixties. Everyday there was some other major exciting event taking place.

I was the photo editor of the *BU News*, and I worked very hard for them, as a matter of fact. Every week there were two or three or four events that I attended, or people that I had to photograph in the Boston area that somehow related to BU. There were feature articles and there were demonstrations and rock concerts, or sports events. We had a darkroom down at the student union and I would be in the darkroom with my friends printing pictures and getting stoned and listening to Dylan and the Beatles and the Stones and the Dead. It became quite a hippie hangout there in the darkroom, you know we just had a blast, we really did. It was one of the most enjoyable periods of my life, really.

He [Ray Mungo] went to Washington to start Liberation News Service and we all stayed in Boston to finish graduating. At one point I actually spent a lot of time in Washington. They had rented a house in the Northwest district and I went down and lived for a while there. I'd set up a makeshift darkroom; I don't know how the hell I did that. I was there for maybe a month doing pictures for LNS and submitting them, but that was short-lived because I really didn't want to live in Washington. Of course I wasn't paid anything for this, mind you. It was all done pro bono because I just believed in the whole idea of it. I just sort of contributed my time. I did it for the experience. It was almost like continuing my education to do that sort of stuff.

I just really fashioned myself as a left-wing alternative culture type of photographer and did all I could to get backstage to see, you know, the Stones or Bob Dylan, whoever was coming through that I really wanted to see. I would use my press credentials to get there.

JEFFREY BLANKFORT
San Francisco Express Times, San Francisco Good Times

When I was a small child my sister and I did some experimenting with old Kodak folding cameras and we had a darkroom in the basement of our house in which we actually learned how to develop film. But then I forgot all about that until I was working at the *San Francisco Examiner*, a Hearst newspaper, after I got out of high school. I learned how to develop film in the darkroom of the *Examiner*, but still I was more of a writer than a photographer until I came across, quite a few years later in the early sixties, the book *Decisive Moment* by Henri Cartier-Bresson. Looking through that book made me decide to become a documentary photographer in the style of Bresson, and so I slowly did.

I had a job working in Marin County, where I lived, but in San Francisco, uniquely, they had a photo center and for a very inexpensive price (I think it was ten dollars a year or six dollars for six months) you had the use of a darkroom, which was complete with chemicals. All you had to do was bring your paper and they had about sixty enlargers, a drying room, a developing room, and they had a studio for doing portraits. It was very unique and a number of San Francisco photographers besides myself owe our careers to the San Francisco Photo Center (it's now named after Harvey Milk) right on Duboce Avenue off

Divisadero. I used to go there after work three nights a week until it closed at ten o'clock. In those days paper was very cheap, you could buy a box of Luminos paper (a hundred sheets) for five dollars, believe it or not. So I could print and print and print the same photograph until I got a print that I liked, and I was sort of learning on the job.

Then came the Sixties. The first movement activities that I photographed were at the Sheraton Plaza sit-in in 1963 on Market Street. Until that time in 1963, unless you had a family that owned a hotel or apartment house, unless you were white, you could not get a job working in a major hotel or restaurant in San Francisco. For three or four days there was a massive sit-in and disruption of business in the Sheraton Plaza on Market Street (at Market and Montgomery). Dick Gregory came to offer his support; the labor unions did not. Despite talking about ending racism, the labor union did not support the students in this case. There were a number of arrests made, but in the end, after four days, the hotels and restaurants signed a deal saying they would no longer practice racist hiring practices. Unfortunately the pictures I took were all underexposed,

totally useless. I had another chance shortly there afterward when the same group—led by the NAACP, which was a radical organization at that time under Nathaniel Burbridge—decided to integrate the automobile agencies on Van Ness Avenue, which was called Auto Row. Three hundred and fifty-seven people were arrested after sitting-in at the Cadillac agency on Van Ness, and after that, the auto dealers agreed to end racist hiring practices. Two major victories for the civil rights movement which are generally unknown by people in San Francisco.

There were no underground papers, so to speak, at the time, and nobody was sending me on assignment. I went to Europe in 1966, left my job and went to Europe to actually become a photographer and see what it was like to live in another country. I went to live in Italy for six months because I had friends there and I sharpened my skills. When I came back [to the San Francisco Bay Area] Huey Newton had been arrested, accused of shooting an Oakland policeman, and I started photographing demonstrations outside the Alameda County Courthouse. One of them was used in the newspaper, *The People's World*, which was the organ of the Communist Party. Kathleen Cleaver saw that picture, got my number, and called me, and that began a friendship that exists to this day. I went over to see Kathleen, and they used that same picture in the Panther paper. Then she asked me if I would print some other pictures, which I agreed to do. From that point on I became kind of the semiofficial photographer for the Panthers.

San Francisco Express Times, vol. 1, no. 8 (1968). Jeffrey Blankfort photo of filmmaker Jean-Luc Godard at a rally for Huey Newton in Berkeley. Opposing page: *The Black Panther*, vol. 3, no. 32 (1969).

THE BLACK PANTHER

Black Community News Service

25 cents

VOL. III NO. 32

SATURDAY, NOVEMBER 29, 1969

PUBLISHED WEEKLY

THE BLACK PANTHER PARTY

MINISTRY OF INFORMATION
BOX 2967, CUSTOM HOUSE
SAN FRANCISCO, CA 94126

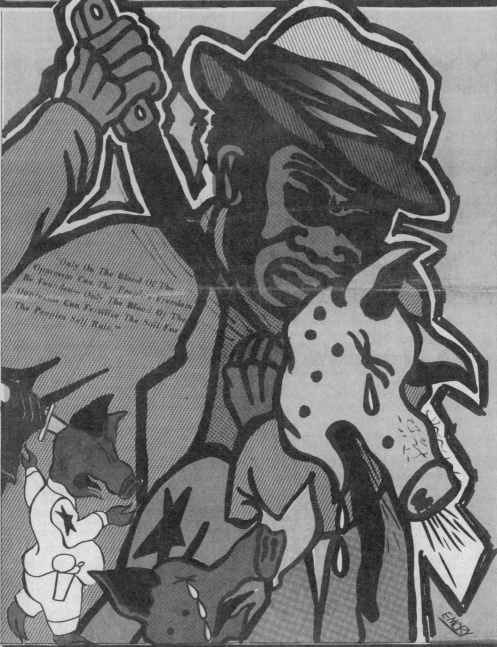

EMORY DOUGLAS
The Black Panther

They had a place called the Black House here in San Francisco where a lot of cultural activity used to go on. Eldridge Cleaver used to rent the upstairs and all the cultural stuff went on downstairs (Marvin X was living downstairs). It was an old Victorian house in [the] Fillmore [district] above Divisadero on Broderick Street off of Sutter. One evening, I went through there and there wasn't any activity going on, but Bobby [Seale] and Huey [Newton] were there. They usually used to come over there to go up and talk with Eldridge because he had worked at *Ramparts* and they knew of his writings and they were trying to recruit him into the [Black Panther] Party to be the editor of the newspaper. So that evening when I came there, Bobby and Huey and Eldridge were downstairs sitting at the table having a conversation. I came in and Bobby said, "I'm working on the newspaper." This was our first newspaper, and I saw him just take it out of the typewriter. He had typed it on a legal-sized sheet of paper, and he was using his markers to do the masthead of it. Because I had been going to City College and took up commercial art, I had a kind of sense of what he was doing. I had materials from City College so I told him I could help, I could go home and get some of my materials and come back and maybe he could use them. He said, "OK." So I walked home, picked up my materials—rub-off type and all that kind of stuff—and came back. It took me about an hour, and when I came back they was surprised that I came back. They said, "Well, you

seem to be committed. You've been coming around and the whole bit. I'm finished with this one but we're going to start our newspaper and we want you to work on the paper. You'll be the Revolutionary Artist for the paper."

The first paper was April 2, 1967, the one that Bobby laid out. It was two legal-sized sheets of paper, typed on front and back, and then they would staple it together. It was done on a Xerox machine. Bobby and them had access to copy machines through these community service programs that they worked in so they printed them like that. They would just hand them out, give them out to folks. The first issue was about the Denzil Dowell murder by the Richmond police.

ABE PECK
Seed, Rat Subterranean News

When I was in Chicago I was a very avid reader of *The Realist*, Paul Krassner's magazine. Krassner, to me, was kind of the godfather of the underground press [because of] his attitude about Dadaism and [his] ability to laser into psychedelic mindset issues of how to think about politics and about government (even though it [*The Realist*] was printed on white paper and Paul was older and all that stuff). Anyhow, Paul had gotten mugged and wrote something in *The Realist* that he was looking to get out of New York City, and it said he was looking for a farm. I was living with a couple people, you know, hanging out with several people, and I volunteered this guy's farm without asking him first, of course. I wrote a psychedelic letter. I had got a lot of colored pens, and I had a Rapidograph, and I wrote—and this all sounds very

REVOLUTIONARY LITERATURE

THE CATECHISM OF THE REVOLUTIONIST

75¢

by Mikhail Alexandrovich Bakunin

with an introduction by
THE MINISTER OF INFORMATION

①

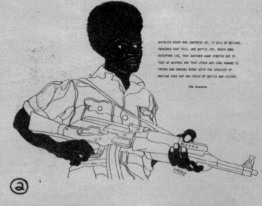

②

REVOLUTIONARY POSTERS *Every* **$1.00 ea.**

$1.25 OUTSIDE OF CALIFORNIA.

SEND CHECK OR MONEY ORDER TO EMORY DOUGLAS
BLACK PANTHER PARTY FOR SELF DEFENSE
P.O. BOX 8641 EMERYVILLE BRANCH CALIFONIA. 94608
ALL POSTERS ARE 17x22

③ HOPE

④ H. RAP BROWN

⑤ LeRoi Jones

BOBBY

CHAIRMAN
BLACK PANTHER PARTY FOR SELF DEFENSE

50¢
⑦

PAMPHLETS
BY
THE
BLACK
PANTHER
PARTY
FOR
SELF DEFENSE

HUEY

MINISTER OF DEFENSE
BLACK PANTHER PARTY FOR SELF DEFENSE

⑧ 50¢

BY THE MINISTER OF INFORMATION

SOUL ON ICE
by Eldridge Cleaver

McGRAW-HILL BOOK COMPANY
330 West 42d Street, New York, N. Y. 10036

**$5.95 AT ALL
BOOK STORES**

Check number of article(s) ordered
and indicate quanity of each beside:

REVOLUTIONARY LITERATURE

___ 1 (75¢)

___ 6 ($1.95) ___ 7 (50¢) ___ 8 (50¢)

REVOLUTIONARY POSTERS
($1.00 each; $1.25 outside California)
___ 2 ___ 3 ___ 4 ___ 5

Send check or money order to:
Black Panther Party for Self Defense
P.O. Box 8641 Emeryville Branch
Oakland, California 94608

And now, man...

SAMPSON/WANDEROO

CHICAGO SEED 35¢

VOL. 3 NO. 11

hokey—but I wrote this letter that was filled with colors and this and that. Instead of Paul responding, I got Jerry Rubin coming out to tell me about this groovy Festival of Life that was going to happen in Chicago, around the time of the Democratic Convention, that was going to be kind of a counter-convention—you know, separate from the creeping meatball kind of politics, as they called it.

So I was excited by this, and I wrote a piece for the *Seed*, which was publishing before I got there (they had started publishing May of 1967, around a Mother's Day Be-In). The papers really were getting by with a little help from their friends, and I just came in with this thing, and, my memory is not specific about this, but I said, "Hey, Jerry Rubin is going to be in town." People knew who Jerry Rubin was and, you know, the *Seed* was an umbrella at that point. Which means, if something was going on in the community that was counterculture or antiwar, the *Seed* was in that mix between covering it and advocating it. So they ran it, and I starting hanging out at the *Seed*. In terms of access to the paper: if you came in with something that seemed simpatico with everything that was going on, I think the odds of getting printed were pretty good. Also, I was a halfway decent writer at the time. It was a combination of the fit of the material and I guess I passed someone's sniff test. I was cool enough to come in.

TRINA ROBBINS
East Village Other,
Gothic Blimp Works, Berkeley Tribe,
It Ain't Me, Babe

I grew up in Queens, New York, in a very suffocating kind of neighborhood.

I escaped into books; my mother was a teacher and she taught me to read. Boy, did I take to books—I read everything. I also read comics. In those days, a lot of parents were worried if their kids read comics because they thought it meant they wouldn't read books, but I read everything so there was no problem. Once a week when I got my allowance, I would go to the corner candy store where they had this spinner rack that said, "Hey Kids, Comics!" and I would buy a comic. I bought all the comics. I loved the teen comics that were basically aimed at girl readers. I bought everything, though, that had a female hero, which meant that I loved Mary Marvel, I loved Wonder Woman, and I also bought all those wonderful Fiction House comics, especially the jungle comics, I loved Sheena, I loved the Jungle Girls. Fiction House, really they were action comics, but they specialized in women heroes. At the age of seven I was very advanced; I was reading teenage books. I don't remember any specific titles, but I read all the classics as a kid: *Little House on the Prairie*, *Pollyanna*, and *Little Women*, all of those. At the age of thirteen I discovered science fiction and I went through a period, I think from thirteen to about seventeen, reading nothing but science fiction. Discovering Bradbury was like how born-again Christians must feel when they discover Jesus.

I'd always drawn, but I never knew what I was drawing . . . it was just these little drawings on paper. I didn't know what they were until there was this little comics renaissance. I had read comics like mad as a kid, and then I stopped when I was a teenager. It was like comics were kids' stuff. But then there was this comics renaissance over at Marvel with

the X-Men and the Fantastic Four and Spiderman and Thor and Dr. Strange. I really loved Thor and Dr. Strange, of course they were my favorites. Dr. Strange was so, like, mystic and psychedelic. And Thor, because I had always struggled with the concept of a bearded guy in the sky, this God, which I never really liked, and I loved mythology, and Thor was like Stan Lee was saying, " Yes, there really are gods. There really is a god Thor." It's like saying, "Yeah, you don't have believe in that stupid guy in the sky, there's other gods." That was great for me, I really liked that. So I got turned on to comics again. Then Batman was on TV and it was very pop art. I started realizing that these little drawings I was doing were sort of like proto-comics, and that's kind of what got me started in drawing comics. Actually, the very first comic I ever did was, I think, around 1965 or 1966 for the *L.A. Free Press* (I had been living in Los Angeles). That was a very small little four-panel thing, basically about a cat falling in love with a flower. To make matters weirder, I did it in French and they published that.

I came to New York in the summer of 1966 and a friend of mine, Eve Babitz, was the managing editor of *EVO* [*East Village Other*]. I knew Eve from Los Angeles so I went and visited her. I met Allan Katzman, who was the publisher, and Walter Bowart, who was the editor, and did a little bit of hanging out with Walter, kind of maybe dating him, going to a couple parties with him, stuff like that. I loved the *East Village Other*, it was much more adventurous than the *Free Press*. The *Free Press* was quite political. *EVO* was more, I guess it was also political, but in a very hippie kind of way. The layout was much bolder. It was less like a real newspaper and the *Free Press* was still almost like a newspaper, but not quite. So I did a little drawing for them of my character Suzie Slumgodess. I went by the office and no one was there, so I just kind of stuck it under the door. Next thing I knew it was published, and that's kind of how it started.

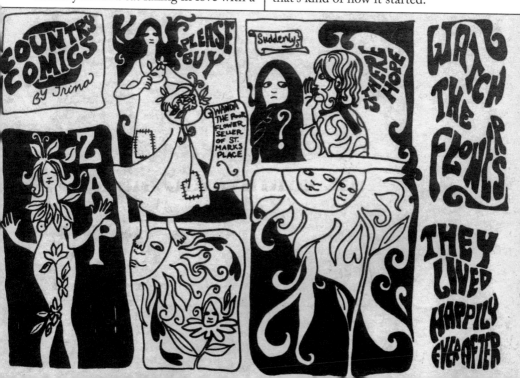

HOWARD SWERDLOFF
New York High School Free Press, John Bowne Was a Pacifist

We were a group that had representatives in a variety of schools, in dozens and dozens and dozens, probably hundreds, of schools. We distributed this newspaper all over the city. At the height of its publication we printed forty thousand copies a month.

I was a student in Queens, New York, at John Bowne High School. We all had our little papers going in our various schools. I was printing a paper in my school called *John Bowne Was a Pacifist*. We all had our little copies of different newspapers that we published. Some were more or less elaborate than others. We knew each other because we were working together in the antiwar movement originally, and out of the experiences we had in the summer of 1968 at the Democratic Convention in Chicago, among other places, we became progressively more interested in other issues besides the war.

If you were white, chances are you came to this through the antiwar movement, opposition to the Viet Nam war. We had been doing this for a couple of years already, most of us. New York City had a very active opposition to the war in Viet Nam. There was an organization in New York called the Fifth Avenue Vietnam Peace Parade Committee on Seventeenth Street, and a lot of us would go there after school. They provided us with facilities to publish our little antiwar newspapers. You would meet students from all over the city there—from Bronx Science, from Seward Park, Brooklyn Tech, you name it. And there was an antiwar organization focused on high school students called the High School Student Mobilization Committee, and a number of us were active in that.

In 1968, where the genesis of this paper occurs, we were a mixed group of kids, white and black, male and female, and from all over the city in New York. Since we were breaking new ground, doing something that hadn't necessarily been done before, we had all kinds of access to equipment and money and resources that we probably would not have if this happened again today. For example, there was a newspaper in New York called the *New York Free Press*, and it was published out of an office on West Seventy-Second Street off Broadway. They gave us access to their facilities at night, after they went home. Professional typesetting equipment, a fully equipped office, and they actually had a woman who was selling advertising for the *New York Free Press* and she sold advertising for us. We had full-page advertisements from Columbia Records. I don't think that would happen today. On the front page we had "Anarchist Calls to Insurrection," and inside you had full-page advertising from record companies, movies and clothing stores in the city, etc. This office was also producing a pornographic newspaper, the *New York Review of Sex*, a high-class version of *Screw*. We also were exposed to a lot of stuff that was going on there that people would be sensitive about today.

A lot of the members of our staff and activists in our organizations were

East Village Other, vol. 3, no. 39 (1968). Following page spread, left: *Gothic Blimp Works*, no. 3 (1969). "I wanted to do something sexy, basically, and I love cats and I love lions. The sexiest thing I could think of was actually, if it were actually possible, to have sex with a lion and have a baby that was part lion; it was just a great concept. Of course, I've always been a real fan of the jungle comics and jungle girls, so she [Panthea] was kind of a jungle girl character." —Trina Robbins. Following page spread, right: *New York High School Free Press*, no. 8 (1969).

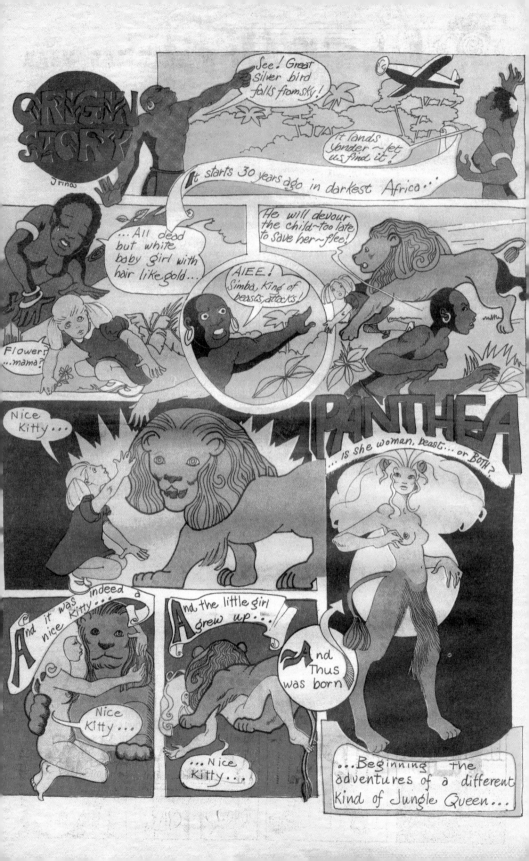

new york
HIGH SCHOOL
FREE PRESS

"Of, by, and for liberated High School Students"

ISSUE 8
SPECIAL
CONSPIRACY
EDITION
APRIL—MAY '69

5 cents in schools
15 cents on newsstands

"four letter words,
filthy references,
abusive and disgust-
ing language, and
nihilistic propaganda."

—Judge Bartel

A mother pleads for her son's freedom at Erasmus High School. hs freephoto by Miriam Bokser

HAPPY MOTHER'S DAY

Published at 208 West 85th St., NYC 10024 Printed Matter

what we called red diaper babies. I wasn't one of those. I was an All-American boy—I was a Boy Scout and an honor student. I lived in Queens and had no connection with the cosmopolitan world in Manhattan. I played in the local band and went to a little provincial high school in Queens, so all of this was new to me. I didn't understand the nuances of the left—the Trotskyists and the Communists, or any of that. I wasn't interested either. I was doing this because I felt that the principles that this country was founded on were being violated by the Viet Nam War, and I had a certain kind of antiauthoritarian streak in me that is very American, you see it today among the Libertarians on the right more than you might see it on the left. That was my thing. We had a variety of perspectives, but what we all shared was this kind of exuberance and antiauthority.

Then of course the African-American students were already in conflict with the authorities over civil-rights issues and over cultural issues that were specific to them. That was already going on before we became active and aware, and we made alliances with them. We started getting very sophisticated about our roles and our power struggles, and we made alliances with African-American students, with Latin students, and we developed a fairly sophisticated degree of coordination by the spring of 1969.

One of the things I left out was that there was a teacher strike in New York in September of 1968.* This gave us all kinds of free time to develop our talents, to build organizations, which we did. That fall was really important because we devoted all of our efforts to building this student organization and this student newspaper.

We went around the city opening up schools in alliance with the black student organizations, and we had the newspaper to give out to students who were milling around or in the buildings conducting freedom classes. We now had this very impressive newspaper and, of course, the strike and our reaction to the strike was on the front page of our newspaper and we started to make connections between all of the stuff that was going on. It was very natural that all this stuff started to fall into place.

Sansculottes, no. 24 (1967). Based out of the Bronx High School of Science, *Sansculottes* was one of the earliest high school underground newspapers in New York City. Here they issue a call to mobilize fellow high school students interested in attending the October 1967 antiwar demonstration in Washington.

* The strike stemmed from a May 1968 dispute between the United Federation of Teachers (UFT), led by Albert Shanker, and the administration in the Ocean Hill–Brownsville school district over the dismissal of thirteen teachers there. The Ocean Hill–Brownville area of Brooklyn was one of three newly decentralized school districts in the city, part of a pilot program initiated by mayor John Lindsay to test the efficacy of community-led school boards. Though once a predominately Jewish neighborhood, the area was, in 1968, a mostly black community, and the newly formed, community-elected school board voted to dismiss thirteen teachers who were all white and almost all Jewish. Albert Shanker and the UFT protested this action as a violation of the teachers' rights and a long, protracted battle ensued. In a series of strikes that took place between September and November 1968 there was a citywide shutdown of the public school system for a total of thirty-six days. During this period, parents and sympathetic teachers and administrators would routinely go around opening schools, but it was only the students who were able to actually keep the schools open and functioning for any length of time. Though the union ultimately prevailed, the strike was widely seen to be a racist denial of the wishes of the Brownsville community and served as a unifying issue for student-activists all over the city.

CONFRONT THE WARMAKERS

Do Your Thing.
The Liberals will hold a rally
to cleanse their consciences &
discuss the Problem of Youth.
The Revolutionaries will jam the halls
to shut down the works.
The Hippies will surround the building
and raise it off the ground with chants.
Everyone Else can run around feeling
important.
Why?
Because Our Leader's popularity has
reached a new low, and because the War
has reached a new peak, and because
when we complain they tell us to
shove it.
So now we're gonna shove them.
October 21, 1967, Washington, D.C.
Hundreds of thousands of us will
show them where it's at.
Be there.
Order bus tickets from FREE YOUTH PRESS.
NOW.
Send in your name, address, & phone #.
And $7

exercise the **PENTAGON**

WASHINGTON
VOL III, NO 3
MAY 1-15, 1969
1522 CONN AVE
20¢
25¢ out of town

FREE PRESS

FILES CAPTURED AT GWU LIBERATION

UNITED STATES GOVERNMENT

PENALTY FOR PRIVATE
PAYMENT OF POSTA

_L INTELLIGENCE AGENCY
WASHINGTON. D.C. 20505
ATTN: MAP LIBRARY

OFFICIAL BUSINESS

PROF RICHARD Y C. YIN
INSTITUTE FOR SINO-SOVIET STUDIES
GEORGE WASHINGTON UNIVERSITY
WASHINGTON, D 20006

BLURRING THE LINES

Participants or Reporters?

A defining characteristic of the underground press was the rejection of journalistic objectivity as an ideal. More than anything, the concepts of disinterestedness and nonpartisanship inherent in any posture of objectivity were anathema to the emergent youth culture, which demanded a lifestyle of total immersion. Whether political or cultural—and oftentimes the two were inextricable—the content of these underground newspapers was, unapologetically, a direct reflection of the hopes, dreams, and activities of the editors, writers, and artists who saw themselves as active participants in, as well as chroniclers of, the scene.

Washington Free Press, vol. 3, no. 3 (1969).

PAUL KRASSNER
The Realist

I went from [being] an observer to a participant when I interviewed, what I refer to as, a humane abortionist. *Look* magazine had said there was no such thing as a good abortionist—they were all in it for the money. And this was Dr. [Robert] Spencer, who would charge as little as five dollars and was known all around the country as The Saint. He had a clinic and was a regular physician who went down into the coal mines to help treat miners who had black lung disease. After publishing the interview, without naming him, I promised him I'd rather go to prison than identify him. I got several calls a day from women who were pregnant and didn't want to be, and, with Dr. Spencer's permission, I put them in touch with him. So throughout the sixties I ran an underground abortion referral service. I got calls from two district attorneys accusing me of being part of a criminal conspiracy. I refused to testify to the grand juries in either of those cases.

One was in Liberty, New York, upstate, where they told me they had interviewed the doctor and they had it on tape that I had been involved with him, and if I testified they would grant me immunity. So I said, "Let me go call my lawyer." I went out and called the doctor himself and he said, "They're just making that up, they never interviewed me." So I went back and they said, "OK, the cops are gonna come here and arrest you at two o'clock." At one o'clock they said, "Alright, you've got an hour to change your mind." They said, "What did he say?" I said, "Oh he told me to continue my position of not testifying." So finally two o'clock came and they said, "OK, you can go home now," and I took a bus back. That's the way they worked.

The other case was in New York. Let's see, it was a district attorney from the Bronx who is now a judge. He told me that they had evidence of all the money that I had gotten in kickbacks from doctors. I knew that he was lying because I never took a penny. In fact, when they offered me something I said, "No, but I want you to take that much off of any woman who I send your way." But he said that because of the money I had supposedly took, I was part of a criminal conspiracy. He said, "But we'll give you immunity if you testify for us." And he stuck his hand out to shake it, and I said, "I'm not shaking your hand. It's not true what you say." My lawyer just said that he was going to sue the state of New York over the abortion laws that were unconstitutional, and that I couldn't be forced to testify about something that was against the Constitution. That [case] won. Some women's groups joined that suit, and later it was expanded into the *Roe v. Wade* case.

My point is that I got involved. I wasn't just a satirist; I was an activist now. It happened the same with marijuana and LSD. I sent Robert Anton Wilson on an assignment to Millbrook, New York, where Tim Leary and Ram Dass (who was then Richard Alpert) were, and I published his article as a front-page story. Then I got invited up to Millbrook by Leary and became friends with those guys and ended up becoming an acid-head myself. Again blurring, well, erasing the line between observer and participant.

Rat Subterranean News, vol. 2, no. 18 (1969). The alternative. Cover by Bill and Louise Etra.

RAT
SUBTERRANEAN NEWS

Gilbert Shelton Interview p. 8

SEPTEMBER 10-23

N.Y.C. 15¢ OUTSIDE 25¢

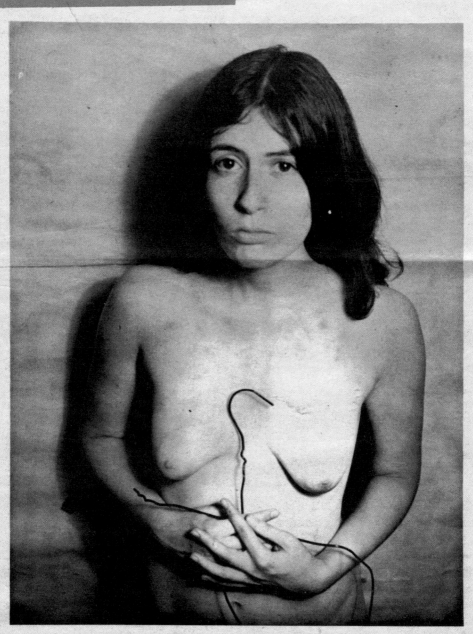

ABORTION

The Parts That Were Left Out of the Kennedy Book

An executive in the publishing industry, who obviously must remain anonymous, has made available to the Realist a photostatic copy of the original manuscript of William Manchester's book, The Death of a President.

Those passages which are printed here were marked for deletion months before Harper & Row sold the serialization rights to Look magazine; hence they do not appear even in the so-called "complete" version published by the German magazine, Stern.

At the Democratic National Convention in the summer of 1960 Los Angeles was the scene of a political visitation of the alleged sins of the father upon the son. Lyndon Johnson found himself battling for the presidential nomination with a young, handsome, charming and witty adversary, John F. Kennedy.

The Texan in his understandable anxiety degenerated to a strange campaign tactic. He attacked his opponent on the grounds that his father, Joseph P. Kennedy, was a Nazi sympathizer during the time he was United States ambassador to Great Britain, from 1938 to 1940.

The senior Kennedy had predicted that Germany would defeat England and he therefore urged President Franklin D. Roosevelt to withhold aid.

Now Johnson found himself fighting pragmatism with pragmatism. It didn't work; he lost the nomination.

Ironically, the vicissitudes of regional bloc voting forced Kennedy into selecting Johnson as his running mate. Jack rationalized the practicality of the situation, but Jackie was constitutionally unable to forgive Johnson. Her attitude toward him always remained one of controlled paroxysm.

It was common knowledge in Washington social circles that the Chief Executive was something of a ladies' man. His staff included a Secret Service agent referred to by the code name *Dentist*, whose duties virtually centered around escorting to and from a rendezvous site—either in the District of Columbia or while traveling—the models, actresses and other strikingly attractive females chosen by the President for his not at all infrequent trysts.

(Continued on Page 18)

The Realist

No. 74

May, 1967

35 Cents

irreverence is our only sacred cow

The other area was in covering the Viet Nam War demonstrations. I ended up cofounding the Yippies, the Youth International Party, with Abbie Hoffman and Jerry Rubin. As a journalist, I knew that you needed a "who" for the "who, what, where, when, and why." So I came up with that name. We were just looking for something that would symbolize the radicalization of hippies—and it worked. We had no budget, so we had to deal with as much media manipulation as we could. If we gave them good quotes, they gave us free publicity. We could, in that context, get the information out about some kind of march or rally that was gonna take place, any protest action.

The most notorious thing I published was "The Parts That Were Left Out of the Kennedy Book" in 1967. Now that's the thing that people remember the most, and that remains my own favorite because it was an exercise in nurturing the incredible in the credible context leading up to the climactic scene which was an act of presidential necrophilia between Lyndon Johnson and the corpse of John F. Kennedy on Air Force One after the assassination. There were people who believed that. They had been seduced by the verisimilitude of the context, if only for a moment. They believed that the president, the leader of the Western world, the one who was escalating the Viet Nam War, was what the FBI called me, a raving, unconfined nut. And people complained to me afterwards that I should have labeled it as satire. And it was intriguing to me because Jonathan Swift didn't say anything about his "Modest Proposal," he didn't say, "Folks, before you read this I just want to let you know that the British didn't actually try to stem the population and the hunger in Ireland by eating Irish babies." I didn't

want to deprive the readers of deciding for themselves whether something was factual or a projection of the implications of what you're writing about.

I think it [the underground press] flourished, it blossomed as it happened, because it fit a need, which was to compare the difference between what happened on the streets how you experienced it and how it was covered in the mainstream press. So the underground press became the missing link between those two poles.

ALICE EMBREE
Rag, NACLA,
Rat Subterranean News

NACLA (*North American Congress on Latin America*) had this little teeinsy apartment . . . a safe house. It had this mystique about it, you know, "We're the movement intelligence agency." Mostly it was just full of a bazillion books. It was up near Columbia . . . a bazillion *Who's Who*, *Moody's Industrials* and corporate annual reports. You'd go in the bathroom and the bathtub was full of *Wall Street Journal*s that needed to be clipped. It was pretty much a small group that did research and produced a newsletter. Fred Goff was there, Edie Black, Marge Piercy was there when I got there (she went on to become a major poet), and a guy named Michael Locker.

At the Columbia strike* we got documents from the office [of President Grayson Kirk]. Everyone remembers it differently. I remember—and I think I have a right to remember this, because it hit me in the eye—the stuff got stuck in Mark Rudd's briefcase, Jeff [Shero] threw it out of the window and I took it.

The Realist, no. 74 (1967).

I just remember at the time I had shoes that were not appropriate for running in the street, and I managed to trip on the cobblestones and gash the heck out of my chin. By the next morning the story is on the front page of the *Times*, and I just look like a casualty of a police riot. I just remember taking it [the briefcase of documents] and making the call, "Can you meet me somewhere? You'll never guess what I've got." It was just evidence. It was evidence of what we suspected and sort of knew.

Then we published it. We copied it so we wouldn't have the originals, of course, and then it also got published in *Rat* and some of those letters in *Who Rules Columbia?* That big pamphlet—which was one of the first to explore the power structure of the university (there was also *How Harvard Rules* and several others that came out subsequently)—was groundbreaking.

JEFFREY BLANKFORT
San Francisco Express Times,
San Francisco Good Times

When I got there [the 1968 Democratic National Convention in Chicago] I went to the office of the headquarters of the Yippies. Jerry Rubin and Tom Hayden were there—I don't think Abbie Hoffman was there—and they told me I should take pictures of the two plainclothes policemen downstairs, who were sitting at the entrance of the office building. So I went down there and I took a number of pictures of them, which they did not like. So then I leave, and when you come into this building you have to sign your name, and I sign out, and they rush to see what my name was—and it was "Che Guevara." So then I go and get my car, which I had borrowed from a friend of mine, Freddie Gardner. He had an old Peugeot, and it did not have a rear license plate on it. So the cops run out, they see my car coming by, they're waiting to see the license plate, I go by them . . . no license plate. That really gets them going.

Open City, no. 67 (1968).

*At the end April 1968, almost three weeks after the assassination of Martin Luther King, a coalition of students from SDS and the Student Afro-American Society (SAS) led an eight-day occupation of five buildings on the Columbia University campus. During the course of the occupation, they found and liberated documents that outlined, in no uncertain terms, the labyrinthine connections that the university had with the world of military research and funding. To get the documents safely off the campus, Jeff Shero threw them out the window of university president Grayson Kirk's office to his then-girlfriend Alice Embree.

The two main issues that provoked the protest and occupation were: 1. Columbia University, located on the Upper West Side of Manhattan, as a growing institution was steadily snapping up real estate and encroaching on its neighbor to the north, the predominantly black community of Harlem. The university planned to build a gym in Morningside Park, complete with a separate (but equal?) entrance for Harlem residents. 2. As the student antiwar movement gained momentum, students bristled at the open presence of the military think-tank Institute for Defense Analyses (IDA) on the Columbia campus.

Actually, after the Lincoln Park event I almost run over a cop on a three-wheeler. He falls over trying to avoid me hitting him, and he gets up and he's really furious. Then he looks at my lapel and I have on a Humphrey button, which I had put on there as a joke. When he saw the Humphrey button—that was like a Tea Partier seeing a Glenn Beck button—he said, "Be careful next time."

I had actually been tear-gassed that night because I didn't have my gas mask with me. (I had it with me but I didn't put it on in time, and someone opened their doors and let me wash my face.) I think later that night they [the cops] were pulling people out of doorways that were not part of the protest. I had my flash—a press flash with a removable head, old-fashioned kind—and the cop said to me, "If you take one more picture I'm going to make a suppository out of that flash and ram it up your ass." So of course I took one more picture. I see a club pass by my head and he smashes the head of my flash. But of course I had another one with me to replace it.

Then finally, in front of the Hilton (after I put all my film away because if I got arrested I didn't want them to take it), I was walking towards where the protest had been, and I ran into Howard Bingham. He was a *Life* magazine photographer, a black photographer more known for his sports photographs; one of the best sports photographers. He had been assigned to cover this by *Life* magazine, and Howard said, of what he had seen the cops doing, "I've never seen anything like this." So then I go out on the street to take some photographs, and the police captain tells me, "Get out of the street, you're gonna get arrested." I keep taking photographs. So then he

orders me arrested. There's a picture in a book on the Chicago riots of me being lifted, by two Chicago policemen, with a helmet and gas mask on, being escorted to the paddy wagon. The helmet fell off into the street, but a cop threw it in for me, which was very nice. I'm arrested along with Barton Silverman, who's still the sports photographer for *The New York Times*, and a guy named Tom something-or-other who is a United Press [International] reporter (who was later arrested for carrying a trunk full of marijuana across the border from Mexico, so you know how long ago that was). I had a beard, and I go into the Chicago police station and there's a cordon of policemen, and they say to me, "Well, welcome, Fidel!"

THORNE DREYER
Rag, Space City!, Liberation News Service

An interesting phenomenon that kind of communicates what *Rag* did and the nature of the Austin community was Gentle Thursday. This was in the very early days of *Rag*. We just all sat around and decided to create this event. We said, "Let's just have a day that we get everybody together." And we decided to do it on the West Campus [of the University of Texas] by the student union. So in one issue of *Rag* we had just a little one-inch thing that said, "Gentle Thursday Is Coming," and then every issue it would get bigger and bigger until it was a full page. There was a little bit of an antiwar message, but basically it was just let's love each other—let's have fun. It was an SDS-sponsored event, and the university freaked out and banned Gentle Thursday. As a result of that it

CHICAGO

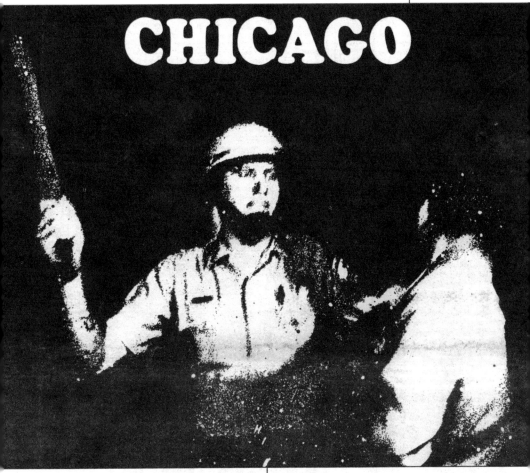

became a political event. Suddenly it was a radical thing to have this love-in. It was a massive success and it did a whole lot to build the movement, to build SDS and to give it that sense of being a joyous thing. Originally there was incredible vision involved. *The Port Huron Statement* is an amazing document. It was a departure from the Old Left, and it was a new way of looking at participatory democracy. It was very, very significant, but most of those guys were academics—red diaper babies. We were very different, and we created a whole different face to the movement.

In the music scene people like 13th Floor Elevators, the Shiva's Headband, and the Conqueroo were the important

early Austin rock bands—they were all our friends, and they did all the benefits. So we were just an integral part of that whole community. We were into the drugs just as much as anybody, but of course drugs meant something very different in that day and time than they do now.

We were internationalists, and we related to what was happening in the world and saw ourselves as being part of it. People I knew were going on the Venceremos Brigades to Cuba, and I went to Bratislava for the meeting with the North Vietnamese. It was this phenomenal group of people, a cross-

San Francisco Express Times, vol. 1, no. 33 (1968). Photo by Jeffrey Blankfort.

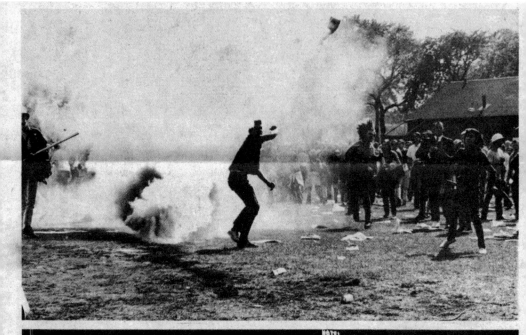

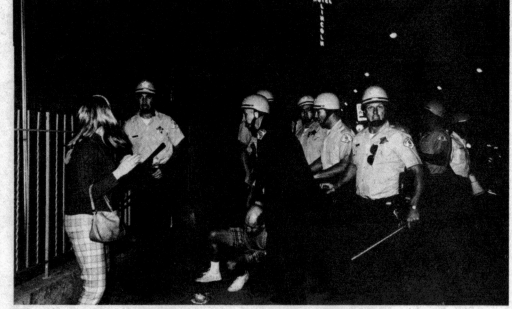

section of the movement, including people like Tom Hayden and other key SDS people. So we went to this thing and met with representatives of the Viet Cong, the NLF [National Liberation Front]. It was funny. We had a chartered plane and it had barely taken off when Malcolm Boyd—he was the first one that I saw—broke out a joint. It ended up there were people smoking dope on that entire airplane—the air was just green. At that time, that was a revolutionary thing.

I don't think that there is such a thing as objectivity. We just thought we were advocacy journalists, but we made our biases clear. One of the important things about the underground press was that it was a collective, communal experience, and everybody came in and got involved and became a part of it, and got politicized through the process.

BEN MOREA
Black Mask, The Family
(Up Against the Wall/Motherfucker)

I went to see the Diggers and stayed with them a couple weeks in about 1963, before *Black Mask*. Peter Berg, Peter Coyote, and Emmet Grogan were the main three. I went out there and stayed with them and tried to understand where we were similar and where we were different. I was friends with them, I liked them, but we were very different. They came out of theater, the Mime Troupe, and we came out of art and evolved to be more political than they did. We were much more action freaks than they were; we became stone street fighters. Everything else fell to the wayside, at some point that's all we were doing. We had evolved from artists to warriors. We

were part of that "hip community." We did a lot of LSD and were completely comfortable with hip culture, but we, at the same time, were political and saw ourselves as warriors. So there was always this gap—we were not hippies but we were definitely not political. We were some other entity, an amalgam.

Rag, vol. 3, no. 6 (1968).
Opposing page: *San Francisco Express Times*, vol. 1, no. 33 (1968). Photos by Jeffrey Blankfort. "He didn't hit me in the head because I was wearing a helmet. I had a kind of bicycle helmet. Cops don't like hitting people on the head if they're wearing helmets."
Following page spread, left: *Helix*, vol. 6, no. 5 (1969). The San Francisco Mime Troupe comes to Seattle.
Following page spread, right: *Berkeley Barb*, vol. 7, no. 16 (1968).

THE
SAN FRANCISCO
MIME TROUPE
FEBRUARY 17 & 18

flynn 69

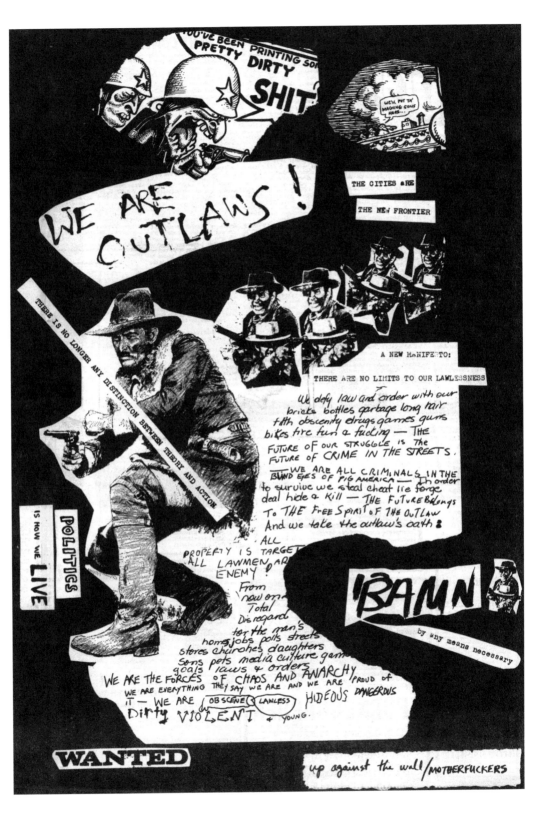

The Free Store was on Tenth Street on the uptown side of Tompkins Square Park. Well, let me correct that, we had two of them. We had one also on Tenth Street, I believe, around Third Avenue. I'm not sure which came first. It was a community center, it had clothing, and we had access to other tools. For instance, if a person who was AWOL came in we would have clothing to give them, would get them ID printed (the printing press wasn't there, we had a mimeograph machine, but we would take them to the printer). We had a doctor and two lawyers under retainer. So if you came in the Free Store needing medical or legal help, we would send you. We had six crash pads that we rented so that we would have a place to put runaways who came in to the Free Store. The Lower East Side was very dangerous for young people. There were a lot of hippie kids, or runaways, or whatever you want to call them, who would come to the Lower East Side thinking it was a nirvana, and it was a dangerous ghetto. A lot of kids were getting beat up, getting raped, so we would protect them, take care of them. It was just a logical outgrowth. We were a community organization, we felt.

We would also disseminate free food out of the Free Store. We had working relationships with Judson Memorial Church, which was a liberal, left-leaning church. They would give us papers saying we were nonprofit so we could go to Dannon Yogurt and get all the yogurt for a week that was mismarked. We would get thousands of yogurts every week, and we had, like, fifty-five-gallon drums or garbage cans that we would fill with yogurt, and we would distribute it in the streets. We had a free dinner night once or twice a week and we would use those same papers to go to the Hunt's Point Market so we could get food that was a little old but yet still edible; we could get it free. We could go to the Fulton Fish Market and get free fish that was marginal whether they could sell it, but it was still good. Once or twice a week we would have a feast that would feed around four hundred. See, one of our things was there was a certain cultural antagonism between the ghetto-dweller and the youth, the hippie. They didn't quite have the same background, so our role was always to try and ease that tension. So our meals had ghetto and hippie youth. Then we would have free concerts. We'd have black bands or steel drum bands, rock bands, and Latin bands all playing together so the audience would be all three. I mean, that was our goal, it was conscious. We would try to bring together art and politics or ghetto and hippie—we were always trying to bridge gaps.

We mostly printed our own stuff, but the machine was open to the public. I mean, we're anarchists, we're not going to say, "You can't use the machine." But generally we printed our own daily stuff, twice a day, three times a day, once every other day. It was not by schedule. A lot of the flyers we put out, like say somebody got busted, we'd put out a flyer, "Hey, such and such happened." Or say there was some bad LSD on the street, we'd put out a flyer saying, "Be careful of this purple acid." It wasn't just political, we were never just political and that's why the politicos didn't like us. They couldn't figure it out. Either we were wasting our time or we were being frivolous. We didn't see it that way; we were neither wasting our time nor being frivolous. We were being total. Warning people about bad acid was just as important as fighting

the tactical police force, to us. That was the difference between us and everybody else, and there was no one else like that. The conclusion we came to then [was that] it was a full time occupation. We were almost suicide warriors. We'd wake up in the morning and say, "Well, maybe this is our day." It was just that's how it was; there was no, "Maybe we'll wait for politics, or we'll wait for this election." Each day it was like, "Maybe this'll be our day, maybe we won't make it."

That sense of absolute struggle was in everything. It wasn't just the demonstration, "OK, next Saturday we're gonna go out and demonstrate." Our life was a demonstration, morning till night every day, in whatever form. For instance, we cut the fences at Woodstock. To me, that was no less important than storming the Pentagon. See, that's the difference between us and all them Leninists and Maoists and horseshit ideologues: we didn't think one was more important than the other. Life was important. What was happening at Woodstock was an affront to us, to the culture. That was as important as going into the Pentagon, but no politico would ever think that. They had this hierarchy of beliefs. If we were walking down the street and we saw an assault and we interfered and we were killed, that would be as important as dying in the struggle. That was the struggle. That's what the politicos never understood about us.

HOWARD SWERDLOFF
New York High School Free Press, John Bowne Was a Pacifist

Franklin K. Lane High School, which was on the border of Brooklyn and Queens, was a place where there was a lot of tension between the white and black students. Of course we had a guy there, a *High School Free Press* guy, who wrote a big article about it. There was a full-blown riot over a Confederate flag being put up and black students trying to take it down. These things all kind of merged into one another. We didn't see ourselves as journalists; we saw this as part of our total existence. We weren't just putting out a newspaper we were encouraging rebellion with this newspaper.

The SDS chapter up at Columbia University, which was near our headquarters on West Eighty-Fifth Street, tried to give us advice. Mark Rudd, Nick Freudenberg, all these characters from Columbia University used to come down and try to give us advice. We thought they were a joke. They would come down and try to get us to read Che Guevara's diaries or Mao Tse-tung. We listened to them politely but we thought they were idiots. We were so full of ourselves that there was no telling us anything. If you were over twenty years old, you couldn't give us any advice. We were very arrogant. We were charming because we were young, but if we had been a little bit older I don't think we would have been so charming.

Because of our young exuberance and our attractiveness to the media people, we had a guy who was making a movie about us following us. He had a Land Rover and so we took advantage of that. No subways for us. We had a film crew that drove us from school to school and provided us with lunches and, of course, some of us would go out with the filmmaker to Times Square at three o'clock in the morning and see Clint Eastwood movies and smoke cigars. We were big shots, we

Following page spread: *Rat Subterranean News,* vol. 2, no. 19 (1969).

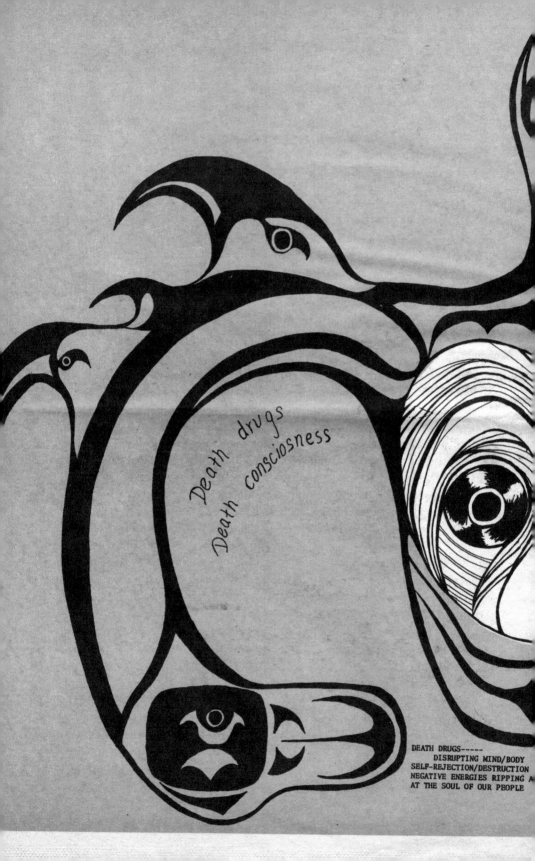

Death drugs
Death consciosness

DEATH DRUGS------
 DISRUPTING MIND/BODY
SELF-REJECTION/DESTRUCTION
NEGATIVE ENERGIES RIPPING A
AT THE SOUL OF OUR PEOPLE

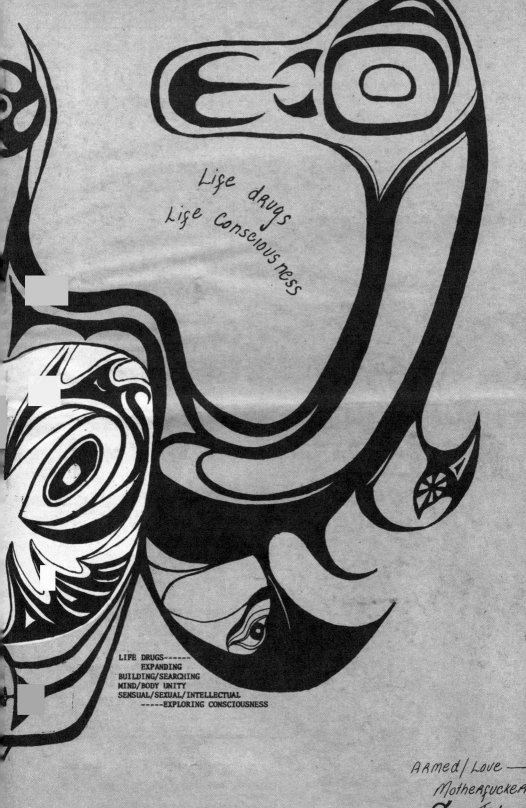

Life drugs
Life Consciousness

LIFE DRUGS------
 EXPANDING
BUILDING/SEARCHING
MIND/BODY UNITY
SENSUAL/SEXUAL/INTELLECTUAL
 -----EXPLORING CONSCIOUSNESS

Armed/Love —
Motherfucker
Tribe

started acting like big shots. Our heads got kind of big, as you can imagine.

Another piece of the story is that one of our members, Robby Newton (one of the writers and organizers of this whole thing), his parents were part of a left-wing collective of psychotherapists on the Upper West Side of Manhattan who believed, for ideological reasons, that youth should be encouraged to break away from their parents and live autonomously. This was part of their core belief system, and they financed an apartment for us in the fall of 1968 on the Upper West Side of Manhattan. They paid the rent, they gave us credit cards to the supermarket, and we had this apartment now where all of us were living and also attracting runaways from all over the country who were coming there to stay with us. We were adolescents, we had raging hormones, so you can imagine what else was finding its way to our doorstep. Of course this was also attracting the attention of the New York City Red Squad, the FBI, and others. It was quite a heady time.

BILLY X JENNINGS
The Black Panther

The paper is not just a newspaper; it's an organizing tool. It's one thing to sell the papers on the avenue as people walk by, it's another thing if you go door-to-door to find solutions at people's comfort zone. People are comfortable at home; they might not be comfortable talking to you on the street corner. That old lady that goes to church, she might not even talk to you on the street corner, but you get up on her porch, she'll give you an earful: "You know what else I don't like? I don't like them damn police coming around messing with these young people. They look like they trying to start trouble for these young people." So they'll talk to you and that's how you get that feedback. Then you can break out the newspaper and show them how in Chicago and Philadelphia they have the same problem, but this is what they're doing about it. There were solutions to be found in the Panther paper; it wasn't just sold for the monetary purpose. It had our ten-point program, it had what we were doing, our social programs, how we was dealing with the present situation, how we was dealing with rats and roaches in the community. We came with a free pest program, which the Center for Disease Control has adopted.

The paper cost a quarter and, at first, all Party members selling the paper got a dime. Later that changed because we had to deal with a solution to housing. We were a growing organization, a came-out-of-nowhere organization, and now we got twenty-four-hour Panthers and no place for them to live. If you want to be a Panther and you ain't got a job, how are you going to live? So a nickel from each paper was taken out for housing. Instead of that dime you was getting, you getting a nickel now, because it was going into a general fund. Now we're growing, we have to feed you. That dime that we gave is now a nickel, and after a while, that nickel became nothing, because we were putting all our energy into living. If we're in an office and we have twenty-five people putting into the general fund, we can eat everyday. We could have two or three houses because rent was only eighty or ninety dollars a month. We could have a crash pad over here, a pad over here, and a pad over here. So that's how the money was coming and how it was divided.

The Black Panther, vol. 3, no. 29 (1969).

LIST OF CHAPTERS AND BRANCHES
WITH BREAKFAST PROGRAMS

NATIONAL HEADQUARTERS
3106 Shattuck Ave.
Berkeley, Calif. 94705
Off: 451 - 845-0103/4

SAN FRANCISCO, CALIF. 94115
1336 Fillmore St.
Off: 451 - 922-0095

RICHMOND, CALIF. 94801
520 Bissell St.
Off: 451 - 237-6305

OAKLAND, CALIF. 94621
7304 East 14th St.
Off: 451 - 568-3334

LOS ANGELES, CALIF. 90011
4115 So. Central Ave.
Off: 213 - 235-4127

LOS ANGELES, CALIF.
Watts Office
Off: 213 - 564-7494

SAN DIEGO, CALIF. 92102
2952 1/2 Imperial
Off: 714 - 233-1470

SEATTLE, WASH. 98122
1127 1/2 34th St.
Off: 206 - 323-6280

EUGENE, OREGON 97401
1671 Pearl
Off: 503 - 342-7276

DENVER, COLORADO 80205
2834 Lafayette
Off: 303 - 255-8486

INDIANAPOLIS, IND. 46205
113 W. 30th St.
Off: 317 - 924-5619

KANSAS CITY, MO. 64128
2905 Prospect
Off: 816 - 924-3206

MILWAUKEE, WIS. 53212
2121 No. 1st St.
Off: 414 - 372-8584

CHICAGO, ILL. 60612
2350 W. Madison
Off: 312 - 243-8276

BOSTON, MASS. 02119
375 Bluehill Ave.
Off: 617 - 427-9693
 617 - 442-0100

NEW YORK, N.Y. 10027
2026 Seventh Ave.
Off: 212 - 864-8951
 212 - 666-3603

QUEENS, N.Y. 11433
108-60 N.Y. Blvd.
Off: 212 - 523-9717

PEEKSKILL, N.Y. 10566
22 Nelson Ave.
Off: 914 - 737-9768

WHITE PLAINS, N Y 10601
159 So. Lexington
Off: 914 - 761-0594

BROOKLYN, N.Y. 11212
180 Sutter Ave.
Off: 212 - 342-2791

PHILADELPHIA, PA. 19121
1928 Columbia
Off: 215 - 236-3353
 215 - 236-3358

BALTIMORE, MD. 21213
1209 N. Eden St.
Off: 301 - 685-6853

NEW HAVEN, CONN
35 Syldan
Off: 203 - 562-7463

MEDICINE MUST SERVE
THE PEOPLE

"The Peoples Free Health Clinic" of the poor people of our communities is open to the people of Brownsville and Brooklyn every Thrusday night from 7:30 to 9:30 p.m. at 180 Sutter Ave. This is another program that serves the basic needs and desires NOW. The people need health services NOW. The Free Health Clinic will serve the people. ALL POWER TO THE PEOPLE!

The paper was very important because it went places that we couldn't go, it went deep in the south. Every place we had a Panther office those papers would filter out into the community. The thoughts and the ideas of the Black Panther Party would be read about, known about. The paper went everywhere. That's why it was very important to get the paper out, and that's why the FBI made a big effort to stop the newspaper.

JOHN SINCLAIR
Work, Change, whe're, Fifth Estate, Warren Forest Sun, Ann Arbor Sun, Guerrilla

For the White Panther Party, such as there was a Party, we didn't know anything about politics; we just wanted to create trouble. We had a rock 'n' roll band that kids loved, so we were coming from right down the middle of the fucking long-haired world. We weren't coming from the left or the right, we were a rock 'n' roll band, basically, and I was the manager and I came from an arts and poetry background. We were a commingling of these two elements: we had an audience and our whole thing was trying to turn this audience on, turn 'em on to the things that turned us on. That way we figured they'd become more like us, opposed to the government, opposed to the war, nonracist, etc. That was really our goal.

Berkeley Tribe, vol. 3, no. 8 (1970). White Panther Party cofounders Pun Plamondon and John Sinclair.
Opposing page: *Kaleidoscope*, vol. 2, no. 8 (1969). Rock and Revolution. The John Sinclair–managed MC5.

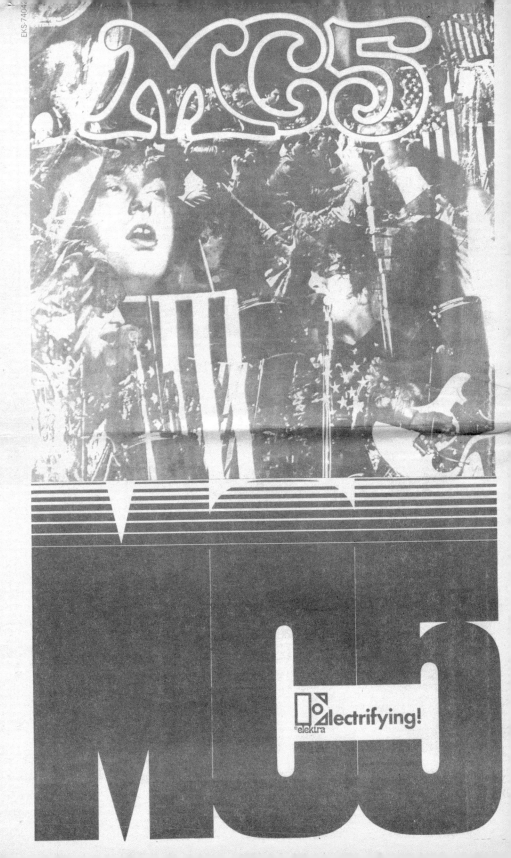

GOTHIC
BLIMP
WORKS

NO. 4

35¢

SLURSH
SQUIRCH

SPAIN

YOU COULD MAKE ANYTHING LOOK LIKE ANYTHING

Graphic Abundance

To prepare each issue of a typical underground newspaper for print, the headlines, typed copy, and artwork for every page would be positioned and pasted on its own layout sheet, which would then be ready to go to the printer, where it would be photographed to be reproduced exactly as it appeared. Manipulations of this photo-offset process were at the heart of the graphic experimentation that would come to define the aesthetic of the underground press. Artists exploited split-fountain blending to stretch the color capabilities of the four-color presses; they used halftone and pattern overlays to add color and depth to images; they sculpted unjustified type around the edges of illustrations—there really seemed to be no limits. Whether they were photos, collages, montages, comix, hand-drawn ads, visual manifestos or rudimentary drawings stuck in the margins, the graphics were ultimately as important as the written word in the underground.

Gothic Blimp Works, no. 4 (1969). Spain Rodriguez covers the fourth issue of *Gothic Blimp Works*, the all-comics tabloid put out by *East Village Other*.

JEFF SHERO NIGHTBYRD
Rag, Rat Subterranean News

In World War II radio was the chief way of communicating, and FDR used radio well. Then you had television and, pretty soon, the kind of graphic revolution that the underground press made, because the standard press was producing newspapers as if they were made in hot type, which means there were big clackety machines of melted lead, and union guys would sit there at these giant futuristic machines that looked like they were out of that movie *Brazil*. Clack, clack, clack, and the type would slide down. You would lay out beds of type and that made everything linear. Then when offset came, which was a photographic process that all the underground papers used, you could make anything look like anything. When we started *Rag*, artists doodled all over the margins and every place. That was visually exciting, and the standard papers not only politically hadn't caught up with the times, they hadn't technologically or graphically or in communication caught up with the times.

There was this group that should be very well known called Up Against the Wall/Motherfucker that was a street gang of artists in New York. They would come in [to *Rat Subterranean News*] and do center pages. They would just do the whole center page and then take five hundred of them and glue them up all over the Lower East Side of New York, and they'd hit parts of Jersey and Brooklyn, wherever they could get them up. These were revolutionary manifestos, but totally graphic. And [because of this] our centerfold became a kind of visual manifesto, some of them brilliant I think.

My only thing is that I let it happen. I let this street gang come in and do the center page. I didn't censor them.

BEN MOREA
Black Mask, The Family
(Up Against the Wall/Motherfucker)

I was friends with Murray [Bookchin]. We didn't agree on politics at all. I don't think we ever agreed about anything. I used to tease him and say he was a Trotskyist in anarchist clothing. He was very bureaucratic and authoritarian, and I was a real anarchist. I was more influenced by the Living Theatre—even though they were theater people—their idea of anarchism. I was really anarchist-oriented, whereas Murray was much more leftist, ideological, Trotskyist, left-wing Socialist more than an anarchist. He liked the anarchist theory but his personality didn't fit. He was a very nice guy but we never agreed on anything. I got involved with him, meaning like going to meetings and discussions that honed my political understanding. It was like an extension of my self-education that I had started in the hospital. The other group that I did this with was the Libertarian League, who were really anarchists and who fought in Spain. They were counter to the Lincoln Brigade, which was more Socialist, Communist. Some of them were sentenced to death by the Communists in Spain and were actually on the firing squad when they were

Rat Subterranean News, vol. 2, no. 8 (1969).
Gilbert Shelton's *Fabulous Furry Freak Brothers* grace the cover of *Rat*.
Following page spread, left: *Rat Subterranean News*, vol. 2, no. 8 (1969).
Following page spread, right: *Rat Subterranean News*, vol. 2, no. 9 (1969).

RAT
SUBTERRANEAN NEWS

MAY 9 – 15

N.Y.C. 15¢ OUTSIDE 25¢

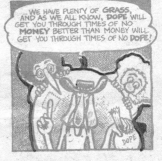

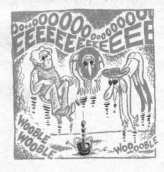

— con't p. 19 —

KNOW YOURSELF
KNOW YOUR PEOPLE

ARMED LOVE

community control of

rescued by the Durruti people. One of them was Vincent Titus. In those days there was no such thing as a hand grenade so they used dynamite, and this guy used to throw dynamite as a hand grenade, and he shook all the time. When *Black Mask* ended and then The Family [started], he came with us. People kept gravitating to us, even though it was only Ron and I that did the paper, and was starting to attract [people] like Dan Georgakas, who was a poet. There was another poet, [Allen] Van Newkirk, who was from Detroit, who was friendly with the White Panthers and those people. So slowly *Black Mask* was becoming this larger group and it stayed kind of *Black Mask*–oriented, but it was getting bigger and bigger and slowly it morphed into The Family organically. There was never a moment when we said *Black Mask* stops and The Family . . . the paper became less of a need. We became more involved.

You've got to realize we were living in this moment of crisis. We had the Viet Nam War, and a lot of us were of the belief that it had to stop. We had to stop it no matter what. I quit painting, and we quit the paper, you know. We were also sympathetic to the black struggle . . . that racism had to stop. Our focus became more full-time protest and evolved into street action and demonstrating. It shifted away from the newspaper. So being friends with Jeff Shero and missing having done the paper (and now that I was more politicized), I thought, "Well, maybe we could do something with *Rat* that would fulfill our artistic desire to create layout but be more political."

We didn't do it every week. We would decide, "Do we do it this week? Do we have something we want to do?" And we would let Jeff know, and we had one night we could go to the office and work on layout. My girlfriend at the time and I, and sometimes Osha [Neumann] or some other people from The Family, would go there and we would do layout and work on ideas together. On occasion, Osha would have an idea and he would just do it. We wouldn't even interact with him. Sometimes we would add something to what he did or he would add something to what we did. It was always amicable; we were really not ideologues. I cannot ever remember having an argument about something among The Family, or earlier among *Black Mask*. We would just figure it out, "OK, you don't like that. How about this?" I mean, so we never had a problem.

EMORY DOUGLAS
The Black Panther

When we worked at Eldridge's apartment Huey asked me to draw a picture of a pig. They wanted to put it on the front page with the badge number of the pig who was harassing people in the community, Frey. So when I first did a couple pig drawings, the quality wasn't what I thought they could have been. So it just happened to come to me one night after thinking, "Why don't I stand this pig up on two hooves, put the pants on it, the belt, the badge, the snout, keep that same stuff and put the flies around it?" That's what I did, and it took on a life of its own.

I just knew I had done something within the Party that Eldridge—all of them—liked and talked about and the whole bit. Also during that period at Eldridge's house Kathleen came in,

because he hooked up with her. When she came (she used to do typewriting also) they all used to talk about the pig drawings and how vicious they was, and that kind of stuff. So I knew that there was something there that had captured the imagination of those who were in the Party. And as it evolved you'd get feedback from people in the community. Then you know that you've tapped into something with your artwork that has some kind of a meaning to it and [that] also was linked to the ideals of what the Party was trying to get across.

During that time there were a lot of woodcuts being done in the movement. I liked that look but never could achieve it because it took so long. So I started playing around with markers and with ballpoint pens to mimic that whole feeling of woodcuts . . . then using prefabricated materials for textures and patterns to give that feel to the artwork. I had seen some collages that had some real energy to them but didn't have no real significant meaning, other than the abstract energy that you got from it. So I wanted to do something that had more link to the politics of what the art was about. That's why I started to integrate the images into the artwork. I wanted to give more depth and scope to the meaning of the artwork. Then I was introduced to a quote by Amílcar Cabral, where he had mentioned that you have to be able to speak in a way that even a child can understand. After a while it flashed on me that you have to be able to *draw* in a way that even a child can understand [in order] to reach your broadest audience without losing the substance or insight of what it represented. What Party members did one morning, I remember being there and we were going out to sell papers at about six o'clock in the morning at the bus stations and they got wheatpaste that morning and they got a lot of papers that morning that we had left over with the artwork in them, because the Party members loved the artwork. So what happened is they went out there that morning with the wheat paste and they started wheat pasting them up on the wall, everywhere they could. So that's how the community became the art gallery for the work.

During the period when the Seven, Los Siete de la Raza, had the trial going for the killing of the police in San Francisco (of which they were found not guilty) they wanted to put out a publication [*Basta Ya!*], but they didn't have no means to do that. So it was suggested that we do it together, and I worked with the young ladies from their organization to put the paper together—they used to come and cut and paste, the whole bit. There was a collaborative element to it, because here it is, they're coming in and they have to be aware of the formats that we were working under, so we'd have to show them all those things and give them suggestions and ideas on formatting and laying out the paper, visuals, and stuff like that.

Basta Ya!, Panther issue no. 4 (1969). Joint issue with *The Black Panther*, vol. 3, no. 22 (1969). Opposing page: *The Black Panther*, vol. 5, no. 20 (1970).

JUST WAIT UNTIL I GET A LITTLE BIGGER
SO THAT I CAN WEAR MY DADDY'S HAT
AND SHOOT MY DADDY'S GUN

BASTA YA! is published by Los Siete de La Raza. It comes out four times a month---twice as BASTA YA! --in English and Spanish--and twice with the Black Panther Paper.
BASTA YA! is a newspaper dealing with La Raza all over Aztlan and the rest of the Americas. It is dedicated to the freedom of our seven brothers--Los Siete-- leaders in the Brown Liberation Movement.
Our thanks to the Black Panther Party for making this publication possible.

LOS SIETE DE LA RAZA

You have to understand, it was just myself for a long time. Every now and then I'd get somebody who'd come in who would cut and paste, then they would pull them because they needed them to work at the school or with the community programs. As the Party started to evolve I got more of a collective, a cadre that worked with me consistently to do typesetting, layout, cut and paste. It became each one teach one. Then, the people I had found that had skills as artists, I would also integrate them into doing the back pages, show them the politics of it. I was actually teaching. Most people had never done cut and paste or anything. It may have been that they just had some art skills but they had no layout concept, they hadn't worked in the printing aspect of putting together flyers and all those kinds of things. That was needed, me showing them how to do it. Then after working on the paper (cutting and pasting and seeing how we did it all the way through), they would take up a page. I would look at it, have some suggestions on it, and they internalized that and began to put their own style and flavor into it themselves. My daughter's mother came into the Party and worked with me as an artist, Asali. Her name is Gayle Dickson now. Malik Edwards, Asali, Ralph Moore,

those were the main ones. There were other artists who were in the Party who sent stuff in: Bo Redd [from Washington, D.C.] used to send stuff in from time to time; Matilaba [Tarika Lewis] was the first artist that worked with me; Mark Teemer also worked with me and the brother down in L.A., Anthony Quisenberry. From that, the inspiration came for the chapters, deputy ministers of information, and deputy ministers of culture who would also do their artwork on the local level for chapters and branches.

JEFFREY BLANKFORT
San Francisco Express Times, San Francisco Good Times

I guess it could be told now. Before Bobby Kennedy was assassinated, Marvin [Garson] and Dave [Mairowitz] came to me and they both wanted me to take a picture of a casket and then use a photo I had of Bobby Kennedy in the casket, poke holes in his eyes and put a headline, "Why Waste Your Vote?" And I said, "Bad taste! I'm not going to be a party to this." So they pleaded and pleaded and pleaded. I said, "OK, I'll go take a picture of the casket." I said, "One thing: don't put my name on it." So Kennedy gets assassinated, and of course the headline in the *Express Times* was "Kennedy Shot Again." My mother calls me from Los Angeles whispering and asking me if I was the person responsible for the picture of Bobby Kennedy in the casket, because it had become a national story. And I said, "Well, I

Basta Ya!, Panther issue no. 2 (1969). Joint issue with *The Black Panther*, vol. 3, no. 20 (1969). Opposing page: *The Black Panther*, vol. 2, no. 4 (1968). One message, two styles. Matilaba (top) and Emory Douglas (bottom).

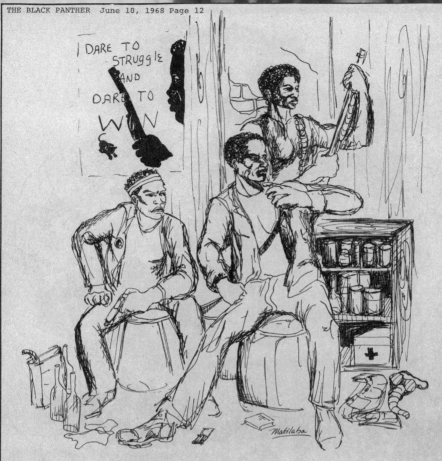

FREE HUEY NOW

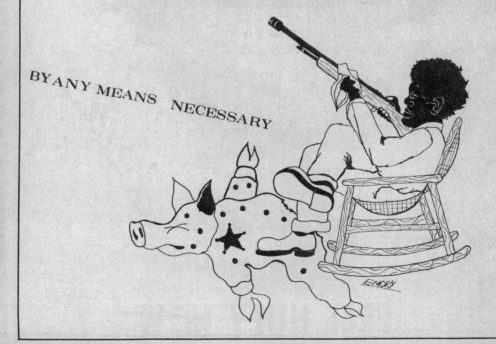

BY ANY MEANS NECESSARY

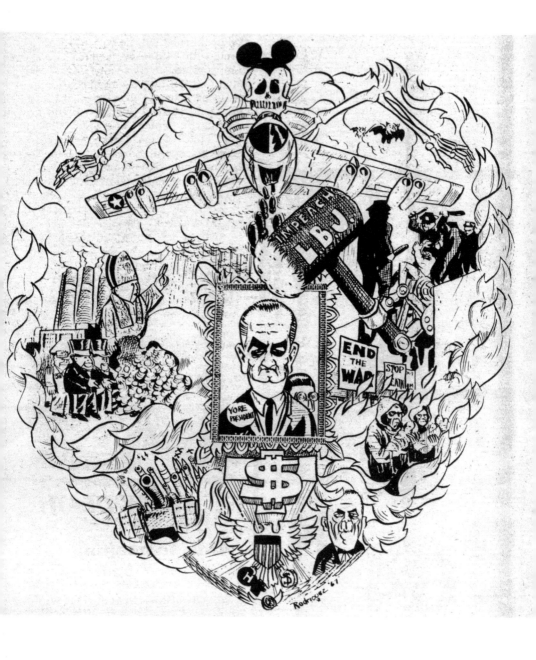

took the pictures, but I didn't make the composite." And she said, "Don't tell anybody." Because Marv Gray, who was the biggest talk show host in L.A., said, "Whoever did that is the most despicable person alive." Then the FBI came around to *Express Times* to find out about it. I mean, obviously I didn't do the composite and, like I said, I thought it was in bad taste, although I was not a Bobby Kennedy fan.

SPAIN RODRIGUEZ
Zodiac Mindwarp, East Village Other, Gothic Blimp Works

I got to know [Walter] Bowart—I went down to his office, showed him some of my work. I would do spot drawings for him, and at some point he says, "Do me a twenty-four-page strip and we'll make it into a comic book." And that's what I did; I did what became *Zodiac Mindwarp* (it was Bowart who thought up the title). Then I started working for them [*East Village Other*] and I did half-page strips . . . but it was just whatever would come to my mind, it was kind of formless. Then once I thought of Trashman all that stuff began to take a more definite shape.

When I had originally been in New York in 1965, St. Mark's and Second Avenue was just another corner. But when I got back there in 1967, it was the corner that every kid wanted to hang out at. The interior of the Lower East Side was weird . . . there was all this weird shit going on. But when I got back there it had just exploded, and Walter was turning out this *East Village Other*, which was really unique and, you know, wild. Art Spiegelman was the first guy I met, and then I was roommates with

Kim Deitch, and Crumb started coming around. Gilbert [Shelton], I knew his work from *Help!* by Harvey Kurtzman—anything that Harvey Kurtzman would publish, I would grab up. It was kind of a wild time, the Lower East Side. During the Summer of Love [1967] I went back to Buffalo. I got busted for some bullshit thing like "loitering to procure narcotics," and I ran into a guy who had been busted in a stolen car when I was sixteen, a day over sixteen. I was telling him about the Lower East Side. He said, "Yeah, I heard of that place. Isn't that where all these rich kids are getting ripped off by everyone who lives down there?" And I said, "I never thought about it, but yeah that's kind of what's going on there."

I got here [San Francisco] in December of 1969. With underground comix you could make a living. I really

East Village Other, vol. 2, no. 5 (1967). Early Spain piece in *EVO* when he was still signing his artwork "Rodriguez." "When I was a kid, I hung out with Irish kids and they'd always be telling me how great Ireland was and one time I said, 'Well, you know Spain's great too.' And they said, 'What? Spain isn't shit!' So we got into this war and we had these two garages and one had a flat roof and we used to go up there and play and so these two guys went up there and the game was I had to get up there by any means I could and they would keep me down by any means they could. And we always had this shit laying around the yard, we had these big strips of rubber—I don't know where it came from but they were out there with these big strips of rubber and every time I tried to get up there they'd whip me. In desperation I found a piece of metal and I threw it up there and I hit this kid in the head. A good kid, and we both felt really bad about that, we all felt really bad and afterwards we pledged eternal solidarity between Spain and Ireland. Everyone started calling me Spain after that. Then when I first started doing artwork I signed stuff 'Rodriguez' and people would say, 'Oh yeah, I love your stuff, man, I saw it in *National Lampoon*.' It turns out there's another guy named Rodriguez who was really fucking funny. And everyone would mistake me for him so at that point I realized that the name 'Spain' was going to stick with me." —Spain Rodriguez.

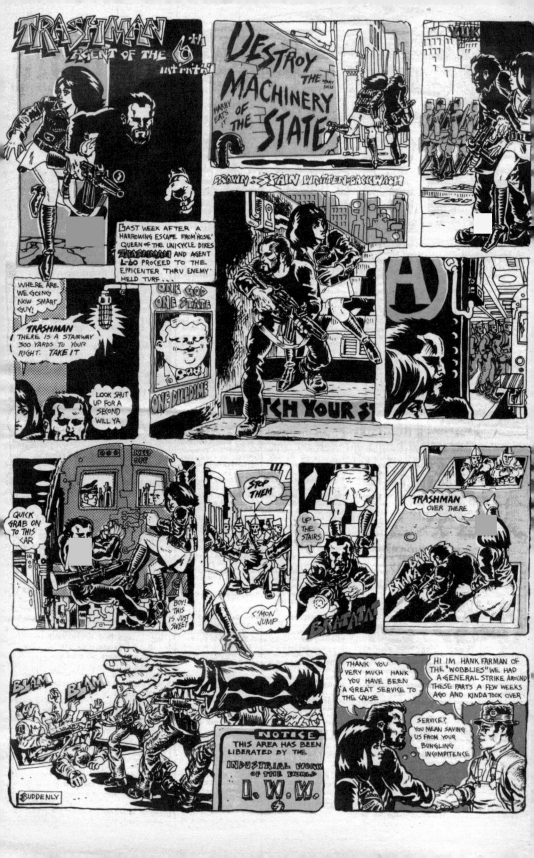

miss that. People come up to you, "Yeah, I'm putting out a comic. Can you do something for it?" "Yeah, sure." You do something for it and then you get paid. Between one thing and another I was on food stamps, but you could survive. You weren't living in what's generally considered luxury, but from my point of view, man, turning out those underground comix was a blast.

RON TURNER
Flagrante Delicto, Last Gasp

Keith Alward was this guy I worked with at Kaiser [Hospital] and he had a New Year's Eve party [December 31, 1968]. He had some *Zap Comix* and I went to a bedroom and got stoned and saw this comic book. I was really into comics as a kid until I gave away my almost-complete collection of Dell to the San Joaquin Valley Children's Hospital in Fresno. Then *MAD Magazine* came along. I was totally into *MAD Magazine*, but unlike most of the guys that became hardcore comic guys I gave it up, and by the time I was in college I wasn't reading comic books anymore. So when I read the *Zap* comic, stoned, I was brought right back to the joy I had of being into comic books. I sought out where to find them, so I met Gary Arlington, who had the first comic book store in the country—San Francisco Comic Book Company in the Mission.

Gary was running an Arab record store in the Mission after he got out of the Army in the early sixties. Then he started a comic book store because he was completely into EC Comics. Somehow he managed to put together enough stuff from flea markets and whatnot to have a store full of comic

books, and that's where everybody started going for their comic books. Within about two years there were probably a couple hundred comic book stores around the country, but he was the first. That's where all the guys who were doing things were—like Don Donahue, who had published the first *Zap*, Charles Plymell had printed the first *Zap*, and they both met in the beatnik poetry circuit. Don was a local boy from St. Ignatius and had gone to Cal, and he and Plymell wanted to find Crumb because they had seen his stuff in *Yarrowstalks*, an underground newspaper from Philadelphia. Then Crumb moved out here, and Don and Crumb met at some party where there was a lot of hippies and beatniks. They ended up printing and publishing the first *Zap*, which was *Zap* 1. *Zap* 0 came

San Francisco Express Times, vol. 2, no. 2 (1969). Opposing page: *East Village Other*, vol. 3, no. 36 (1968).

along later because the artwork was lost. The Xerox survived and three years later reappeared, and so to keep the continuity they made it *Zap* 0. I'd say Don was the kingpin, but you needed these various pillars to do things. In the underground days you needed a place to sell the stuff, that's one pillar; you needed a guy who could print it, that's another pillar; you needed a publisher, someone who could direct it and put it out there; and the fourth [pillar was] you needed the artist and writers to do it. So that all came together and I was close behind the confluence of that.

I had worked with the United Farm Workers down in the Valley back then and my girlfriend had been César Chávez's secretary, and we were living together up in Berkeley. Another friend of ours, Rod Freeland, was a printer at the Farm Worker's office in Delano. He was a great guy and he would take a couple years off from his political stuff, get a high paying job as a printer, and save up all his dough so he could go back to devoting a couple years—at virtually no pay—to the movement. He worked with the Berkeley Ecology Center, which was a brand new idea, and we would get together sometimes, like once a week, because his girlfriend was a good friend of my girlfriend. We'd all sit around and smoke dope and talk about different things. We had this idea of how to raise money for the Ecology Center. We thought the best way was to do an underground comic because it was the thing that was speaking to the youth and [we thought] the youth needed ideas or directions about how to get these ideas about ecology into motion. So I went over and talked to Gary Arlington and Donahue, and I had some drug dealer friends who I bullied into

lending the money for the first printing of *Slow Death Funnies*. Gary helped me out on the title; one of us (neither of us can remember) came up with the name of *Last Gasp Eco Funnies* or *Slow Death Funnies* for the title. Finally we selected *Slow Death* and the company needed a name so we took the next title for the name, and it became Last Gasp Eco Funnies.

It was late 1969 that we had the idea, and by Earth Day 1970, the first Earth Day, we had copies printed and bound and out on the campuses. Lucky for me, I had a Gilbert Shelton page and a couple-page strip from Crumb—Greg Irons did the cover. Gary Grimshaw (he was the minister of art for the White Panther Party) was underground at the time, so I could only deal with Irons (who was a friend of his) to get his pages. So that's how it sort of began.

Slow Death Funnies, no. 1 (1970). Last Gasp Eco Funnies is born. First printing of Ron Turner's first comic book, *Slow Death Funnies*. Cover artwork by Greg Irons.

SLOW DEATH
FUNNIES

50¢

1

adults only..

GIANT *new* CATALOG

OF GOODIES & RIP-OFFS FROM

THE RIP OFF PRESS

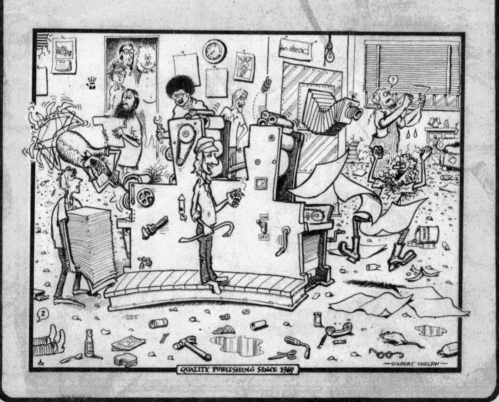

QUALITY PUBLISHING SINCE 1969

—GILBERT SHELTON—

BALLS-TO-THE-WALL, NOSE-TO-THE-GRINDSTONE

Production, Paste-Up Night, and Office Culture

T he underground press was the filter through which the Sixties counterculture passed, and the scene itself often walked right through their doors and into the office—people placing classified ads, people responding to classified ads, parents looking for missing children, missing children looking for a place to crash, salesmen of every stripe, musicians, artists, writers, poets, politicos, heads, and an occasional appearance from the tac squad goons. In the midst of the madness articles were written, artwork created, photos developed, and the whole thing pasted together and prepped to be printed. Equipped with a youthful idealism, fueled by a sense of purpose, and aided by communal effort, the staffs of these papers were able to churn out a high-quality product at an incredible pace while a party raged around them.

Rip Off Press Catalog (1972).

ABE PECK
Seed, Rat Subterranean News

It was just kind of the sheer balls-to-the-wall, nose-to-the-grindstone, laughing-all-the-way daily life. Supplies would walk into our office. People were essentially ripping off their daily jobs to help the *Seed*. Some of the cutest young women would walk in and have a box under their arm, maybe they were working somewhere, and there'd be, like, a thousand envelopes. Detritus of the movement was all around. We had this big cardboard cutout of a soldier that someone had stolen from the National Guard recruiting office. We had stuff hanging from the ceilings, we had posters, we had people doing the stippling on the negatives who hadn't slept in two days who were just gibbering to each other. We had a group of envelopes on the wall to help us sort out our copy. You know, for stuff that would come in from Liberation News Service (which came by mail), we would cut it up. Our biggest folder was called "No More Goddamned Hippie Poetry" because there was some truly dreadful poetry that would come in. There was some very good poetry, but most of it was truly horrible. Everyone thought they were a poet, so we'd have this bulging envelope. It was extremely cluttered . . . probably an animal or two running around. We were very determined and—unless something terrible happened, like [the murder of] Fred Hampton—up, just pretty upbeat.

JUDY GUMBO ALBERT
Berkeley Barb, Berkeley Tribe

One of my very first jobs was doing classified sex ads for the *Berkeley Barb*. I was the front-desk person. I was twenty-six years old. The *Barb* office was on University Avenue, which wasn't nearly as trafficky as it is now, so you could hear people coming from a distance. I always knew when one of my favorite clients was walking down the street on his way into the *Barb* office because I recognized the loud clanking from the chains he wore.

The classified section of the *Barb* was called "Adadada." There was a drawing of a naked woman with her legs spread in the upper right-hand corner of the form that a customer filled out. The guy with the chains, who was very sweet and polite, would write, "Seeking young man for western games." I've asked friends what that means. Apparently you kneel down and put your butt in the air; it's an actual phrase for sex acts. I met so many characters who would just walk in to place their sex ads. They were mostly heterosexual men: "Good-looking man seeks woman for SFL (Sexual Freedom League) Party. Call so-and-so." I was a naive young woman from Canada; this job really opened me up to, and made me appreciate the diversity of human sexuality.

The classified ads were a revenue source for the *Barb*, but the real revenue generators were large full-page-display sex ads for nightclubs, massage parlors, and rock concerts. If you look through the old issues of the *Barb* you will see two or three full-page-display ads in each issue. I worked two days a week,

Berkeley Barb, vol. 7, no. 20 (1968).

Monday and Tuesday, because we only took classified ads on those days. The paper was laid out by hand . . . not by me. We didn't have modern computerized technology; we cut and paste on blue-lined sheets. The *Barb* went to print on Thursday nights. One staffer would drive the layout to the printer in the Mission District in San Francisco. The rest of us would go over to Max's house (Max Scheer, the editor) where Jane Scherr (who we all referred to as Max's wife, although they never married) prepared dinner for about twenty people. The house itself looked like a seedy southern plantation. It had white Corinthian columns and a blue vinyl backseat of a car on the front porch. The kitchen looked like a truck had dumped stacks of mail, newspapers, brown sugar boxes, paper bags, photographs, and an army of bottles all over its chipped black counter. It had a virtual thrift store of dishes, each a different style and color, in the sink or stacked randomly on the oak kitchen table.

The thing about the dinners (we'd all go there, Jane was a great cook) was Max never gave Jane any money to buy food. So what Jane would do is, she would literally skim cash from the receipts. (Jane was also responsible for taking the money to the bank that the vendors brought in from selling papers on the street.) Jane was forced to skim money off the top so she could provide this meal. Max insisted on the meal; he just would not give her money to buy food.

BILL AYERS
Osawatomie

Red Dragon Press was an invention of the Weather Underground. We relied very heavily on the underground press and saw them as allies all through the years that we were underground. I remember the *Berkeley Tribe*, I believe, ran a centerfold picture of Bernardine Dohrn shortly after we went underground. They ran a picture of her with the caption "Bernardine Dohrn Welcome Here," and people had put it up in their windows all over San Francisco, Berkeley, and other places. I remember driving in San Francisco and seeing this poster up in people's windows, and it just blowing my mind that people had the sense that we were part of the same tribe, that we were part of the same movement. That was really important. So we subscribed, not literally but metaphorically, to the importance of having an independent press that represented the culture, that represented the movement, that vehicle to talk to one another. And then when we decided that we were going to do a journal that was going to explicitly intervene in this world with our political views on things, and you know we were too earnest by half but nonetheless we decided to start a little paper called *Osawatomie*, which was John Brown's nickname coming out of Kansas. So we started this journal called *Osawatomie* and a group of us developed a press, a seriously underground press. That is, it had no address, no public distribution network, and so on. The first thing we produced was a political statement called *Prairie Fire*, and *Prairie Fire* was an attempt to sum up the politics of revolutionary anti-imperialism and

Berkeley Barb, vol. 8, no. 4 (1969).

OSAWATOMIE

SPRING 1975 NO.1

WEATHER UNDERGROUND ORGANIZATION

THE BATTLE OF BOSTON

NO! to RACISM

ALSO IN THIS ISSUE: ROOTS OF THE ECONOMIC CRISIS

DEFEND CUBA
first free territory of the Americas
23 anniversary of the assault on Moncada 26 de Julio 1976

create the groundwork for a political organization that went beyond the ending of the war in Viet Nam, which was imminent. That effort was costly and bold and the people that undertook it were, I think, very brave and filled with energy. In a warehouse district in a city in America they created a fully functioning press that could publish a book, that could distribute thousands of copies of that book nationwide, and they did it all away from the scrutiny of the FBI, the State, the local police.

It was self-funded. We had no way to collect money, we were a completely illegal and underground organization. By putting a price on it all we were doing was saying if we drop off a bundle of twenty of these at a local bookstore that bookstore, simply for handling it, should be able to collect fifty cents an issue or whatever it was. That journal was reprinted by a lot of public presses, the book *Prairie Fire* was reprinted multiple times by people who took what we gave them and ran it through another press.

We had a whole production staff that ran this little print shop, kind of off the radar. As an organization ideas would come to people and we would talk about themes and what we might do, and then we would assign articles and somebody would take responsibility for writing about the school shuttle in Boston, or the state of the antiwar movement. They would write it, it would go through editing, and then it would be given to the production staff just like any other paper, the only difference being that we were very, very careful to keep this press way, way, way off the radar, so nobody even coming close to the building that we were occupying would know that we had a functioning press behind that wall. We did our own graphics, as well.

EMORY DOUGLAS
The Black Panther

The second paper we started working on . . . they had convinced Eldridge to work on the paper, but he was still not a Panther, and he was still working at *Ramparts* magazine in San Francisco. Because he was an ex-con, he was still on parole, so he was concerned about being violated. His cover was working for *Ramparts* magazine. His lawyer was Beverly Axelrod. We started working at her house and I was the only one laying out the paper; they gave me that responsibility. And so I was starting to cut and paste and put things together, and in the middle of that paper Eldridge got his studio apartment up on Castro right above Haight and Divisadero. I used to live right on the corner of Haight and Divisadero, so I used to walk a couple of blocks right up to his house and that's where we started working out of his apartment on the paper for a year or so.

They took the example of the Vietnamese and applied it to conditions here. The Vietnamese, in the struggle, used to have it on the run. To get out their information they had these crank mimeograph machines where they would copy stuff, put it out, telling the American soldiers that they weren't the enemy and the whole bit. Well they said the same thing, we have to set up our operation so we can do it on any level at any time. So that's basically what we did. We had a table, and we had wax paste, and whiteout, and rub-off type, and a typewriter. So, the first couple of papers,

The Black Panther, vol. 1, no. 5 (1967).
Previous page spread, left: *Osawatomie*, vol. 1, no. 1 (1975).
Previous page spread, right: *Osawatomie*, vol. 2, no. 2 (1976).

THE BLACK PANTHER

Black Community News Service

25 CENTS

VOLUME I July 20, 1967 Number 5

PUBLISHED BI-WEEKLY BY | **THE BLACK PANTHER PARTY FOR SELF DEFENSE** | P.O. BOX 8641 EMERYVILLE BRANCH OAKLAND CALIF., 94608

Police Slaughter Black People

Special: THE SIGNIFICANCE OF THE BLACK LIBERATION STRUGGLE IN Newark

It has happened, and is happening all around the world. Oppressed and subjugated people have let their blood flow in the streets so that they may taste the sweetness of freedom. It has come

Continued On Page 11 Col. 1

WHITE 'MOTHER COUNTRY' RADICALS

Editorial:

The Black Panther Party For Self Defense has had some very interesting experiences since the Sacramento Incident. In the first place, certain so-called radical groups from the white community have been exposed through their actions as extremely dangerous infiltrators into the black community. The Communist Party, the Socialist Workers Party, the CNP, and a host of others, pretend to be the friend of black people when in fact they are opportunistic conspirators against the best interests of black people.

The classic relationship between revolutionaries in the colony and radicals of the mother country is that the mother country radicals did everything they could to aid the revolutionaries in the colony. They easily realize that it is their natural function to help supply the revolutionaries in the colony with the means for

Continued On Page 6 Col. 1

The combined police forces of all Bay Area counties have joined together in a step-up of the power structure's relentless war to supress black people. In the last few months, these police agencies have shot and killed many black people. A few of them, because of the flagrant way in which they were carried out, have been in the news and so

Continued On Page 10 Col. 1

HOW CAN ANY BLACK MAN IN HIS RIGHT MIND LOOK AT THIS PICTURE IN RACIST DOG AMERICA AND NOT UNDERSTAND WHAT IS HAPPENING? ITS OBVIOUS THAT THE BROTHER ON THE GROUND IS THE UNDERDOG AND THAT THE ARROGANT GESTAPO DOGS ON TOP HAVE THE ADVANTAGE. WHAT IS THE ESSENTIAL DIFFERENCE BETWEEN THE MAN ON THE BOTTOM AND THE PIGS ON TOP? THE GUN. IF THE BROTHER HAD HAD HIS PIECE WITH HIM, IT IS OBVIOUS THAT THE PIGS WOULD HAVE HAD TO DEAL WITH HIM IN A DIFFERENT WAY. AND THE BROTHER MAY HAVE GOTTEN SOMETHING DOWN -- THAT IS, IF HE KNEW HOW TO SHOOT STRAIGHT.

PHOTOGRAPHY COURTESY OF
 KENNETH GREEN
 AND
 ELVOYCE HOOPER

GUNS BABY GUNS

SUPPORT YOUR LOCAL POLICE

you would see a mixture of rub-off type for headlines, typewritten galleys, cut and paste for articles, and some of the people we knew in the movement who had typesetting equipment . . . we could go to them and get certain amounts of stuff typeset. So it would be a mixture of typewriter-written articles and galleys set at the actual typesetters at that time.

There was this youngster named Audry [Hudson] who was in the community. Every week we'd come in to work on the paper, she'd come in and type it up, and all that stuff, on the typewriter. Then I would come in and they'd give me certain stuff they wanted me to cut and paste, the rub-off type, and I would do that. Then Bobby and Huey, and Lil' Bobby sometimes, would come over in the evenings after they had been out organizing in the community, and they would be talking with Eldridge, but Bobby would be doing cutting and pasting as well because he had those skills too. So it was initially myself and Bobby Seale that were doing the actual construction of the paper, as far as laying it out.

Bennie Harris's role wasn't connected with the newspaper per se but with developing the in-house press that we had, where we could print all of our other materials, anything except for the newspaper. That was where we had our San Francisco distribution headquarters, even before we had a Central Headquarters in Oakland. So what happened is that we used to be putting out the paper there and some guy came in and gave us a printing press—a shell of a press, like an old car where you put it up on the bricks and it don't have no wheels, no engine, no windows, no nothing. Well that's the way that you could say this press was, a Heidelberg. Bennie got the book to the press and went and got

all the different parts and developed our first printing press. That was the printing press that we had throughout 99 percent of the duration of the Party. He also developed our darkroom system, burning our own plates, everything.

It wasn't nine-to-five; it was whenever we got started. Initially it was sporadic. We might have been there two or three days straight working on the paper. That's the way it would go because sometimes they might have left me there and I'm frustrated because they left me and everybody done gone, and they come back and start to kick in and help again. That happened especially in the early days of the paper because Bobby and Eldridge were getting speaking engagements. I'm responsible for the paper and I'm cutting and pasting and laying out. Then they come in and have to proofread it, and there's corrections to be made and there's things to go into the paper, things that they want to adjust and change and take out, then I'd have to do all those things as well. A lot of intellectual conversation is going on with Bobby and Huey and all the rest of them, and so I'm wading through that, as well, until it gets back to focusing on the paper again, you see. So you had all those dynamics too that went into output of the paper.

It began to change when we got our Central Headquarters. Because of John Seale, Bobby, and people in the community we developed layout tables and all the other stuff. So there was a layout area that I used to work on, but it was also connected. It was all in this big front area. We always got these houses or these places where we lived at to develop our layout stuff. It was more comfortable because you could go to sleep in the other bedrooms. We still had fun, cooking at the office, talking smack, living life.

I used to go on the patrols with Huey and Bobby and them in the earlier days, even do a little security during that time, but as the Party evolved and grew and the paper became the organ, they wanted to start getting the paper out on time and they wanted to make sure that the quality of the paper was good. So my responsibility was to focus on the paper. That's what they told me: "We want you to focus on the paper. Get the paper out every week because that's the Party's lifeline to the people." And that's what I did.

RON TURNER
Flagrante Delicto, Last Gasp

Often artists drew their comic strips on fucking paper. The strip came in in the size of the paper, not the size that it had to be to fit into the comic books. There were a lot of things you had to pay attention to: how things get printed, how they get photographed, how to do the separations, the color separations. All that, to me, was fascinating because I had never done it before. With the first comic I learned about 80 percent of what I still know today about everything. You just have to learn; it's like basic training. You learn by doing. A sexual intellectual is someone who does, a fucking idiot is someone who talks about it.

JEFFREY BLANKFORT
San Francisco Express Times, *San Francisco Good Times*

I was photographing for the *San Francisco Express Times* from the beginning. The editor, Marvin Garson, got the money to run *Express Times*

from the proceeds of the play that his wife, Barbara Garson, had written about Lyndon Johnson called *MacBird*, which was quite popular. So at that time, the *Express Times* was actually paying on time, thirteen dollars a photograph, which doesn't sound like much today, but in 1968, thirteen was about seventy-five dollars or more.

Wherever I lived I had my own darkroom. I started developing film with metal Nikkor tanks back in the Sixties (I still use the same tanks). I would develop film wherever I could find a dark space. In San Francisco, where I was living, they have these apartments that have a pantry off of the kitchen, and I made the pantry into a darkroom, a full-blown darkroom. My landlord used to come and say, "Do you have any water leaks?" Because I used to run water all the time into the darkroom, and the landlord would say, "I have a tremendous water bill; you sure you don't have any leaks?" And I'd say, "No leaks at all." Rent was really cheap then too, but it was a really great darkroom. So I could get my prints out very, very quickly.

THORNE DREYER
Rag, *Space City!*, Liberation News Service

There wasn't a hierarchical structure to what we were doing, so anybody could come and get involved. When we did layout we'd always have lots of people come in, there were artists that would come in. We didn't know what we were doing, we didn't know how to layout a paper. We built makeshift layout tables and created a kind of

Following page, left: *Rag*, vol. 3, no. 8 (1968). Following page, right: *San Francisco Oracle*, vol. 1, no. 9 (1967). A great poem by George Tsongas, but readability be damned.

THE RAG NEEDS EXTRA HANDS esp. TYPISTS General Staff Meeting Monday at 10:00 pm : 2nd floor of YMCA

MICHAEL KLEINMAN
New York Herald Tribune

It was a high school paper, distributed all over New York . . . fifty to sixty thousand copies.

My job was selling ads. I was really good at getting full-page ads from the record companies. We were actually their target audience, if they thought about it for ten seconds, which of course I asked them to think about for ten seconds. We were their test market—they loved us. We were getting all these freebies because we were from the press. They had parties, [we'd] go see shows, they'd get you into all the movies you could see. It was quite a racket, actually.

What money we had went right back into what we were doing. We had our own storefront on St. Mark's Place, eventually. We grew into the White Panther Party—we didn't want to be Yippies. We were Communists and we weren't afraid to say it or admit it in our approach back then. We had a three-point program: dope, rock 'n' roll, and fucking in the streets.

We shut down the whole New York City fucking school system one year. We all went to Stuyvesant High School. Back then only boys went. We were the class that integrated it with girls. We shut down that school three or four times, but we shut down the whole city in 1970. We led a march from Manhattan over the Brooklyn Bridge and met Boys High and all those dudes coming from Brooklyn, and then came back, took over the New School on Fifth Avenue and made that the headquarters. You don't even understand: there was barricades in the street, people were ready for war.

format for pages, or whatever. We typed on an IBM Selectric and would type the stories twice so we would justify them. I don't know why we decided to do that, it was a lot of work. Then we would cut and paste—this was back when cut and paste meant cut and paste. It was a big event. Sometimes we worked for two days and two nights, straight through, with a little bit of chemical assistance, but primarily just on our adrenaline and energy because we were really so excited, and it was so much fun.

We had a lot of gall and a lot of chutzpah. We were fearless, and we just went out and did it. We learned as went along; we taught ourselves how to do it. It was never really slick, but it's remarkable that it came out as good as it was. *Rag* always had excellent writing, political analysis and cultural coverage. It was always very, very well written, and that was one of the things that pulled people. Also, when we started it we decided that we weren't going to be boring, we weren't going to be heavy, we were always going to have a lot of humor and a lot of cultural stuff, and in that sense, we sort of reflected the Austin community. We always had a lot of arts, art coverage and *actual* art in the paper, but we weren't like some of the papers that got so McLuhanesque that you couldn't even read it. *The San Francisco Oracle* . . . frequently you couldn't read the copy!

the i,i,i,i,i,i,i,i,

becomes the abstraction of the body
no belly, no head
no arms the whole body disembodied floating in a viscous
liquid or not reacting at all weightlessness the prime cause of which
is the i,i,i,i,

no concern with anything but the i,i,i,
which in itself becomes non-existent

the abstraction continues until only the mind exists
a form of whirring
by itself and through space weird and weirdness predominant
in the conception of the world around the space becomes occupied by a
spacelessness that threatens to extinguish the i,i,i,i,
which poses a greater and greater threat to one's self
herein lies the contradiction
and the attempt at salvation western religion is especially notable
for this leaving the body helpless, withered, and quite lifeless
an aching bitterness and scorn for the real world which is that of
personality & selflessness selflessness being anathema to the i,i,i,i,

as the i becomes more intense there is a diminution of sense
no realization of dress or undress
right or wrong
the body itself unconnected to the mind which is now playing a
predominant part a part that does not acknowledge the body but
cannibalizes it

dress and undress become indistinguishable
the questions concern mostly self or truthfully that lack of self
which the body feels and searches for while the mind goes off
without it represses it the self has actually disappeared

in conversation
one finds this alienation increased, this antipathy toward self
turns it against the body every conversation leads into a
discourse of one's own problems this is admittedly shallow
yet the highest moral values still prevail though they are only felt
viscerally this is very important because all the good feelings can be
aroused can be felt but cannot be acted the contradiction
therefore is in the action the extreme concern with self negates
these values because they can never be acted upon the organism
does not work toward them for to work toward them would be a
betrayal of the heightened self

thus the fearful i predominates, and the good intentions collapse into a
sort of chaos and inability to act spluttering at first, and then
acquiescing gathering momentum until the monstrous i is gladly
accepted as predominant this is the monstrous i monstrous because it
has no relation to self, the surrounding world to that existential i
which is sought, but which blindly careens through darkness, emptiness,
space
by the time acceptance arrives its velocity has been so heightened
that only the promise of self destruction is able to assuage the debauched
and rejected self

total acceptance is the other side of the coin
which is even more confusing, and must be defended even more
bitterly this eventually degenerates into an ineradicable psychosis

this impulse much of which is chemically motivated just as the
octopus or the squid emit their ink for protection brings all down about
it it is recognized as a motivation to hurl oneself (projectilism)
or to fall through space a velocity apparent in the mind which rushes
the person onward without knowing where without actually caring
as in dress/undress destruction of self becomes the keynote
in the lack of awareness of others and what others may desire
the cannibalistic desire to please oneself at all costs closes the mind
to the plight of others and alienates one from the world

the contradiction of destruction of this kind is that it will (must)
destroy itself in order to maintain itself, to protect itself because it
cannot stand rational scrutiny thus it is totally negative it
never destroys to create in its place but only to destroy without a
thought of what will happen to itself of course, its own destruction
is what it wants least but it cannot see that suicide that will ensue

therefore the forces it tries to stymie are the same ones it values
and these we have agreed are suicidal, and in fact, non-values
social disintegration is implicit in this theory, and accepted as a
rational value but inverted

an example of the conversational technique:

a conversation is begun by another person, perhaps mentioning a
problem or discussing a subject

the i impulsive then shifts the conversation toward his own
emotional needs a confessional actually without a subject

however, conversation is too slow, and the person must project his
emotional problems in lieu of self but self is what he believes
he is projecting

this gradual weaning away from the intent of the conversation tends
to increase the possibility of psychotic action since the other person
does not have it in his power to solve the problem or alleviate it in

any way (psychotic action-reaction which backs
up in persons so motivated)

as the insistence upon the iiii as a substitute for a healthy self
believing this to be the healthy self psychotic action
becomes of primary importance paranoia, depression, scizroid etc...

now manifestations of the super ego appear, and nothing is resolved
the lack of resolution increases the frustration and the road to
irrational behavior is fully opened the original person,
and the i are all forgotten, confused appearing & disappearing
with a maddening inconsistency

in the society
it manifests itself as forms of totalitarianism
ie - irrational push of bureaucratic depts., personalities etc...
to accomplish things without assessing the results of these
goals... the consequences totally ignored in order to do
something ANYTHING!!!!

a current example of this is the need to push the freeways through SF
the freeways have become a point of honor with the governor and the
highway dept. though this has nothing to do with the problem
no highways equal dishonor etc... don't tread on me etc...

ex- war becomes a matter of patriotic intent rather than the exacerbation
of the social fabric by the misuse of the social tools as well as
materials

ex- the facts are manipulated or misconstrued (deliberately or not
doesn't matter) or squeezed into an inelastic structure
made necessary by the emphasis upon ego gratification in order
to protect the psychic self from anymore attacks a walling
off, an armoring when this point is reached all of society,
the social fabric is at war with the other segments, pieces, parts etc...
(social mechanism and other archaic terminology) this in itself is the key
to disintegration of that particular society or social mechanism, and
heralds the approach of a new whether better or not is
indeterminable

an example of this is shown in the schools - the bureaucracies become
less flexible as the children's need for flexibility become greater this is
almost an inverse proportion then skirmishes are fought which the
bureaucracy loses, but determines never to lose again thus inertia is set
up, and things become harder and harder until they break or the school
bureaucracy is thrown out but the latter never happens and the
bureaucracy then functions as a brake it fights rearguard actions
and nothing for the good is ever acknowledged except in the stiffest
and most face saving terms

thus everything is squeezed further into a logical mold which is illogical
because the point of view upon which it was constructed is itself
illogical thus we again get to a point where the world appears to
disintegrate the irrational aspect predominates
the need for flexibility is then regarded as heinous, heretical, blasphemous
and necessary to be put down

whereas, in reality, this flexibility is the safety valve for the social
mechanism bent on its own destruction

we are now at a point where reasonable alternatives become
totally unacceptable because they cannot be predigested
and squeezed into the logical mold, which as said before
is illogical, but in addition, by experience
we must conclude that it is also unreal...

the practitioners of reality then are the practitioners
of unreality, and are the impractical men mainly because
they lack foresight which they have sacrificed in a vain
attempt to be clairvoyant... but their elan voyance is
false and structured and limited by events they cannot
possibly control

this unreality then reflects mental aberration
the most galling and preposterous thing about this is
that it appears real to those driven by this
fantastic ego fear the self abdication which
they have pursued

as though walking down the street they will suddenly disintegrate
into little pieces bit by bit by bitterness

reality then is the focus
the interpretation of reality the battle

the interpretation depends upon a humane appraisal of the
world inhumane appraisals of the surrounding
world connote a psychotic state thus we can conclude
that suspiciousness (fears, paranoia of all sorts) are
destructive in themselves, and when projected upon the
social fabric show an inability, a refusal, to deal with
the humane reality

thus reality is social
and cannot be abstracted
into hedonistic terms such
as liberty, death, freedom etc...
honor, my country tis...

as long as reality is social
then abstruse terminology for
that reality show a disintegration
of the very terms that are deemed
applicable to the solution of the
situation

18

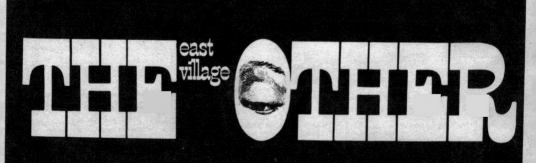

LSD ON PAGE FOUR!

Sales and Distribution

Connecting scenes around the country and the world, the papers initially traveled through the underground via the Underground Press Syndicate. Locally, papers could be found on the newsstands and in news boxes in busy areas as well as in the head shops, bookstores, and boutiques that were beginning to line the main drag of most nascent hip-communities. As the counterculture grew and circulation increased, many papers utilized distributors to get their papers to the individual subscribers and communities scattered across the country. Whatever their preferred method of formal distribution was, almost all the undergrounders depended, to a large extent, on street sales. Generous commissions attracted small armies of street sellers who would be on every street corner in high-traffic areas shouting out front-page headlines and catchy phrases. Depending on your leanings, the chorus of street sellers was either music to your ears or an unbearable cacophony—as with all things in the underground, subtlety was seldom on display. The combination of both novel and established approaches to distribution, along with droves of street sellers hawking the paper, all but guaranteed that what was once a network of intramural communication would ultimately penetrate the consciousness of the culture at large.

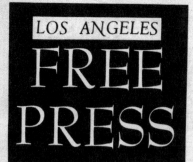

LOS ANGELES FREE PRESS

"THE DEPUTY" REVIEWED

WILCOCK IN GREECE (AGAIN)

LIPTON: A MORALITY PLAY

136 PLACES TO GO THIS WEEK - PAGE 12

10¢

Vol. 2, #34 (Issue #57) COPYRIGHT 1965 THE LOS ANGELES FREE PRESS Friday, August 20, 1965 10¢ (15c OUTSIDE OF LOS ANGELES)

The Negroes Have Voted!

"It is always a great crime to deprive a people of its liberty on the pretext that it is using it wrongly."

DE TOQUEVILLE

L.A. TIMES, YORTY & PARKER DO NOT UNDERSTAND EVENTS

Art Kunkin

The demonstrations in the streets have completely ended the myth that the Negroes of Los Angeles are the happiest in the whole country.

It has been an election without ballot boxes and the Negroes have cast their votes. Whether or not the white majority likes this vote, it is time for the analysis which follows every election. It is time to listen to the Negro.

Attempts to simply establish "law and order," to simply establish the pre-demonstration status quo, are doomed to failure. Anyone who thinks in these terms is fundamentally anti-Negro and will be understood as such by the vast majority of Negroes.

"Law and Order"

The great tragedy is that the government officials and the major news media have not understood what has happened. They have simply seen the breakdown of "law and order" and have been showing by their statements and actions during and after the events that they did not hear the message that the Negroes were broadcasting for all with ears to hear.

Indeed the stage is now being set by the so-called responsible leaders of our community for reprisals against the Negro community, not for any positive confrontation of the problems which led thousands in Los Angeles, the "Safe City," to face death at the hands of police and soldiers because they had given up hope that ordinary democratic methods would really do anything for them and their children.

The climate locally is such that anyone who criticizes Chief Parker or the city administration for their role in the disturbances is called a Communist or a supporter of criminal elements. It is actually very dangerous in Los Angeles today to offer reasonable objections to the sensationalistic reporting and ridiculous charges of conspiracies.

Danger

Yet the voice of reason, of compassion, of immediate positive action must be heard, and it must be heard from the white community, or else the next Negro protest will be still more severe. Not only the Negro ghetto but every neighborhood in the city will become an armed camp. Not only white businesses in the ghetto will go up in flames but the very mountains and oil fields ringing Los Angeles.

And who will really be to blame then—the Negroes who act and explode out of sheer frustration, or the white community which has the power to act decisively but which did not listen before the explosion, and is not listening now?

The Los Angeles Times editorial of Tuesday, August 17, the very day the curfew ended, is a classic example of how not to listen and how to best provoke future disturbances. The Times states as one of certain "basic truths" that "What happened here was not the doing of the Negro majority in Los Angeles. Far from it. Innocent Negroes were among the saddest victims of the burning and looting." Another so-called "truth" is that "even by inference, none should condone the criminal terrorism, or dismiss it as the inevitable result of economic and sociological pressures." The Big Times makes its proposal—a Governor's Commission to inquire into the causes and circumstances of the riot and, above all, why the National Guard did not come to the scene sooner. "The Commission should be cautious of irresponsible criticism of the Los Angeles Police Department and its chief, William H. Parker, . . . Nonetheless, the Commission should concern itself with the possible (sic!) need of better communications between law enforcement and the Negro community . . ." Furthermore, the Times calls for "an increase in the size of the Police Department." The third Times proposal is that aid be given for the rebuilding of destroyed businesses in South Los Angeles and guarantees given them against future disorders.

No Action Proposed

The astonishing thing is that in two editorials nothing concrete and specific is said about doing anything immediately about the conditions that led to the riots.

Nothing is said about education, jobs, or housing except in terms of advice to "proceed in ordinary fashion to secure still other advantages so long denied them." How long are people to wait, Times Editor Nick Williams and Times Publisher Chandler? It has been a super-disaster situation in the Negro ghetto for years. The people are fed up with unemployment, with subsistence on government handouts and Bureau of Public Assistance checks. The War On Poverty has done little and most of the local publicity relating to it has emphasized the haggling among politicians.

As Police Chief Parker ha... pointed out with some perception, "You can not keep telling them that they are being abused and mistreated without expecting them to react." But, Chief Parker, do you really think that "they" need to be told about mistreatment? Don't you recognize that "they" are being mistreated? What would you have Washington do, Chief, not even promise the

(Continued on Page 3)

CORE LEADER OBSERVES GHETTO FIGHTING

Bob Freeman

On Wednesday night about 11 p.m. I arrived in Watts, a Negro ghetto in the heart of Los Angeles. Amid a hail of bottles, rocks, and stones, as an angry mob of residents, seething with resentment, was surging forth toward a group of policemen, I could hear shouting: "We will kill you, you beat and kicked that woman." "You've beat and we've been running. Who's beating who and who's running now?"

I would estimate the number taking part in this action at that time at about 1500 persons.

As I drove south on Avalon Boulevard south of Imperial Highway, I saw four police officers crouched over one man as two other officers sat on him. The four were beating him about the head, arms and shoulders with billy clubs. To my left approached a crowd, shouting "Don't kill that man!"

The crowd began to attack the officers as the officers responded with "Shut up, dirty niggers" and "You better get out of here and go home, niggers." Just then the crowd came closer and began to attack the officers. The officers first attempted to fight back but then ran away.

As I drove south another block I saw four officers approach one Negro who was walking along the sidewalk emptyhanded. One officer said, "Come here, nigger." As the man turned, the officers jumped him and began to beat him.

He fell on the ground, but instantaneously the crowd was there running the officers off.

I felt then it was wise to park my car and inquire of some of the people on the street what had happened to start this. I approached two men who had just discharged their last stones and bottles and asked my question.

They replied that the cops had stopped some man about a traffic violation. Two women had approached the scene and during the ensuing events the officers had knocked one of the women to the ground and hit and kicked her. They said this had enraged the crowd which had been looking on.

While enroute to Watts I had

(Continued on page 2)

ART KUNKIN
Los Angeles Free Press

In the first year the paper was very tiny, and I had built it up to five thousand paid circulation, at fifteen cents apiece. The *L.A. Times* wrote a piece about me, "Why Does the *Free Press* cost ten cents?" and I got little boosts like that. I began giving papers to kids to go out and sell in the streets and make some money. Eventually I rented a garage up in Hollywood, and kids would come by and leave a knapsack or something and get a pack of papers and go out and sell them and then bring back the money to rescue their knapsacks. And they, you know, hundreds of kids were supporting themselves eventually like that.

But the first big break took place during the Watts Riots. During the Watts Riots I ran a headline saying, "The Negroes Have Voted." I had lots of contacts in the civil rights movement and I had helped start the Congress of Racial Equality here and I'd been on the NAACP board. So I had some knowledge of the black situation, and I wrote this headline on this front-page article saying when the negros don't get their issues handled in the courts, they go out in the streets—and that's a different kind of voting. Everybody else was talking about fires in Watts and criminals, and I'm saying that this is a rebellion and people are voting with their feet, so I was on every program in L.A. that week. I was on maybe ten news programs, and that week the paper jumped from five thousand to twenty-five thousand paid circulation. People were buying more copies in the street, and I bought more boxes. When I had started the paper in May of 1964 (the *Village Voice* was about five or six years old) the *Village Voice* had a paid circulation of 27,600, and so that was my target. I figured, you know, if I had ever arrived there, that was success. And the week or two after the Watts Riots, that's where I was. I had jumped from a little tiny hippie paper to being sold on the streets.

Seed, vol. 3, no. 2 (1968). Artwork by Paul Filth. Opposing page: *Los Angeles Free Press*, vol. 2, no. 34 (1965).

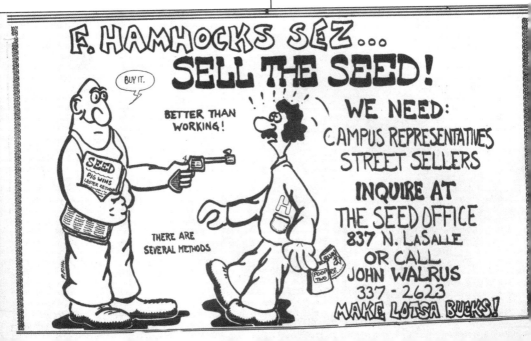

ABE PECK
Seed, Rat Subterranean News

It was all distribution from below. We had a network of head shops that all the papers had developed, so we knew that (I'm making up a name) Zeke's Head Shop would take twenty papers. So that's part of what we did in our day: ship papers out. We'd have to roll them up in butcher paper and ship them out. It was all cottage labor. Over time there were a couple of national hip distributors that built up and we would send them bulk, and they would distribute directly to the head shops, hip bookstores, and record stores.

But most of our sales were on the street with this army of street sellers. When I went downtown, there'd be a seller on every corner. They'd be yelling, "Hey, get your *Seed* here!" or they'd say, "LSD on page four!" or "Read your hippie paper here!" You know, just funny chants. It was a carnival kind of scene.

Obviously, if something was happening around town you weren't going to cover it, you were going to be in it. So if there was a demonstration down at the courthouse, you'd go down there; if there was a press conference, you'd go down there. People were always drifting in through town. We had this army of street sellers. We had won a court case with the Civil Liberties Union to allow street selling, and we had had a battle. We had a guy who was the king of Old Town, owned a lot of buildings, and he had called the cops and some people were arrested. So we printed a thing in the paper called the Reporting for Arrest card, and it said, "Hey, we'll be on the corner of North Waller, eight o'clock next Saturday. We're gonna report for arrest unless we get the right to hang out." Hundreds and hundreds of people showed up. The guy gave us a vacant lot and we just hung out, and people could sell pizza there. It was a little bit of a people's victory, street style.

People were coming in to buy papers all the time, and we would front them the papers and they'd leave their driver's licenses. One time I think we had about twenty bogus licenses (or licenses where people just needed the money more, so they never came back for them). It was like, "Oh, Nebraska! I never knew what a Nebraska driver's license looked like." We would run out and do our own personal stuff. People would go out and come back with smiles on their faces, if you get my drift. The other important thing to realize is that it was essentially possible to live on next to nothing. We might have gotten fifty dollars a week from the *Seed*, those of us who were there all the time, but that sounds high. People were laying stuff on us all the time, but also there were just ways to support yourself. Some people did sell the papers, but you could rent an apartment in Lincoln Park then for something that you couldn't pay your dry cleaning bill with now. It was just possible to live on essentially next to nothing.

Helix, vol. 9, no. 6 (1969). Seattle street-seller Randy Grosser with a stack of *Helix*. Photo by Paul Temple.

WEATHER
COMMUNIQUE

The Following is a communique the Seed received from the Weather Underground:

They've pushed me over the line from which there can be no retreat. I know that they will not be satisfied until they've pushed me out of this existence altogether.

On Saturday, August 21, 1971, George Jackson, Black warrior, revoluitonary leader, political prisoner, was shot dead by racist forces at San Quentin. Murdered for what he had become : Soledad Brother, soldier of his people, rising up through tormen and torture, tyranny and injustice, unwilling to bow or bend to his oppressors, George Jackson died with his eyes fixed clearly on freedom.

Tonight the offices of the California prison system in San Fransico and Sacramento were attacked. One outraged response to the assassination of Geoge Jackson.

There are still some Blacks here who consider t hemselves criminals--but not many. Believe me my friend, with the time and incentive that these brothers have to read, study and think, you will find no class or category more aware, more embittered, desparate or dedicated to the ultimate remedy--revolution. The most dedicated, the best best of our kind--you'll find them in the Folsoms, San Quentins and Soledads.

The prisons are part of a strategy of colonial warfare being waged against the Black population. For over a hundred years, the U.S. government has tried to "civilize" the continents of Africa, Asia and Latin America. For the same reasons, the government has stolen the land and labor and attempted to rip apart the culture of Black People. Originally kidnapped from Africa to work the plantations of the South Black people today are being torn from their families and communities to be incarcerated in slave labor camps. Under the Slavery and Emancipation Act of 1866, slavery and involuntary servitude were abolished for everyone except convicted convicts ed for everyone except convicted criminals. Accordingly, the prison system of this country is run at a profit, with prisoners paid pennies an hour to produce everything from shoes to missle parts. Like in Vietnam, where "rebellious" populations have been "relocated" to strategic hamlets and tiget cages, the rebels of Watts, Harlem, Detroit, Hough have beenshipped to places called San Quentic, the Tombs, Parish Prison and Cook County Jail--- concentration camps whose sole purpose is to crush the spirit of resistance in the Black population.

Inside are those who have fought back against the white armies which occupy their communities, those who have experienced the slow death of heroin, those who have not accepted hunger, unemployment and racism as a normal way of life. Fifty percent of the prison population of California is Black and Brown. There are more Black men in prison than in college. Once in jail, the point is to keep them there. Thousands of prisoners are serving indeterminate sentences--one year to life is the required California sentence for robbery. There is a high price for parole--that of utter subservience to daily racism and indignities. Prisoners must accept arbitrary transfers, denial of visitation rights without explanation, inhumane medical treatment, atrocious food, overcrowding and rampant brutality. They must accept continual denial of parole by white Adult Authority members. George Jackson was denied parole many times between 1961 and 1969, although his only "crime" was a $70 gas station robbery. If a prisoner becomes identified as a militant, as an agitator, the Adjustment Center awaits. In San Quentin's Maximum Security Adjustment Center, almost all the prisoners are Black and Brown. The guards and trustees are almost all white. It is in this wing that Fleeta Drumgo, John Clutchette and Ruchell Magee are now being burned and beaten.

The colonial administrators of the system--"correction" officials, parole boards, youth boards, guards, adult authorities--are there to make sure that no freedom fighters get out: that those who are still unbroken remain inside, to be subjected to constant psychological and physical torture, and if necessary, to be assasinated...The execution of George Jackson is the North Amerikan prison system's final solution to the "problem" of Black resistance?

We recokon all time in the future from the day of the man-child's death...I want people to wonder at what forces created him, terrible, vindictive, cold, calm man-child....

The masters would have us believe that violence is a choice in the world, that the best of us choose non-violence as a means of change and that the deviants choose violence. The loudest cries for restraint and non-violence come from the throats of those bent on violence as a means of control. The Vietnamese are told to be non-violent from the cockpits of B-52s; Blacks are told to believe in progress while their children are systematically forced through schools where they are taught how NOT to read and write. So long as the master-slave relationship continues, violence will be a fact of life. Thousands of Black and Brown babies die of malnutrition and lead poisoning each year; one-third of all Puerto Rican women are sterilized in birth control experiments. Those who place the blame for violence upon those who resist this oppression are prolonging slavery. George Jackson was a humane man who had to use every means to fight for survival in a racist country. Violence, bloodshed, madness--this has always been the cry of the slave-master after a rebellion. But these are words which describe those who crack the whips and maintain power by standing on the throats of others. It is not violent to reach for life, not mad to risk all for freedom.

Medgar Evers, Malcolm X, Bobby Hutton Brother Booker, W.L. Noland, M.L. King, Featherstone, Mark Clark and Fred Hampton--just a few who have already gone the way of the buffalo.

There is a pattern to this country's attempts to control colonial peoples. One of its chief weapons has been the periodic assasination of major leaders. From the murder of Patrice Lumumba in 1961 to the shooting down of Malcolm X in 1965, the targets are those who have assumed center stage in the struggle for Black Liberation at any given time. With rebellions throughout the prison system this past year, George Jackson had emerged as a key figure in the Black community--a spokesman for enraged men and women who are honing themselves for a fight to the death within this' country's detention camps. Every prisoner throughout California has heard of Jackson; his execution represents a major attempt at mass propaganda--to convince the youth who are now entering the Folsoms and the Quentins that rebellion is hopeless, that those who inspire and lead will pay the price of death.

There must be a price for racist attacks, a higher price for murder. Mass actions outside the Tombs last year might have prevented the murder of two Puerto Rican prisoners a week after the rebellions. If Edward Hanrahan had been dealt with for the murder of Fred Hampton, James Parks might have thought twice before participating in the murder of George Jackson. Every prison official must learn to balance his actions with his desire for personal safety.

The history of Black people in this country has been one of passionate resistance to the slave masters. All too often, they have had to wage that fight alone. Black and Brown people inside the jails are doing all they can--must they fight alone even now? White people on the outside have a deep responsibility to enter the battle at every level. Each of us can turn our grief into righteous anger and our anger into action. Two small bombs do not cool our rage. We nurture that rage inside us. We view our actions as simply the first expression of our love and respect for George Jackson and the warriors of San Quentin.

I'll never forgive, I'll never forget, and if I'm guilty of anything at all it's of not leaning on them hard enough. War without terms.

Weather Underground.

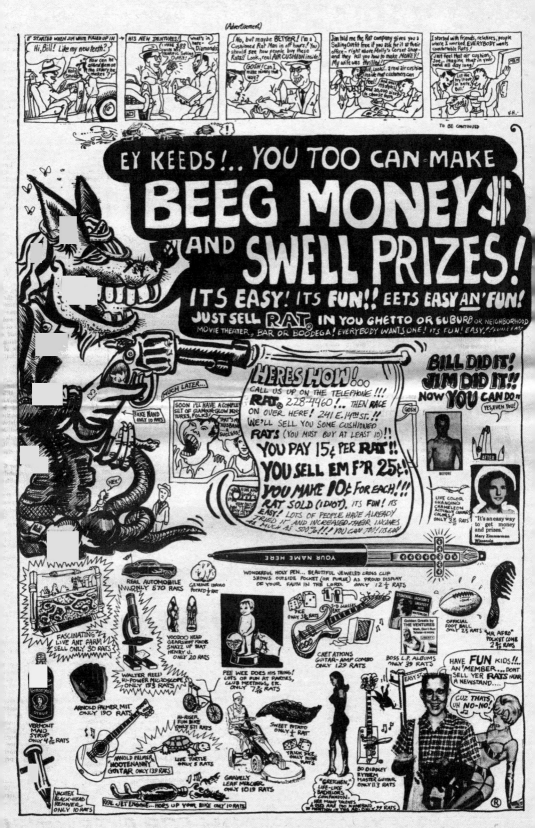

BILL AYERS
Osawatomie

When we took actions that were public, we always released communiqués and relied on the alternative radio and the alternative press to pick them up. If we would leave a communiqué, we would leave it for *The New York Times*, but we would also leave a copy for the *Rat* because we knew that while the *Times* might distort it, the *Rat* would run it full. We felt like we were in communication in a lot of different ways, but one of the ways we were in communication was through the vehicle of the underground press. We could count on them, even if they didn't agree with us, even if they didn't think what we were doing was terrific, they also felt a responsibility to report the truth about all the various kinds of upheavals that were going on. They were, I think, a very important force for us so that we could be in dialogue with the movement.

Part of planning an action was planning how to write something that was coherent and sensible, that amplified the ideas that were supposed to be embodied in the act itself. Then, typically what we would do is take copies of this communiqué all over the country. We would tape them to the bottom tray of a phone booth near *The New York Times*, near the *Washington Post*, near the *L.A. Times*, near the *Chicago Tribune*, near the *Detroit Free Press*, and then simultaneously, in all those places, we would call the news desk twenty or twenty-five minutes before whatever was going to happen was going to happen, and we would say, "This is gonna happen, and if you want to understand why go, to the corner of such and such and you will find

a statement." It was remarkably effective in the sense that, very quickly, the major news outlets and the underground press and the FBI and the local police had to recognize the authenticating gestures of what made something truly from the Weather Underground. They would send someone out, check out the communiqué, report on it. That became a fairly routine way of communicating. It was important to us because while we felt that the actions themselves had to embody what we were trying to communicate. In other words, they couldn't be so vague and open to interpretation that people wouldn't get it. On the other hand, we also wanted to have the opportunity to amplify what was said.

JEFF SHERO NIGHTBYRD
Rag, Rat Subterranean News

We had Mafia distributors. In Manhattan and most of New York the Mafia controlled magazine distribution. Everybody paid them off, even *Time* magazine would have an added fee; they didn't call it payoff, but they'd call it, like, "security fee" or something. *East Village Other*, for a while, wouldn't go with these distributors, so they [the Mafia] would take the *East Village Other*s and run their razor blades through the copies and throw them in mud puddles and stuff. So I talked to Allan Katzman and he said, "Well, yeah, we'll have to switch over."

These guys, the Mafia guys that I dealt with in New York, were just street-level, working-class Italian guys whose job it was to distribute papers—it wasn't glamorous. What I liked about

The Black Panther, vol. 2, no. 2 (1968).
Previous page spread, left: *Seed*, vol. 7, no. 7 (1971).
Previous page spread, right: *Rat Subterranean News*, vol. 2, no. 23 (1969).

those guys . . . we never even signed agreements, their words were good. That's how they did business, that old-fashioned way. I thought it was a pretty clean and good process.

EMORY DOUGLAS
The Black Panther

I was the only paper seller in San Francisco when we initially started because we were still working out of Eldridge's house. They would send a couple hundred or more papers to Eldridge, and then I would get a whole stack of about hundred papers and I would sell them. Because I was raised in San Francisco, in Hunters Point and Fillmore, and I knew a bunch of people who I went to school with who lived out by City College (by Lake View district),

I used to go to all those areas and sell my papers. I would always sell out. Plus I knew a lot of folks who owned nightclubs, and they would let me come through the clubs and sell the papers on Divisadero and up and down Fillmore. It was after Sacramento* and people were aware of us. I also was involved in some of the social activity in the Black Arts movement before that, and my work was published by Marcus Books, which was the first black bookstore in the Bay Area. So when I was out there, a lot of folks were aware of who I was and what I was a part of.

*On May 2, 1967, an armed delegation of Black Panthers, including Emory Douglas, walked onto the floor of the legislature in Sacramento to protest the passage of the Mulford Act, a bill being passed that would restrict the right to carry guns in public. It was ultimately signed into law by then-governor Ronald Reagan, and the resulting publicity thrust the Black Panther Party onto the national stage.

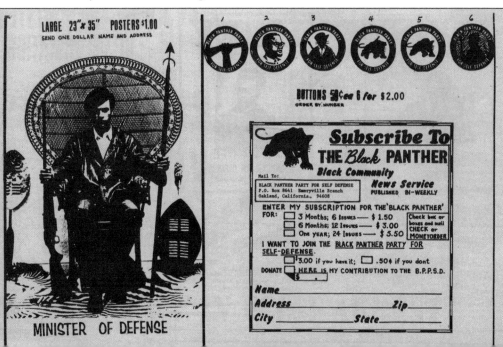

BILLY X JENNINGS
The Black Panther

Every Party member was required to sell the Black Panther Party newspaper every week that it came out. At the time that I joined the Party, I wasn't a full-time Party member—I was a Panther in training. If you had a job or something you didn't have to come to the office everyday, and I had a job. I had two jobs as a matter of fact. I had a job working for the public defender's office, and I had a job working at the local McDonald's. There was only one McDonald's in the East Bay, and I worked there. So I would take about fifty papers out and sell them in the course of two or three days, and maybe I'd come back and get some more papers out of the office, because I had to pass the office to go home.

My spot would be on Bancroft and Telegraph, right where Bancroft ends on the campus. That would be my spot or right across from where Rasputin Records is right now. I would sell papers there, up and down that street. And then for lunchtime I would go to Adolph Fish and Chips or Top Dog in Berkeley. But I would be up and down that avenue selling papers, talking to the business people and stuff like that. At places like Moe's Books they would get fifty Panther papers a week, but they would always run out. People would go down there looking for the Panther paper but Moe's out. I said, "Man you need to be getting seventy-five or something like that." And there was a record store before Rasputin's called Leopold's, which was the legendary record shop back in the day, and they used to sell Panther papers out of there, too.

I'd be yelling out the headlines saying, "Come read about Huey's latest statement!" "Find out about Bobby Seale in Chicago, gagged and chained like a slave!" "Find out how the Panthers are serving the community right here in the Black Panther Party newspaper, only twenty-five cent!" Man, some guys would come up, they'd give you five dollars. You know you start making change and they say, "Keep it, man. You see the next three or four brothers you just give them the paper for me man." A lot of times people would just buy your whole stash of papers from you, just give you twenty dollars—and twenty dollars was big stuff back in the day. So you wouldn't have to sell the paper, you could just give it away to people.

Central Headquarters was in Berkeley, and at different times it was Oakland. But National Distribution was in San Francisco, and it was run by Sam Napier. He was a high-energy guy and was success-oriented. He wanted shit to work, and he would think of practical ways to get things done. He was one of the first people I met as a Panther. When I lived at Seventy-Fifth and Spencer I would see the Black Panther van in my parking lot from time-to-time, and it was the distribution van. It was like a big milk truck with a big panther on either side and it said, "Black Community News Service." Andrew Alston was my neighbor and was the distribution manager. Sam was the circulation manager, so they actually ran the newspaper and made sure it got to every place [it needed to]. Now this was my neighbor, he brought me into the Party. I went to see Jimi Hendrix and came back to the house, and they were outside smoking and drinking—a drink called Bitter Dog, it's a Panther drink. Bitter

Dog was a drink made famous in the BPP by Lil' Bobby Hutton. He drank that port wine and grapefruit juice. We poured out the poison off the top and mixed in the grapefruit juice. After Lil' Bobby was killed it became the drink. Every chapter of the BPP and almost every Panther would drink it socially. Later on, to show support for the UFW [United Farm Workers of America], who were boycotting grapes and Gallo, the Party stopped buying Gallo port, and we changed to Italian Colony. We supported our brothers in the field.

I joined the Party in 1969, and I was a real good paper seller. Sam always rewarded his best paper sellers, so in June 1969 they was having the Monterey Pop Festival, and I was chosen to go along with maybe twenty other Panthers and maybe six or seven women. The women were security and they packed the guns. Guys sold the Panther paper, and the women just wore mini skirts and hot pants. They had the big guns and all of them could shoot—these are all dead-eye shooting women. So we all went down there and sold papers. I heard Janis Joplin sing, and stuff like that. It was a heavenly event; I've never seen anything like it in my life. I seen people dressed sharp, young people macked out—it was the bomb. And everybody was there and everybody was buying Panther papers. Panther papers was the shits, homeboy! No matter if you was the macaroni from L.A., flew in from motherfucking Chicago or came down from Seattle, you had a Panther paper in your hand, homeboy. So, you know, we went to all the major events selling Panther papers.

Panther papers could be found anywhere in the Bay Area—any corner. Panthers would be out in the middle of the street. Our office was on Seventy-Third and East Fourteenth, and I used to be OD. OD means I'm the guy in charge of the office; I run the office and tell everybody what to do. So I'm at the office all the time, but I sell papers out in front of our office and there's a big traffic light there. I might could sell a hundred papers just bullshitting around . . . that's ten bucks to me. Panthers sold Panther papers all over the black community. During that time there was no BART, so they would go to the AC Transit bus terminal where, if you've got a job in San Francisco, that's where you gonna be getting off at. We had maybe about eight or nine Panthers selling Panther papers there. The Panther paper was what was going on. All black people in BSUs (Black Student Unions) sold the Panther paper. People that was in BSUs, high schools and colleges, would take two or three hundred papers out. The whole BSU might buy three hundred papers and sell and distribute them on the campus, and shit like that. Not just Panthers sold the Panther paper; there was white people selling the paper. So the Panther paper got distributed wide.

The papers always came out on Wednesdays, and they would be ready to be sold on Thursdays. So the paper would be printed on Wednesday over in San Francisco, and we would pick the paper up from Howard Quinn, who was our publisher, and take it over to Fillmore Street where our San Francisco distribution office was. And then from there, Wednesday night was the big production night to get the Panther paper out. We had hundreds of people working to get that paper out because it was a tool, a source of information, and we wanted the paper out because it explained what we were about. So we had hundreds of people working to

get this paper out, we had trucks and vans picking up the paper from Howard Quinn and bringing them to the Panther office. And they would come in bundles. We would pull the truck up to the office and establish a picket line, and they would throw bundles from the truck and everybody would throw bundles, pass them to each other. That might go on until the truck was empty, and we would have two or three trucks come in a night, these are big trucks. We would load the papers into the Panther office and some of them would go upstairs to distribution. That's where we did the labeling—bookstores, newspaper stands, college libraries, home deliveries. That took a lot of time because we had to put labels on each paper, and the paper had to be wrapped. So papers went up there, and then the large bundles went into another area, a big kind of warehouse area, where there were a lot of brother Panthers in there breaking the papers down from bundles and putting them in boxes. We would take them from hundred-bundles and put them in a box (three hundred in a box), seal that box up, and stack that box. Now we would do that over and over and over because, at that time, we had about forty-eight different Panther offices throughout the country, and we were shipping Panther papers all over the world. So we had an ongoing operation from maybe four o'clock to twelve o'clock and we had students from UC Berkeley, San Francisco State, San Francisco University, Hastings Law College. People would come to distribution on Wednesday just to help, and that's how we got a lot of recruits, that comradeship. People liked that. They liked what they saw, they liked how we treated each other, and that recruited a lot of people.

The story about the paper, how it got to be [printed] on Wednesday, is that back in the day when the Party just started, we were looking for a printer, somebody to print our paper. Most of the establishment printers would not touch our newspaper—too revolutionary, too black. They wouldn't do it. So Elbert "Big Man" Howard one day called up the *Berkeley Barb*'s Max Scheer and said, "Hey we're trying to get our paper printed, and nobody wants to mess with it." And Max said, "Hey we got a printer over in San Francisco. We get our paper printed on Wednesday, so why don't you ride over with us and you can get your paper printed?" So that's how our paper came out on Wednesdays, that connection with the *Berkeley Barb* editor and owner. Simple, just like that.

SKIP SHOCKLEY
The Black Panther

About four or five days out of the week we would be out there at least from about four to six hours. We distributed a certain amount of newspapers to each comrade and they would go to different areas. Most of our areas were at El Centro Junior College, which had a Black Student Union that we organized, so there was a large readership there. We would [also] sell downtown Dallas, because during that time a lot of people would hang around downtown and south Dallas because that was a majority black neighborhood.

At El Centro we actually had these bracket machines that you put a quarter in. We was able to get that through the Black Student Union, so we had that stationed on every floor at the college.

The Black Panther, vol. 4, no. 28 (1971).

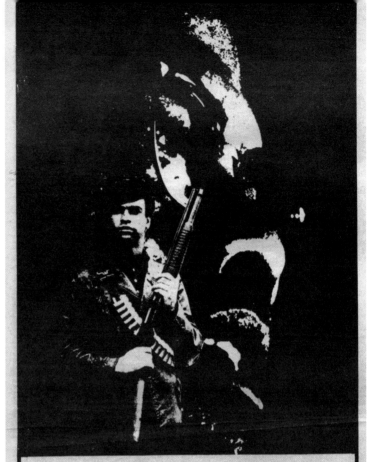

Huey would say, "a newspaper is the voice of a party, the voice of the Panther must be heard throughout the land."

We found we as citizens of this country were being kept duped by the government and kept misinformed by the mass media.

The Black Panther Party Black Community News Service was created to present factual, reliable information to the people.

The Black Panther Party Black Community News Service is the alternative to the 'government approved' stories presented in the mass media and the product of an effort to present the facts, not stories as dictated by the oppressor, but as seen from the other end of a gun.

ALL POWER
TO THE PEOPLE!

SEIZE THE TIME!

We'd also sell outside the college as people walked by. Downtown we would sell to people that walked by, especially during the noontime as people would take their lunch. In South Dallas we would take certain communities and go in and out of juke joints, clubs, beauty shops, barbershops, churches, restaurants, and we would sell our newspaper there.

We sold it to everyday people—black, white, Hispanic. We usually went downtown to sell the paper. It started to get real popular because of the coverage on the mainstream news. So we was even selling to businessmen, to little old ladies, they would pick up a paper. So the readership of the paper during that time, from 1971 to about 1974 was really at its height. People began to read what we was putting into print.

When selling the paper, we always had two detectives that was assigned to us. So every day when we went out, they would stand there and observe us. We knew them on a face-to-face level because they was assigned by the city of Dallas to actually follow us around and observe us. On other occasions, we would get guys who would try to hassle the women that was out there selling the papers. Sometimes somebody would try to offer you a joint or offer you some kind of drug, and we felt it was a setup, so we never did give in to that, especially when we're talking about the newspaper. Now, the local newspaper would say that you have a bunch of Angela Davis supporters, a bunch of Black Panthers, out here spreading their propaganda, and some citizen newspapers would say, "I wouldn't buy those Communist-inspired newspapers." But for all that, we pretty much had a good buyership.

One of the things we would do when we picked up the paper . . . we would pick it up in different areas. Love Field was the main airport in Dallas during that time, before DFW, and sometimes when we would go pick up the newspaper, the FBI would be there. They would water down the paper, or burn the paper, or make the workers who unload the airplanes throw the papers away or destroy them. So we would always have a different port of trying to receive the papers. You had Continental Trailways or Greyhound. If they destroyed the paper in Love Field, they would delay the paper a couple of days, but we'd always get papers through so we could sell them and they wouldn't be outdated. We'd think of different ways to sell the newspaper because we always knew we were going to have some kind of encounter, something is going to happen where they would try to stop us from selling the paper. Sometimes as we pick up the paper or on the way back to the office we'd be stopped by the police in the searches. Sometimes they'd take the paper away from us so we had to order again and hire lawyers to put injunctions against the police department because they were taking away our constitutional rights.

We had an old party member back in the time that we were living in the communes. He lived on his own during the time he was in the Party, and he was one of our conduits, meaning that he always had a way of getting the papers on his own where it didn't look like it was coming from Black Panther to Black Panther. So we would always have enough papers if we felt there was something going down. Usually when there's a conflict, I know there was a period of time in Oakland where you actually had conflict between, I guess, the East Coast and the West Coast, and we were getting a lot of interference from

guys who used to be in the Party, a lot of interference from the FBI because they knew what was going on and that that was a good way to destroy us. So we would rely on Odinga, one of the Party members, to receive the paper. We would meet with him either at his home or a designated place to pick up newspapers so we could get the distribution out. The national circulation manager was Sam Napier, before he was murdered, and he would always find a way of getting papers to us. He would say, "I'll send a bunch to Continental Trailways at this time, but go to Greyhound at this particular time and pick up those papers because there might be some interference coming from Continental Trailways." So we would do different things to throw off people who would try to destroy our newspapers.

RON TURNER
Flagrante Delicto, Last Gasp

Comic books piggybacked on the hip poster movement that was going on, so they got into all the head shops. There were maybe twenty or thirty thousand head shops in the country, and so it was big-time sales. Some of these books, like some of the early *Zap*s, were selling two or three hundred thousand copies a year; *Freak Brothers* are selling up to three hundred thousand copies a year. Big time. There was only a fifty-cent cover price, which meant that the distributor bought them at twenty cents, which means that as a publisher you got twenty cents back. Printing them up and getting them ready for sale cost you like six or seven cents, the artist cost you five cents or so. Eight percent usually works out to what the costs are on a good day, but 12 percent on a bad day. You were

making maybe a penny or two a book, so it had a lot to do with volume. You really couldn't fuck up. What I've noticed in publishing—although I've been one of the fortunate ones, I guess, because this is my forty-second year—is that you can't afford to have four fuck-ups in a row. That's Ron's rule for failure. You have four fuck-ups in a row, by all means, you should be out of business. That's why publishing is mostly the domain of rich people or trustafarian money.

The way I started, when I had the first comic book, was to go around and try and sell it to distributors, and they said, "OK, we'll take it." And what got me into distribution . . . besides by hand selling at all these different rallies around the Bay Area on Earth Day, I went around to Rip Off Press and to Print Mint, who had big numbers of books they were selling. They took my comics, then when it was time to pay me they said, "Oh we don't have any money, will you take our books?" I said, "Yeah, if we trade cover price for cover price." So we did. Then they gave me restrictions on where I could sell, they had certain key places that were critical, like Shakespeare [& Company Books] in Berkeley, Print Mint had its own store in Berkeley, the Tides in Sausalito, and City Lights in San Francisco. I couldn't go into any of the major accounts. So, armed with the *Zap*s and the *Freak Brothers*, I started selling them in leather shops, beauty parlors, and salons, a lot of different places that no one ever thought to go into with books before because it was a novelty.

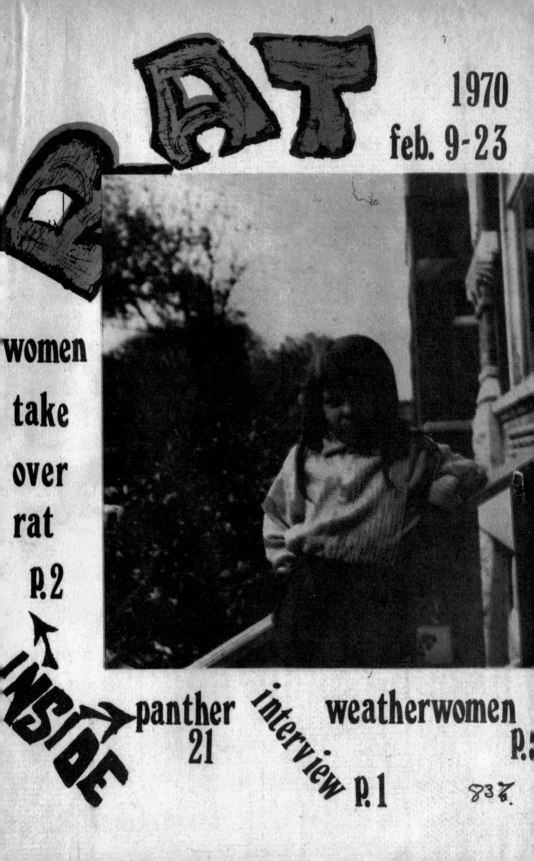

RAT

1970
feb. 9-23

women take over rat p.2

INSIDE

panther 21 interview p.1

weatherwomen p.5

83¢

WELL, DOES SHE HAVE GOOD POLITICS?

Growing Pains and Increasing Sectarianism

T*he speed of the growth of both the counterculture and the underground press exerted tremendous pressure on what were fragile institutions in their infancy. As the Sixties came to a close, stress fractures started to appear in the façade of what seemed, from a distance, to be a unitary whole, but which was, in fact, a vast patchwork of various affinity groups with differing and sometimes competing outlooks, motivations, and goals.*

Money was flowing in but only trickling down. The rhetoric of full equality made any inequality insufferable, and the intensity of the daily grind amplified any differences already extant. Once marginal but newly empowered groups that had traditionally been relegated to second-class citizenship within the very movement that they helped to create were now demanding a place at the table. The stakes were high—the revolution was coming, and any compromise seemed to be out of the question. The problems had all been articulated; now only action remained.

Rat Subterranean News, vol. 2, no. 27 (1970).
Women Seize *Rat*!

SISTERS STRIKE!
SEE PAGE 5

JUDY GUMBO ALBERT
Berkeley Barb, Berkeley Tribe

Robin [Morgan] was an early Yippie. She and a group of New York radical women "liberated" the *Rat* from its editor, Jeff Shero. This was a time of grand historic movements including the women's movement—it was absolutely time. So while I don't know if Robin's grievances against Jeff and the *Rat* were real or imagined, or some combination of the two, the time had come for this to happen. Let's be honest, the men were sexist and macho in those days. It was part of their attraction—at least to me. And we women really did have a secondary position. But it took a while for us, i.e. women, to actualize ourselves and stand up. So when Robin and her friends seized the paper and turned it into the liberated *Rat*, it was one of the first situations of women standing up to what we perceived and experienced as male domination.

JOHN SINCLAIR
Work, Change, whe're, Fifth Estate, Warren Forest Sun, Ann Arbor Sun, Guerrilla

I was in prison*, so I thought she [Robin Morgan] was a jive bitch—I wanted to strangle her. I was in prison for two joints of marijuana; I gave them to an undercover policewoman. A woman put me in prison, quite frankly, so I didn't think she had any right to do that. I just felt that was really awful. I wouldn't have attacked anyone that was in prison that was part of our movement. I said, "Fuck your woman till she can't stand up." Well, I understand that now, but a lot of women I knew, that's what they wanted. It wasn't some male fantasy on my part, it was experiential knowledge. She didn't even know me. I felt that the intimate things she said about me off of that one sentence was really off the deep end. Our practice had been exemplary. From the very beginning my wife and I worked together in this mimeograph revolution: I did the typing, she ran the machine. We didn't

Berkeley Tribe, vol. 2, no. 2 (1970). Gumbo takes no shorts. "Eldridge [Cleaver] used to call me Mrs. Stew [Albert]. I told him that was sexist, so he decided to call me Gumbo because gumbo went with Stew." —Judy Gumbo Albert.

*John Sinclair was in prison with a ten-year sentence (he was released two years into his sentence after the Michigan Supreme Court ruled that the state marijuana laws were unconstitutional) for giving two joints of marijuana to an undercover policewoman during the time that the female staffers at *Rat Subterranean News* led a takeover of the newspaper. The first issue after the takeover featured Robin Morgan's seminal essay "Goodbye to All That," a haughty denunciation of many of the leading figures of the male-dominated left, which heralded the rise of the women's liberation movement. She had this to say about John Sinclair: "Was it my brother who wrote 'Fuck your women till they can't stand up' and said that groupies were liberated chicks 'cause they dug a tit-shake instead of a hand-shake? The epitome of female exclusionism—'men will make the Revolution—and their chicks.' Not my brother, no. Not my revolution. Not one breath of my support for the new counterfeit Christ—John Sinclair. Just one less to worry about for 10 years."

give a fuck. Women could do whatever they wanted in our organizations—it was wide open. Anybody could do whatever they were willing to do, as long as they would put the work in and not let you down. So I felt we had been in the vanguard of that, even though our language wasn't what it should have been. We supported the women's liberation movement, then we started the Red Star Sisters; we had women in leadership positions. We weren't SDS, we were hippies. Women were great powers with hippies. We didn't have secretaries. We had communal child care, cooking . . . we were trying to attack these things materially.

ALICE EMBREE
Rag, NACLA,
Rat Subterranean News

I think that women's consciousness kind of crept up. There were conversations. I had a long conversation one time walking down the street with Jane Alpert, who was one of the people involved in the *Rat* takeover. A lot of what women were saying was, "This is a major contradiction and, as women, we've got to deal with this." And then a counter, kind of, left narrative is, "It's not the major contradiction. You can't take energy away from the antiwar movement or from trying to bring down imperialism or racism." So there were all these kind of left debates that did not embrace that as where your energies should be.

I look at stuff now and, you know, we changed the world in terms of gender roles and the left. I know it was tough on the poor guys who were like, "The rug has been pulled out from under us. What can we do with our leadership?" It was truly a difficult period for a lot of men on the left, as they just didn't have the same standing, the same roles that they had played.

In a lot of ways, you can't develop leadership very well in a situation without having some of that

Berkeley Tribe, vol. 3, no. 8 (1970).
Opposing page: *The South End*, vol. 58, no. 5 (1969) This photo accompanies a story about Trans-Love Energies, the legendary commune founded by John Sinclair, Leni Sinclair, and Gary Grimshaw. Caption reads: "Brother Skip gets a free feel from one of the Trans-Love girls, Jackie. Skip is shown here designing a flyer concerning the Ann Arbor rape murders. Trans-Love has been holding community meetings to gather information about the slayings. Jackie was arrested on the streets of Ann Arbor the night this picture was taken for questioning a cop who was busting a street brother."

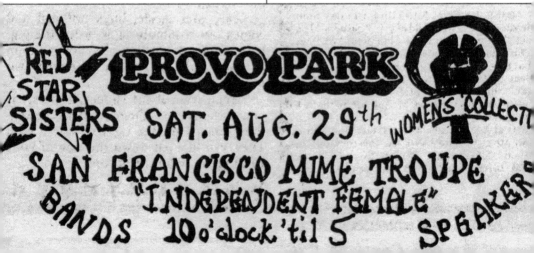

separatist . . . because women would not speak up in a room with men the way they would speak up in a room with women. And it almost had to happen that way, I think. I remember SDS meetings just being dominated by . . . I mean, the occasional women would speak up, but it was almost entirely a given that men would be the ones talking to the media, you know. It was just kind of a given. It's like you don't know that until you know it. Then you look back and you go, "Oh, those were the behaviors that drove me crazy." But you don't recognize them at the time. It's kind of like we all slogged through the fifties going, "Well I guess racism is just how it is," not with the idea that things could be different. I think feminism is kind of the same way, and I think that every group that's felt marginalized has had to assert themselves to gain a voice and a place at the table.

TRINA ROBBINS
East Village Other,
Gothic Blimp Works, Berkeley Tribe,
It Ain't Me, Babe

The misogyny started showing up maybe around 1968, when Crumb started really doing misogynist stuff. His early stuff wasn't. It was really sweet, the early stuff, but suddenly he became very misogynistic, by 1969 maybe, not even 1968. He just did all these depictions of women being

DEAR JANE,

YOU LEFT THE WATER RUNNING.

love,
the RAT collective

P.S. ALL POWER TO UNDERGROUND SISTERS!

On May 14 the Press reported that Jane Alpert, alleged member of a bombing conspiracy, had disappeared. Jane was a member of the RAT collective.

RAT 28

San Francisco Express Times

Volume 2, Number 7, February 18, 1969/15¢ Bay Area, 25¢ elsewhere

PRESIDIO FUGITIVES SPEAK - p.4

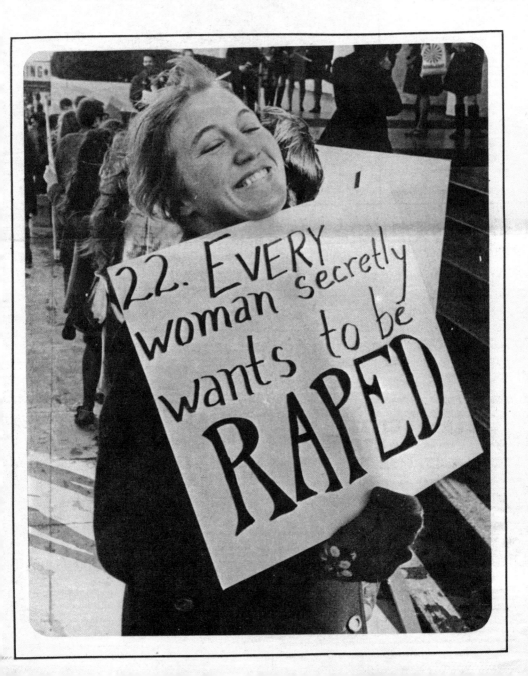

raped, and women being mutilated and humiliated, and all the guys thought it was really funny. And I would say—I didn't even use the word misogyny yet—I just said it was hostile to women. And they just didn't want to accept that. They would say, "You have no sense of humor, this is just satire." One of the writers for *EVO* interviewed him, and in the article he says, Trina says you're being hostile to women, but really I can see that you're just using the viewpoint of a little boy. And Crumb said, No, it's not the viewpoint of a little boy; it's the viewpoint of me, a twenty-four-year-old. Yes, I am hostile to women. So he admitted it, but the guys didn't want to admit it. In the underground, at times, I was the sole woman voicing her opinions about this, and I was very alone. I could have backed down, but I couldn't back down. The result was that I really was not accepted.

I went to San Francisco in December of 1969. In San Francisco it became really, really clear that I was not welcome in the comic scene—that's when it really showed. San Francisco was the Mecca of underground comix. A lot of underground comix were coming out of San Francisco at that point, and the guys would put together books and would just phone each other and say, "I'm putting out a comic. Do you want to contribute? You wanna do six pages? You wanna do eight pages?" But no one phoned me and asked me to contribute. It wasn't the publishers, it was the guys, because I would do things on my own for, like, *Yellow Dog*, which was this comix anthology. Don Schenker, who published *Yellow Dog*, had no problem . . . always published my work. It wasn't the publishers, it was the guys themselves that didn't include me in their scene.

Then I got a call from the *Tribe*, which was a newspaper in Berkeley, saying they needed an artist to come in and do illustrations for articles on paste-up night, you know, do the illustrations right there. And I just needed so badly to be published. At this point I was pregnant, and pregnant and all, I would take the bus to Berkeley. The papers were very irregular, so it wasn't like once a week. But it would be paste-up night and I'd take the bus in at night and be there until two in the morning doing art, for which they paid me the grand sum of twenty-five dollars, but that wasn't the point. The point was I needed to be needed. I needed someone to want to publish me.

So I worked for them [*Tribe*] for a while and then somebody showed me the first issue of *It Ain't Me, Babe* [newspaper]. I was so excited. It was the first women's liberation—I've been told by no less than Robin Morgan that it's the first women's liberation paper in America. Anyway, I found them and told them I'm a cartoonist and I want to work for you. I met them at a be-in in Golden Gate Park. I was wearing a t-shirt I had designed with a super-heroine on it that said, "Super Sister," and they loved the t-shirt and said, "Yes, come work for us."

East Village Other, vol. 4, no. 13 (1969). R. Crumb. Previous page spread, left: *Rat*, May 22–June 4, 1970. (By this time the all-women's collective that ran *Rat* had dropped *Subterranean News* from the title, discontinued the system of volumes and issue numbers, and were publishing biweekly.) Jane Alpert was a staff member at *Rat* who was arrested, along with three others, in November 1969 and charged with the bombing of several buildings in New York City. On May 4, 1970, Alpert and the other defendants pled down to a charge of conspiracy. Rather than wait for sentencing she jumped bail and went underground. She may have left the water running.
Previous page spread, right: *San Francisco Express Times*, vol. 2, no. 7 (1969). Jean Raisler photo of the women's liberation picket line outside the KYA Bridal Fair on top of Nob Hill in San Francisco.

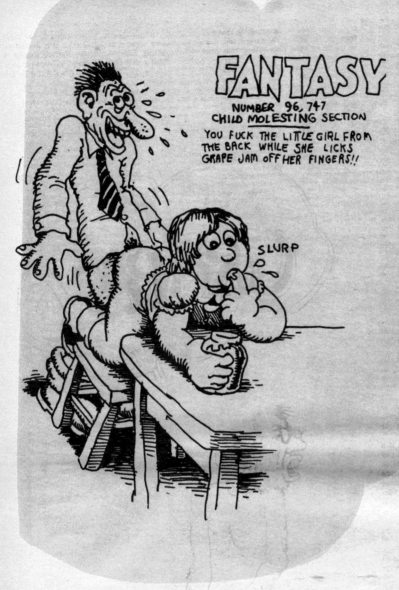

Last week, New York's Republican Senator Jacobs Javits embarked on a new crusade. Together with twelve medical school deans, he announced the formation of a select committee to look into possible instances of hunger in the Empire State. In announcing the program, Javits confidently predicted that only isolated instances of malnutrition would be found because of what he termed "the State's efficient welfare program."

To tens of thousands of New York's migrant farm workers, the Senator's pious pronouncements must seem like a pathetic joke. For hunger and the other manifestations of poverty are are daily facts of life in the rural communities of Long Island and upstate New York.

Typical of these communities is Fredonia, a small town of 8,000. Located some 40 miles southeast of Buffalo, the town is a study in paradox. The progressive Grange movement was born here. But the town is also the center of one of the most primitive forms of exploitation to be found in the United States, the migrant system.

Just outside Fredonia, there is a large chicken coop that a farmer decided was unsafe for his poultry. He moved out his chickens and without substantially altering the construction, made the coop into living quarters for 400 migrant farm workers. Its walls are still covered with chicken shit.

Four hundred men, women and children live in small 9 foot by 9 foot cubbyholes that are separated by plywood wall dividers and loose electrical wiring. The six showers on the first floor are considered a great luxury by the 400 people who use them. No one really seems to mind the fact that the water pipes run through the building's sewage. A family of four will pay $60.00 per week for the privilege of living in the coops, and eating a diet that consists largely of rice and beans. In Fredonia values are clear: chicken are better cared for than human beings.

Every year nearly 6,000 Puerto Rican and Negro workers journey here in the hope of finding jobs and decent wages. What they find instead are migrant camps with conditions

similar to those of the chicken co____ stoop labor that permits them t___ $200 or $300 at the end of a six m___ season. They are the harvesters o___ grapes of wrath.

I first came to Fredonia at the ___ student group that had been v___ some of the area's grape picke___ spent a summer attempting to ge___ ices for the migrants and helping ___ ing an embryo union. While th___ successful in starting the union, ___ ceed in getting some health care f___ ers and even managed to have on___ horrible migrant camp condemned. ___ hoped that I might be able to w___ on the migrant situation because ___ seems to care how they live."

Wages for most of Chatauqua C___ workers were not regulated by a___ wage law. As a result most migra___ in the area of 50c an hour.

Hours were long — 12 hours a d___ en days a week. The farmers fou___ vices to separate the grape-picke___ meager paychecks. A migrant ___ quired to live on the farmer's pro___ to have the privilege of working ___ and board were charged, and the ___ make a healthy profit by collectir___ per week for $2 worth of rice a___

Hunger could be seen everywh___ children filled their bellies with p___ and coffee grinds.

The farmers of Chatauqua Cou___ old men. To make certain that t___ don't break camp before the harve___ devised a "bonus system." Sim___ "bonus," is a portion of a farm w___ fully earned wages. The grower, h___ onto these wages until the end ___ season. If the worker lasts the s___ lects his "bonus." If not, well, to___ case, a grape-picker worked the se___ but his bonus was forfieted whe___ an appendicitis attack two days b___ of the harvest. Although the ___ needed his money to pay medical ___ mer refused to pay. "Rules are ru___

Child labor is also a fact of lif___ and it is commonplace to see chi___ the fields. Schools for the migra___ not exist. The children have ___ adept at picking strawberries an___ of the area's alternate crops. ___ necessary to help a family eke ou___

New York State and Commonw___ to Rico agencies are allegedly r___ the inspection of migrant camp ___ wages. But few migrants in Frede___ seen an inspector and the cam___ decades of neglect. One migrant le___ ed that the state agencies worl___ with the farmers. He pointed to a ___ from a New York State Emplo___ that stated; "Jobs on farms: wag___ Good housing is available." "The ___ cheap labor," the migrant leade___ of them sit on state migrant co___ tell the state to put up posters ___ come here thinking they can m___ living. When they get here they___ truth.

Two years ago, a Bronx born m___ Tresjan, began to organize her ___ workers into a union. A farm wo___ than ten years, she had read ab___ ses of the United Farm Worke___ Committee in California and was ___ velop a similar organization in ___ first, things went slow. Many mig___ timidated by farmers. The stue___ with the union were threatened ___ However, when two men were bu___ in the former tractor shed in wh___

THE PLEASURE IS OURS, FOLKS!

WE REALLY *LIKE* DRAWING DIRTY CAR-
TOONS! IT HELPS US GET RID OF PENT-UP ANX-
IETIES AND REPRESSIONS AND ALL THAT KINDA
STUFF... WE HOPE **YOU** ENJOY LOOKIN' AT
'EM AS MUCH AS WE ENJOY DRAWIN' EM !!

"WHAT THIS WORLD NEEDS IS MORE SATISFIED CUSTOMERS!"

I left the *Tribe* on friendly terms. Then I started, still pregnant, taking the bus into Berkeley to work on layout and art for *It Ain't Me, Babe*, and doing that comic, *The Adventures of Belinda Berkeley*, which was extremely simplistic propaganda.

After I had been doing stuff for them for a while I thought, "Well, we can do a comic book." I could never have done it myself, my self-esteem was very badly damaged by the fact that I was being excluded by the guys. I needed moral support and I got that from the women at *It Ain't Me, Babe*. I had spoken already with the Print Mint, who were really nice to me and who liked me, and they were interested in publishing a women's liberation comic. Ron Turner had put out his first comic book called *Slow Death*, and it was a perfect example of me being left out, because Ron, he didn't know anything about comics. He didn't know who were the comics people, so he simply told Gary Arlington (who ran this comic book store that carried all the undergrounds and where the underground guys used to all hang out), "Can you get together a bunch of cartoonists for me, for this ecological comic I want to do?" So Gary invited all the guys in the Bay Area, and of course did not invite me. This was classic. This was exactly an example of how I was left out. But then I heard, somehow the news reached me, that Ron Turner was interested in doing a women's liberation book. At that point I had put the whole book together. I had managed to find women to draw comics. The only two women who were really working on comics in the Bay Area were me and Willy Mendes. Both of us had come from New York, both of us had contributed to *Gothic Blimp Works*, and both of us were in a similar situation

where the guys were not publishing us. So she and I did the largest part of the book. She did, I think, the first story, an eight-page story, and the back cover. I did the front cover and two stories inside, and then I found women to do other stuff—and they were good. We got them to do a good job. So I had the whole book in hand when I heard Ron wanted to do a women's liberation comic. I called him and said, "I hear you want to do a women's liberation comic. I have an entire book right here that I've put together." And he came right over. He came right over with a check for $1,000, which in those days was a huge sum. This is something I've never forgotten and never will forget, what Ron did for me and what that meant for me and how that gave me the emotional strength and the self-esteem to carry on. And later, when the book came out, Don Schenker asked me why I hadn't given it to him, and I answered him quite honestly. I said, "Well, Ron came right over with a check for $1,000." It was as simple as that. That's why Ron got the book and not the Print Mint.

It Ain't Me Babe Comix, no. 1 (1970). "The second book I published was called *It Ain't Me Babe*, and Trina Robbins was the editor of that. We made it the first all-women's comic book. The first printing was twenty thousand, and then we printed another ten, and we changed the color of the cover a little bit. By the standards back then, it was a success for publishing. These days you'd be lucky to sell five thousand of something." —Ron Turner.
Previous page spread, left: *Snatch*, no. 2 (1969). R. Crumb.
Previous page spread, right: *It Ain't Me, Babe*, vol. 1, no. 7 (1970).

SPAIN RODRIGUEZ
Zodiac Mindwarp, East Village Other, Gothic Blimp Works

Well, Walter Bowart was a businessman, and his vision of the *East Village Other* was more toward a kind of psychedelic and mystical direction. At some point he married Peggy Hitchcock (who is part of the Mellon fortune, which is one of the five biggest fortunes in America) and just disappeared. He just went down to Arizona. So basically we were keeping the paper together. He might have left us for dead, but we weren't about to die. The political stuff came more to the fore [in the paper], and also the war in Viet Nam was escalating. All this radical stuff was going on, and it was just hard to avoid—even if he'd been around. At some point he comes back, and he was trying to replace us with another team, and so he brought in all these people. A lot of them were people we knew and they didn't want to see us tossed out. So he had a kind of initial problem.

Joel Fabricant, who unfortunately died and who was a really good guy . . . if you were in a fight you'd want to have Joel next to you—I miss his ass. So, you know, Joel was running things and this period of weeks goes by. [Eventually] Joel says, "Listen, what we could do is we could try to get a majority of the stock. On the other hand, what we could do is get some money together and have him bumped off." And these are all hippies, this was 1968 or something, and every hand goes in their wallet and every hand comes out with every last buck they had. Everyone wanted to bump him off, right? All these people are kind of a little nuts, it's the *East Village Other*, there's all

these drugs, and all this stuff going on. But the thing is, when Walter was there it was hard to be confrontational with him because he was just such a charming guy.

During paste-up night—which was when everyone got together and you had to get the paper out by seven o'clock and send it down to the printer down in New Jersey—everyone is kissing his ass. I went to the bathroom wall and I did this cartoon image of everyone down on all fours in a praise Allah position with Walter kind of prancing over everyone. He comes in while I'm doing this, and I just looked at him and signed it. And then he just did this cartoon of me, because he was a real good artist, and I was real fat with a hammer and sickle and I was saying, "America sucks, Russia's great," which I never said, actually, and then I had a really small dick, which he was no authority on my dick, but it was kind of like a cheap shot. With this everybody started writing on the wall and making these personal attacks on the guy, and the wall quickly filled up.

Then the Up Against the Wall/ Motherfuckers came up to me and said, "Hey, you need any help?" And I said, "Not right now, but stand by." So finally I said to Joel, "Tell him, 'Listen, man, we'll make a deal with you. You can get out now with your ass, otherwise the Up Against the Wall/Motherfuckers are going to be looking for you. And the guys are gonna mug you if you go in the backroom. And I'm gonna call the Road Vultures.'" We were all just stoned-out hippies. It never dawned on us that we would get into anything physical. We liked him, we just wanted him to treat us right. I mean, we kept his paper together over more than a year and so him

basically booting us out seemed unfair.

The next week it was kind of the same thing, everyone was kissing his ass. Then he calls me and Kim Deitch into the room. I didn't have much of an appetite for having another confrontation, but if that's what I had to do, I had to do it. But Kim Deitch, who is a true gentleman, says, "Listen, Walter, I don't think very much of you for what you're doing." He runs the case down, "You know, we've kept this paper together, now you're gonna boot us out? What the fuck? That's not right, man. We're your friends." So he just laid it out, much better than I could have. And Walter said, "OK, here's the deal." We were living at the *East Village Other*. We were going to move into the *East Village Other* loft, which was on Second Street upstairs of two Puerto Rican social clubs (and that was a whole other adventure), and we were getting fifty bucks a week and that would go down to forty dollars a week because we were [going to be] getting free rent. It was a good deal for us.

Later on I heard from a bunch of people, and I heard this from Walter too, that Walter had all these Gulf Oil guys (Peggy Hitchcock was connected to Gulf Oil) look at the situation at the *East Village Other*, and they told him, "Get the fuck out of there. There's all this weird shit, all this drug shit going on there. Get the fuck out of there." So, you know, as it was it worked out, he just had a different vision. I don't know what could've happened. I miss him, we just had this quasi-confrontational relationship but, you know, this was the newspaper of record on the Lower East Side.

ART KUNKIN
Los Angeles Free Press

I had many adventures keeping the thing going, but I survived for ten years. The reason I went bankrupt was that the paper kept on being profitable but there was . . . I had published a list of all the narcotics agents in California with their home addresses, and the state of California sued me for $25 million. The attorney in that case was Ron George, who's just retiring as head of the California Supreme Court. They put their best attorney on the job to prosecute me in the $25 million case. So anyway, they got to my printer and told my printer they were going to make him a part of my lawsuit unless he wouldn't print my paper (it was a totally illegal deal), and the printer gave me a month's notice. He agreed to print four more issues but said I would have to get another printer. This was in 1969. So I'm looking to see if I can print in Berkeley and bring the paper down here [Los Angeles] by train, and then I heard of a pornographer, a guy named Marvin Miller, who was going out of business. He had a huge newspaper printing plant and was moving his operation into film, and the printing plant was closed. So I called him up—I discovered he was a subscriber too; I had his home address. There's a famous pornography case in California, which is *Miller vs. California*, and this is the guy that I was meeting with. He has this estate out in City of Industry, I drive out there, and we meet in his kitchen and there's a tank full of piranha, meat-eating fish. It was a whole tone of, you know, something very strange. So I tell him my story and he had seen me on television the night

before debating the police, the former chief of police, [Ed] Davis. So, to this pornographer I was a hero, and so he pulled his keys out of his pocket, a big ring of keys, and he said, "These are the keys to my printing plant. There's paper in the plant, here's the name of the foreman and he'll get you a crew together. Go there and print your paper this week, and we'll sit down next week to work out the details." So I did that.

The next week I sat down with him and his lawyers and my lawyers and I did a lease-option on the plant—I would operate it for three months at a lease figure (by this time my printing bill was $5,000 a week, so I had money to play with). So I leased it for three months and then eventually bought it. Then I went to England and I bought the latest newspaper printing press from Morgenthaler, one of the biggest manufacturers of printing presses in the world. I went there and ordered it right on the shop floor. It was a quarter million dollar press and I moved it to the City of Industry on top of this other press (the building was big enough for both presses), and I had one of the largest newspaper printing operations in the country. It was, I think, number twenty in the country. I was operating it seven days a week, twenty-four hours, three shifts. I had fifty people working there, printing the *Free Press* and printing a lot of other newspapers and shoppers and so forth. But the press didn't work! The three installations in this country all went bankrupt because the press was just bad. I mean, this huge thing, it stands twenty feet high, and the castings on it would break and the ink system wouldn't work. It was like the press I had bought from Marvin Miller but it was twice the

size. It doubled everything so that each unit, instead of printing eight pages, would print sixteen tabloid pages and had these huge rolls of paper running through the machine.

So the printing plant went bankrupt, and I had put the stock of the *Free Press* up to buy the printing plant. Marvin Miller took the thing over and retained me as editor—I was still running it. Meanwhile, I was planning on going into bankruptcy over the printing plant and I couldn't talk to people about it because I was negotiating with the Internal Revenue Service. So the staff began planning their own paper, and the night that they broke away from me they came to me and wanted me to edit their paper. It wasn't anything personal against me, they felt that I was up to my ears and I wasn't able to control things. I had my obligations to Miller and to other creditors (by this time I owed big bucks), and I had to make a decision to go with the staff or to go with Miller and repay my debt. I didn't trust the staff. Eventually what happened with their paper [*The Staff*] was they put all their money into a drug deal that didn't work, and they fell apart. I had kind of anticipated that scene, so I continued with Miller. Then Miller went to jail . . . this story goes on and on, and he sold the paper to two pornographers from San Diego with the proviso that I continue as editor. There was constant conflict between me and them, and the week that they made their last payment to Miller they fired me, and I was out on the streets.

Eventually the paper got into the hands of Larry Flynt. When Flynt was recovering from being shot, I went to him (and his wife meanwhile had closed the *Free Press*) and spoke with him, and

he gave me the name back. So in the eighties he gave me the name back, and in the nineties I've made several attempts to revive it, but they haven't worked.

JUDY GUMBO ALBERT
Berkeley Barb, Berkeley Tribe

Max [Scheer], sadly, ended up pretty much a pathological miser—he was that tight with money. Max paid his reporters twenty-five cents a column inch, with the result that every single person who wrote for the *Barb* tried to stuff as many words as possible into what they were writing, which did not lead to what you might call "quality journalism." I must have made two dollars a week, or maybe three dollars, for my two days work on the sex ads. I think Max paid his staff, the editors, thirty-five dollars a week. It was very, very low—deliberately low— wages. One of the reasons that we, the *Barb* staff, went on strike was . . . we went on strike for higher wages. The *Barb* strike happened right after People's Park, so we were all riled up. The park had been destroyed—there were fences around the park. So, essentially, we took our anger at the defeat of People's Park out on Max. The rumor around the *Barb* office was that he was bringing in—in profit, in net—$300,000 a year. Now, was that true? Who knows? We believed he was bringing in $300,000 a year while he was paying us twenty-five cents a column inch, or two dollars for two days' work, and he wasn't giving Jane money for food. So when you add these things up they really come to show a man who was a little . . . I'll just say this and then go back to the *Barb* story: Jane eventually divorced Max, sued him for palimony because she had made

enormous contributions to the *Barb*. She lost. It was before women were winning palimony suits. In revenge, Max cut the two children he had with Jane out of his will. He hid his money in Aruba. So that was Max.

It took a while for me to understand this. When I worked with Max he was very genial, he could be very warm and open and interesting. He looked like a Hasidic Jew gone bad. But he had real problems. When the *Barb* staff went on strike, Max decided to sell. Sell the *Barb*. By then, Stew and I were living in a house on Ashby Avenue, along with Tom Hayden (except Tom is basically not there because he's living with his then-girlfriend Anne Weills). Max tells us that Tim Leary wants to buy the *Barb*, so we set up a meeting with Leary in our living room. So there we are, all the *Barb* staffers, maybe thirty of us, and Leary walks in with this guy Billy Hitchcock, a scion of the Mellon banking family. Leary makes my skin crawl, with the ponytail, the necklace, the supercilious smile and the "I'm the great Tim Leary. Turn on, tune in, drop out." Leary was about to run for governor of California and we, the *Barb* staff, feared Leary wanted to buy the *Barb* to promote his "Love for Guv" campaign. We were afraid he'd change the *Barb*'s militant politics. We did not want that. Leary starts out trying to impress us. He says, "I'll do whatever you want. You can have access to the books. You can write whatever articles you want." In my opinion, he was shining us on. He said, "The police and the demonstrators are going to give flowers to each other. It's all going to be peace and love and good

Following page spread, left: *Berkeley Tribe*, vol. 1, no. 1 (1969). The Tribe gathers.
Following page spread, right: *Berkeley Barb*, vol. 9, no. 2 (1969). Max reacts.

Barb on strike

VOL. 1 ISSUE 1 JULY 11-17, 1969
526-8945 , BERKELEY, CA.

15¢ BAY AREA 25c ELSEWHERE

'MAX IS A PIG'

Berkeley Barb

VOL. 9, NO. 2 ,ISSUE 204 July 11, 1969 PUBLISHED WEEKLY 204 **15c BAY AREA** **25c ELSEWHERE**
2042 UNIVERSITY AVE., BERKELEY, CA. 94704, 849-1040

They ask for debate

+ then they gag you

As BARB goes to press, the printing plant is being picketed by 2 to seven persons for the Red Mountain Tribe.

This plant is 100% union. The union which represents the plant's workers told the Red Mountain Tribe it cannot recognize the validity of their picket line. The picket line outside the printing plant is an illegal secondary boycott.

The work being done on the Red Mountain Tribe's so-called strike edition is being done by scab labor, on a press that has given only lip-service to the legitimate printers' union, according to people who should know.

There is no labor dispute between the Red Mountain Tribe and the Barb, by the Tribe's own admission.

The Tribe has admitted publicly, in print, that what it is trying to do is take over the BARB. They are trying to force the Barb's owner to sign a contract to sell the BARB to them - - a contract unlike the one negotiated for 10 days but never signed by them. They presented THEIR contract not for negotiation but as an ultimatum.

The word from the Tribe was SIGN OR ELSE.

What the Tribe is doing smacks of pure blackmail.

It may be that one man cannot resist a gang determined to destroy him. It may be that you, the public, will never hear this small voice except when it is too late for you to come to the aid of the true BARB.

It may not even matter.

I make this appeal for you to try to understand the unspoken words, words that lie heavy on a man's heart when he knows he is RIGHT, even though MIGHT is opposed to him.

This is an age when a small group appears to be a mass. Do not let them fool you.

This Tribe has offered to debate the issue publicly, yet they are trying to prevent me from printing my side of the story in my own paper.

Let their actions speak for them. *Max the Pig*

vibes." Then out of the blue Leary asks, "What's your position on guns?" In those times, primarily because of the influence of the Black Panthers, all of us were into self-defense. So Stew, right, he reaches under some cushions and pulls out a .30-06 rifle that we have. He holds it like this [raises hands above her head] and he says, "Here's our position on guns. We've got 'em and we'll use 'em." It was completely spontaneous. Total Yippie theater. Leary and Hitchcock turn white, stand up, and leave. There goes Max's *Barb* sale.

Then we enter into negotiations with Max to buy the paper. Max wants us to put up some security, some backing, which would be perfectly reasonable today, except that in 1969 most of us on the *Barb*, you know, what assets have we got? The clothes on our back and the .30-06, that's what we've got. A few of the *Barb* staff, however, did own property and they, quite understandably, did not want to risk it. So we all go out on strike. Max changes the locks—locks us out— then that's when we put out the "*Barb* on Strike" issue, and Max puts out the "Max is a Pig" issue. Max's front cover was way more exciting than ours, I must admit.

ABE PECK
Seed, Rat Subterranean News

As things really accelerated, especially after the 1968 convention, the office became almost the revolution-of-the-month club, where things would happen so fast. After the convention we got much more militant, of course, so that office became a real hub of activity. We also let the Black Panthers use our light table. More militant people were coming in, so we were having all kinds of

influences on it. Mike [James] came in, before *Rising Up Angry* started, and gave me a speech. He tried to organize me. He held up my hand and made a "V" with it and said, "This is where we're at." Then he made my hand into a fist and said, "This is where we're going." So we had that kind of stuff.

We moved after our windows got shot out and stuff. It was probably time to go. We moved up to a couple offices: one on Halsted Street and then one on Wrightwood. The *Seed*, at that point, was selling a lot of papers, so we had a little bit more resources than some [other] papers. A couple of things changed. I think the *Seed* had more women working on it. We had also merged with *Chicago Kaleidoscope* (which was an offshoot of *Milwaukee Kaleidoscope*) that was a little more militant. It was strange because the people who were the most militant, who we merged with, six months later were living on a farm in Wisconsin. They had said, "No, I don't like these politics."

The original *Seed* was edited by a woman, then it got more male, then it was more gender integrated. As the rise of the feminist movement happened, we went away from an editor hierarchy, so we had rotating editors, we had rotating responsibilities, and, you know, it had all the pros and cons of that. The pros were that people were getting trained; people felt empowered. The cons were that not everyone was as good at everything as other people, and it just kind of got hard to put the paper out. And things really were happening fast. I mean, we had one issue that had a special section in it, and there were so many things happening then it was probably the only time these two groups have been together in print. It was the Gay Liberation and American

RISING UP ANGRY

EARLY SUMMER 1970 25 cents VOL. 1 NO. 10

TO LOVE WE MUST FIGHT

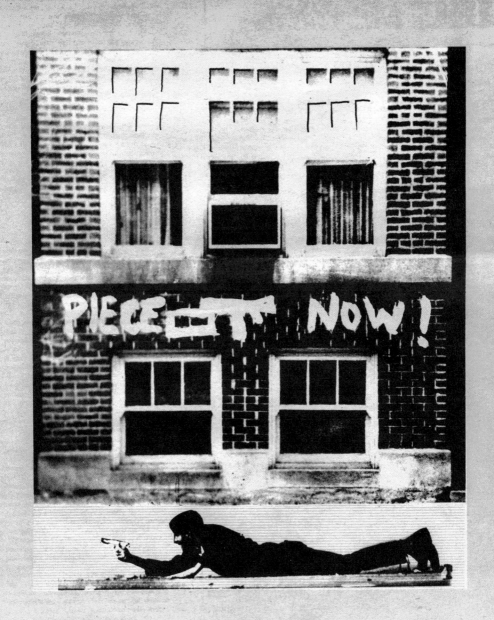

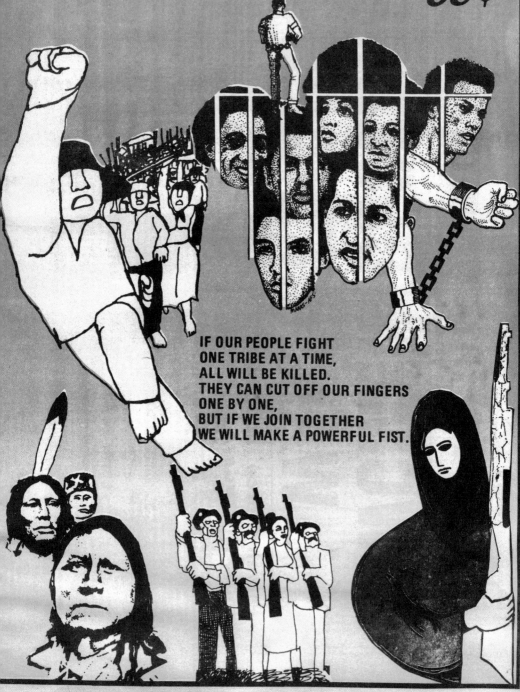

SEED
chicago

vol. 8
no. 9
35¢

IF OUR PEOPLE FIGHT
ONE TRIBE AT A TIME,
ALL WILL BE KILLED.
THEY CAN CUT OFF OUR FINGERS
ONE BY ONE,
BUT IF WE JOIN TOGETHER
WE WILL MAKE A POWERFUL FIST.

Indian supplement. There was this kind of weird agglomeration of things happening so fast that we were literally shoveling groups together in the paper.

HARVEY WASSERMAN
Liberation News Service

LNS became very, very popular. We had, I don't know, four or five hundred subscribers around the U.S. and people used our stuff. On the left we were a major force, but we were just a ragtag bunch of hippies. When I would come to D.C., I would stay at the same house we stayed at during the Pentagon march, and I'd go in and write articles and type them up and deal with the mailings and stuff. I'll never forget one time . . . it was in the middle of winter and I walked into Marshall's office. He was sitting behind his desk, and he didn't have a shirt on and, well, that was all right, the heat was up. We talked for a while. Then he got up, and he didn't have any clothes on at all. He was totally out there. When the riots happened in Washington (Marshall, when he was in Europe, had actually gone to Morocco, and he had this djellaba, this long woven robe that he wore) he dropped acid and went walking through the ghetto in this Moroccan robe with this wild, crazy hair. I can't imagine how people reacted to him walking down the street like that, but he wasn't harmed, thank God.

So we ran the news service, it was incredibly successful, but Marshall got incredibly burnt-out just trying to raise money day after day. Not that it took a lot of money—the news service was a really low-budget operation—but we had nothing. A hundred dollars is a lot of money when you've got nothing. Finally, when the takeover occurred at Columbia, Marshall said, "Let's move to New York. Maybe we'll be able to raise money." So we moved up to New York, but when we got there, there was a whole other crew of people waiting to take over the news service. By then I was out of graduate school, and my plan was to come to New York and be full time at the news service. I got a teaching job. I was going to teach elementary school in New York and be at the news service (I had to teach elementary school to stay out of the draft). That was my plan.

We had this tight little group— Marshall, me, Raymond, Veranda and a few other people—that we were really close to. And I've seen this many, many times in any group, you start off with a small core and people are on each other's wavelength, personally and politically, you all think the same way, as Marshall, Ray, and I did, and there's no decision-making problem. It's a family situation, really. When we were in Washington we never had editorial meetings. Anybody in our little group who wanted to put

Fag Rag, no. 5 (1973). Photo of Marshall Bloom by Peter Simon. Illustration reprinted from *Home Comfort: Stories and Scenes of Life on Total Loss Farm* (Saturday Review Press, 1973). Opposing page: *Seed*, vol. 8, no. 9 (1972).

out an article, put it out. We all loved each other's stuff; I never remember reading anything that Marshall or Ray wrote that I didn't think was fantastic, and they were the same way toward my stuff. We really were just all on the same page. Then when we got to New York, suddenly, we were the victims of our own success. Other people wanted to come in and we didn't necessarily see eye-to-eye. The group in New York wanted to have editorial meetings to decide what was going to go in the news service. Our feeling was: we're not a newspaper, we're a news service; we're putting stuff out there and if the editors want to run it that's up to them. Why beat our heads against each other here deciding what's going to run? We wanted a news service where we just put stuff out and didn't have to argue about anything. Marshall, Raymond, and I, I suppose, we had disagreements, but it was family. We just did what we did and we got along beautifully. It was a magical time for us. And that word "magic" was used because somehow everything was impossible, all the situations we confronted were impossible, and somehow we got through them.

They wanted to throw us out. Basically, they wanted to throw Marshall out. Marshall was gay-baited—even though he was not officially gay. Marshall never, to my knowledge, came out and said publically, "I'm a homosexual." That never happened, to my knowledge. And the term "gay"? I don't even remember it being used at the time. But there were some really, really ugly moments. We started having these meetings to work things out. It's like a marriage, when you start having meetings you know you're in trouble. So we start having these meetings with

thirty, forty people (many of whom we didn't know because we had no structure, anybody could walk in off the street— and did—and become part of the news service). So from one week to the next we're having people at these meetings we've never seen before, and suddenly Marshall's sexuality was an issue—which was ridiculous, absolutely ridiculous. It was incongruous and just plain offensive and wrong.

We're having these meetings and they're very hot. It's in this basement and people are not liking each other. We were definitely, by the way, infiltrated by the FBI; there is absolutely no doubt about it. This is a conspiracy theory that's true. The documents came out in the seventies through the Freedom of Information Act. There was a wonderful journalist named Angus Mackenzie who wrote about it. It was part of COINTELPRO, and their mission was not to spy on the news service; their mission was to destroy the news service. This is what they were about. An agenda item on the FBI's COINTEL operation was to destroy the Liberation News Service. I don't know who the people were. To this day we don't know who they were, but there were definitely FBI agents in those meetings.

What happened finally—it became very clear, I mean, we weren't stupid—it became clear this was not going to work out, and that if they couldn't get rid of Marshall, they were going to make it impossible for him to function. Then we had a vote, and they decided we would have editorial meetings, and these editorial meetings would decide what was going to run in the news service. Now, that was not going to happen in my world. I was not about to sit in some basement in New York City and have a

group meeting decide whether or not my articles were going to go on the fucking mimeograph machine. And certainly Raymond wasn't going to do that, and certainly Marshall wasn't going to do that. We believed in divine anarchy. We believed that whoever was part of the group, you want to put something out there, put it out. Suddenly we were confronting the idea of a party line. And, you know, we had a party, not a party line.

As it turned out, somewhere along the way, for tax purposes, Marshall had incorporated the news service, and the board of directors was Marshall, Raymond, me, and Allen Young. Allen Young had been a mainstream journalist and then came over to the bright side, the antiwar side, and was a very good writer. At the time, he was in Bulgaria, at some conference, and so with Allen gone, the board of directors was the three of us. And then, in the middle of one of the meetings in New York, I'll never forget this, Marshall just rolled his eyes and called me and Ray over. We went into a room and had a board of directors' meeting, which was completely legal, and decided to move the news service. Of course we didn't tell anybody else— well, we didn't tell that meeting. We had a little cabal, and we started having secret meetings at an apartment around the corner. Along the way, Marshall got the infamous idea of moving the news service without the other group. And it was perfectly legal. Today, technically, it would be known as a hostile insider takeover.

What happened in the interim in New York is that Steve Diamond, who had not been a member of the original group but was on our side secretly, was believed to be neutral but was on our

ONLY EAST COAST SHOWING
LIBERATION NEWS SERVICE BENEFIT
The BEATLES
MAGICAL MYSTERY TOUR
SUN. AUG. 11 **2 SHOWS 8 & 10:00 PM**
FILLMORE EAST
2ND AVE & 6TH ST
TICKETS $3, $4, $5 **BOX OFFICE OPEN**
 DAILY 1:30-7:00 PM
(BENEFIT TICKETS AT $10 & $25 FOR 10:00
SHOW & COCKTAIL PARTY)
ALSO: UNDERGROUND NEWSREEL

side, loved Marshall and the whole romance of the deal. He was a great guy, Stevie. He just passed away a year or two ago. He got the idea that we should ask the Beatles for this new movie they'd made, *Magical Mystery Tour*, to show as a benefit at the Fillmore East. It was such a longshot, but Stevie happened to know their New York agent, Nat Weiss. He got a meeting with Nat Weiss and went in there and talked about this idea of using that film, and Nat said, "Well, let's call the Beatles and ask them." He called George Harrison and got him on the speaker-phone, and Stevie made the case, and George said sure. So the next thing you know, we have the *Magical Mystery Tour*, thanks to George Harrison.

These flyers went around the city, three, four, five dollars to come see *Magical Mystery* at the Fillmore East. Of course, tickets sold instantly, and within a matter of days we had $5,000 in cash, and Stevie was in charge of the money. So Stevie and Marshall hopped in Marshall's Triumph, his little Spitfire, and they drove up to Amherst because Marshall had gone to school there and knew the area. So they had five grand

and they found this farm, Montague Farm, for $26,000. Marshall took the five grand, he found a suit somewhere and went into the Amherst Savings Bank and got a mortgage. The only reason they gave him a mortgage was because he had been to Amherst College. He didn't have gainful employment or anything like that. I don't know how he pulled it off, but things were a little looser back then.

We probably had another meeting or two, but by then we knew what was going to happen. On August 11, they (whoever they were, the other side) went to the beach and we, this was a Sunday, went into the office and cleaned it out. We took everything out of the office and put it on a U-Haul truck and sent it up to Massachusetts. I didn't go because I had the teaching job and I wanted to stay in New York that year, but I wrote from New York for the news service. That night I stayed at a friend's house. I stayed at the house of Peter Simon and we went to a movie that night. If the other side had known what we had done, they would have beaten the crap out of me. Thankfully they didn't know. It was all very surreal. I was actually the last one out of the office that morning and I put Duco cement in the lock. I think they had to take the door off to get into the news service the next morning.

They found out where the farm was and they went up there to try and get the press back. They held everybody hostage for the night, but Marshall had moved the press somewhere else. It was not pretty. Marshall filed kidnapping charges, which was a mistake. It was not a great entry, not a real quiet, graceful entry into Montague, Massachusetts. There was suddenly this sleepy town in

Western Massachusetts with a bunch of hippies who are in court with kidnapping charges and doing a radical news service. I mean, geez, that must have really blown their minds up there.

I went up periodically from New York. I wrote stuff from New York, then I moved up there in 1969, and then Marshall committed suicide on November 1. We tried to do the news service out of the farm with the same mimeo machine, but the goddamned thing froze. We had no idea what we were doing, the place was uninsulated. We were a bunch of city kids trying to run wood stoves; it was a disaster. There was frost inside the windows . . . it must have been 40 degrees inside the house if you were lucky. It was pretty rough those first couple years. The news service did not survive at the farm. It was just too hard; we were too isolated. The physical challenges were too great. The postmaster in Montague was extremely hostile, did not like doing the mailings, didn't want to have anything to do with the farm and didn't want to be mailing this stuff out.

They restarted the news service in New York, they reconstituted it. For the first year or so it was very shrill, very sort of doctrinaire left, but after the first year or so the personnel changed. Allen Young became one of the leaders and the news service in New York reverted to form and became very much like the original news service. There was a lot of drugs, sex, and rock 'n' roll. As a matter of fact, I think later they ran some of my stuff from time to time. It actually had a tremendously great outcome because the news service in New York was more than

Liberation News Service, no. 117 (1968). One of the few LNS packets that came out of the farm in Montague, Massachusetts.

LNS LOVES YOU!

LIBERATION NEWS SERVICE
of the New Age
The New Media Project, Inc.

Chestnut hill Road, Box 269, RFD #1, Montague, Mass. 01351 • (413) 367-2073

APPLICATION TC MAIL AT
SECOND CLASS RATI PENDINC AT
MONTAGUE, MASSACHUSETTS 0135

the new age

acceptable. It was actually very good for the next ten years.

Our news service disappeared, but we got into organic farming. Living on Montague Farm was paradise—it was incredibly beautiful there. We developed a wonderful community there, and many other communes came into the area. And then, in 1973, the local utility company announced that they were going to build a nuclear plant four miles from our house. This was completely out of right field for us. Here this power company comes into this little backwater town in rural Massachusetts thinking they're going to have a cakewalk building this nuclear plant, and they run smack into a commune of antiwar, organic farming, hippie activists, and we just kicked their butts. They didn't know what hit them. So the great irony is that here's this Liberation News Service infiltrated by the FBI, split in part by the FBI, and it results in a hippie farm that gives birth to the antinuclear movement. You know, I sometimes like to say that J. Edgar Hoover was the godfather of the antinuclear movement, and I hope it makes him spin in his grave.

ALLEN YOUNG
Liberation News Service, Gay Sunshine, Gay Flames

Marshall and Ray epitomized disorganization. They were very anarchistic in their approach, and I think people wanted it to change. While we were working and getting out the packets, there was also this conflict that developed.

There was a lot of tension in the meetings, and I have some misgivings about the stance that was taken, that we needed to have political review of articles. The earlier LNS did kind of serve as an open market for articles. There was really no attempt to develop a political position. The point of view was very broad and included a very strong pacifist element, and I think at this particular time, especially due to the influence of SDS, which was romanticizing third-world revolutionary movements (Cuba as well as Viet Nam, even North Korea), there was a pressure from the more left-wing side, the Marxist side, to develop a political line. I think that really went against the grain for people on the other side who wanted to be more freewheeling. I have some regrets about how LNS evolved, as far as its insistence on supporting this concept of armed struggle in the third world and militancy. I have some different views now than I did at that particular time, but I can understand why there was a division there; there were some real reasons for it. Our side was right in insisting on a more organized and collective kind of structure, but I think the other side was right in wanting things to be a little more loose, as well, especially when it comes to allowing for some political diversity. We didn't favor political diversity; we favored some kind of correct line. We didn't use the term political correctness in those days, but we did talk about good politics. Somebody's name would get mentioned, and somebody would say, "Well, does she have good politics? Does he have good politics?" I think that was unfortunate, it intimidated some people and didn't allow for as much diversity of ideas as it should have. So I think that was a big part of the split.

I took advantage of an opportunity to go to Europe, so during the actual split when they stole the presses and went off to the farm in Massachusetts, I was in Europe. It was the World Youth Festival, a big festival [that] was basically sponsored by the Soviet Union, largely a cultural event with some politics, and this one was in Sofia, Bulgaria. I thought maybe I can get a free trip. I was very good all through college and graduate school with getting free trips and free scholarships, so I pursued that. After the festival was over, a group of us had traveled by train all the way from Sofia to Moscow, and I think we spent a week or ten days in the Soviet Union.

When I left for Bulgaria I didn't think there was a point of no return; I thought that things would get worked out [at LNS]. After my time in Bulgaria and the Soviet Union I went to London and visited the *International Times*. I walked in and introduced myself and said I was from Liberation News Service.

The guy, I don't remember who I talked to, said, "Which one?" I think I froze because I knew right away that a split had taken place. In a sense, I knew. I hoped that it would be OK, but I wasn't surprised that a true split developed.

East Village Other, vol. 3, no. 39 (1968). The Montague crew. Photo by Gabriel Cooney.

THE east village OTHER

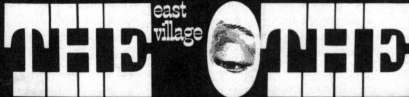

JUNE 3, 1967 20 cents outside N.Y. **15c**

"My God! My God!

Where is this happening? This is America!"

THE THINGS THAT WE WANTED TO DO WERE NOT WHAT THEY WANTED TO HAVE DONE

Repression

The beast bites back.

East Village Other, June 3, 1967. Extra!! Special issue of *East Village Other* dedicated to the Ninth Precinct's brutal breakup of what was a peaceful Memorial Day gathering in Tompkins Square Park, a harbinger of the coming repression. Cover photo by Phil Stiles.

FIRST AND BEST IN THE FIELD IT CREATED

SCREW

MORE PAGES

THE SEX REVIEW

NO. 33

75¢

EVEREADY DILDOS P. 9
FELLATIO FOR FUN AND PROFIT P. 10
GOD EXPOSED! P. 19

WARNING ADULT TYPE SEX MATERIAL

THIS LITERATURE IS NOT INTENDED FOR MINORS AND UNDER NO CIRCUMSTANCES ARE THEY TO VIEW IT, POSSESS IT, OR PLACE ORDERS FOR THE MERCHANDISE OFFERED HEREIN

TO THE NEWSDEALER: You are warned not to sell this newspaper to a minor. If you do it will be grounds for refusal to serve you with future issues. The Editors of this newspaper have made every effort to insure that the contents of this publication are not obscene or pornographic under the law, common sense, or contemporary standards of candor in sex. DO NOT PURCHASE SCREW IF YOU WANT PORNOGRAPHY!

AL GOLDSTEIN
Screw, Gay, Bitch, Gadget, Mobster Times, Cigar

In the early issues of *Screw* (which is 1969), the cops arrested my blind news dealers. I had just been arrested again, and I'm in the Tombs with blind news dealers whose canes are going across the cement floor, and I'm thinking I don't want these guys to know that I'm the reason they're here. The charges against them were dropped, but it was severe enough that a lot of my news dealers stopped carrying *Screw*. The harassment was unbelievable from the FBI and the Irish cops. Occasionally, you'd find a cop that'd say, "Go get 'em, Al, you're doing a good job." But we also had Catholicism, which was fucking me up because the Church was very powerful. Now with the harassment of children, the Church has lost its power; people spit on the Church. But when I started in 1968 it was a very powerful lobby, and it really hurt us. It's a good thing we had advertising money or we would have gone out of business.

But the cops were harassing us, and the Irish cops would basically say, "Jew bastard, we're gonna close you down." The more they said that the more I stood erect. What the government didn't realize was that every time I got arrested, when they said United States of America vs. Al Goldstein, I was so starved for attention and recognition that that encouraged me. If they'd only been quiet maybe I would have gotten bored, but every time they busted me it only made me say, "Fuck you." I'm so ornery and insane that I wouldn't accept it.

The Mafia was good. The Gallo brothers took me over on issue 12. The good thing about them is they hated the cops, too, so whenever I got arrested they didn't run, they continued to distribute *Screw*. I had a good Mafia gang; I liked them. Donald Gray was the officer that arrested me every other week, and I remember I had a little bag with a toothbrush and talcum powder and stuff. I felt like Jesus Christ carrying the cross. I said, "No one has given this to me, I earned it." And so on one hand I'm getting arrested twenty-one times, and on the other my distributors are Mafia and I'm dealing with Joe Gallo, who got shot, and I'm thinking my life is not easy. The cops want me to testify against the Mafia but I'm not going to. Just my belligerence in the face of all this adversity made me feel like I really deserved it. I don't walk around saying, "Thank you, thank you." I deserve every bit of fucking praise I get—I paid the price.

RON TURNER
Flagrante Delicto, Last Gasp

There was a press called Majestic Press up by Sacramento. We printed a color issue of *Young Lust* no. 3—I think we did a full color thing—and they didn't like the fact that they saw images that were nudes. So they refused. I think they destroyed our negatives or something like that. There was another press down in Riverside where we were printing things, too, that were kind of that way. Either some of their pressmen or some of the women on the lines in the binderies were offended by images.

They mostly tried to get people on pornography charges, not political charges, in the underground comix world. What you'd have to do to go to

Screw, no. 33 (1969).

a printer in those days, because you'd have to print stuff on web presses for the insides, was you'd go to them and say, "Do you have any objection to printing the word 'fuck'?" Warren Tipton had a press called Warren's [Waller] Press in San Francisco, and he got all the business for the underground papers because he didn't mind printing the word "fuck." Some of these guys, you'd think they were the bastions of freedom, but they were more like Libertarians than left-wingers. They were more like extreme right-wingers, a lot of these guys. They'd take the negatives and they'd have a special room in the back where they would use chemicals to drip out the silver content of the negatives, and they had little safes where they would show us their little bars of silver that they had collected. They would prefer silver coinage, in other words. They were something else.

THORNE DREYER
Rag, *Space City!*,
Liberation News Service

Rag and *Space City!* were in some ways similar but were also like night and day in difference because Austin and Houston were so different. Houston was all spread out, you know, there were antiwar people and there were rock 'n' rollers but there wasn't anything to pull them together. *Space City!* created a place where all these people could come together. *Space City!* generated all these counter-institutions (a food co-op, a drug crisis center, and a democratically run rock 'n' roll center called Of Our Own) so that it became this kind of center for this whole network, this community network of institutions. Houston was not

a right-wing city. It was a kind of laissez-faire city, but there was a lot of right-wing activity. The Ku Klux Klan and the Houston police [department] were created in the same East Texas town, so you had a lot of overlap. The entire left in Houston, not just the political left, was under siege from the Ku Klux Klan. I mean, our offices were shot up. My mother's art gallery was shot up, they threw paint on the front. They bombed KPFT, the Pacifica radio transmitters office . . . it was bombed off the air twice by the Klan. They shot up anybody who advertised in *Space City!* So we were facing all of that. But, in fact, it made the community tighter, it brought everybody together.

In Houston we had infiltration from the Klan. We had a famous incident. This kid started coming around and hanging out; his name was Mike Love. He seemed like just an odd fit, very kind of hicky. There were lots of people that got involved, but he just didn't seem to have any politics or any reason for being there other than he just started coming around. At the time the black movement became more militant, I think the Klan decided that we were an easier mark, so we were under assault. Well, we started suspecting him, and Cam Duncan and a couple people from the paper went to a Klan rally and saw Mike Love there in his sheet. So the next time he came to the office [they] confronted him. He started running, so they chased him down the street. I think it was Dennis Fitzgerald [that] tackled him, and they took a picture of him. He never showed up again.

In Austin, of course, there were right-wingers, but we faced stuff from

Space City!, vol. 2, no. 6 (1970). Getting it together in Houston.

space city!

·formerly space city news·

vol 2 no 6 aug. 22 – sept. 4, 1970 houston, texas

HUEY
IS
FREE !

The ideas which can and will sustain our movement for total freedom and dignity of the people cannot be imprisoned, for they are to be found in the people, all the people, wherever they are. As long as the people live by the ideas of freedom and dignity there will be no prison which can hold our movement down. . .The people are the idea; the respect and dignity of the people as they move toward their freedom is the sustaining force which reaches into and out of the prison. . . The dignity and beauty of man rests in the human spirit which makes him more than simply a physical being. . . The prison cannot be victorious because walls, bars and guards cannot conquer or hold down an idea.

– from "Prison, Where is Thy Victory"
BLACK PANTHER PAPER
Feb. 17, 1970

GETTING IT TOGETHER IN HOUSTON:
IN THE WAKE OF CARL'S DEATH

...pages 4-5

the fraternity crowd. Larry Freudiger, who was the printer, had a rock thrown at him [that] split his head open one time. I remember we'd get kicked out of restaurants because we had long hair . . . the sort of thing that happened everywhere in the country. We never had the kind of problems that we had in Houston, or the kind of problems they had in Dallas. They were just under absolute total continual siege from the police in Dallas; they were busted, thrown in jail all the time. We didn't have that, but the [campus] administration at one point sued to keep *Rag* from selling on campus, and it became a major free speech issue. The ACLU took it up and it went all the way to the U.S. Supreme Court—and we won.

send our papers to motherfucking Toledo when they should be going to Fresno. So those kinds of things happened with the Black Panther Party newspaper. Once the Panthers got them [the papers] in their hands, they still were harassed on the streets for selling papers, and they still would go to jail for selling papers. They would think of some flagrant bullshit law about selling papers, [something like] not having a license or a permit. You don't need one; it's freedom of the press. Meanwhile, they take you to jail just to keep you off the streets. You might be in jail all day and they let you out that evening. They've accomplished what they wanted to, just to get you off the streets. But then this is the type of harassment that happened every day across America to Black Panther Party members.

BILLY X JENNINGS
The Black Panther

There were incidents even at Howard Quinn Press. I know that the FBI talked to various members of his staff about the Black Panther Party newspaper. That's why, when we sent the paper to be printed, we sent two or three people over there with it. And from there (after the paper had been printed and it made through that cycle), we would take it to the office and immediately start sending trucks and stuff to the airport to send the papers out. Now, at the airport they would lose our stuff. The FBI would come, find our bundles and water them down, or misship our stuff on purpose. You might be a clerk, and the FBI came and talked to you and said, "Hey, these guys ain't no good. They hate white people. You'd be doing your country a big favor doing this for us." And they might

JOHN SINCLAIR
Work, Change, whe're, Fifth Estate, Warren Forest Sun, Ann Arbor Sun, Guerrilla

We tried to model ourselves on the Black Panther Party. We didn't know anything about politics; none of us had any background even in campus politics, like SDS and that stuff (well, my wife did, but she didn't let it bother her). We just wanted to do things, and the things that we wanted to do were not what they wanted to have done. We smoked weed and took acid, and we were racially mixed as a group. All of these things were not accepted by the mainstream at the time, at all. By smoking weed, of course we drew the attention of the police, and they were a constant pain in the ass.

Berkeley Tribe, vol. 2, no. 2 (1970). John Sinclair, cigar-chomping psychedelic gangster.

INTERNATIONAL FREE JOHN SINCLAIR DAY
JANUARY 24, 1970

JOHN SINCLAIR was sentenced to 10 YEARS in prison for passing out free, to an under-cover government agent, TWO JOINTS of marijuana. He was busted along with 55 other people in Detroit's Artists' Workshop communes, in a "raid" designed by the police narcotics department, Wayne University, and the lying mass media. The "raid" took place on January 24, 1967, and was an attempt to stomp out the growth of a hip cultural alternative which involved black and white people working creatively together. Over two years later, on July 28, 1969, John was sentenced, and became a POLITICAL PRISONER along with tens of thousands of other victims of cultural repression IN AMERIKA who know marijuana is not a narcotics. He has been denied appeal bond by the Michigan courts, even though his case challenges the very existence of all the insane anti-MARIJUANA laws on constitutional, medical, and social grounds. There are tens of thousands of pot-SMOKERS in prison and tens of millions out of prison. We are all victims of a calculated cultural repression. The POLICE-STATE use of the anti-grass laws has created a vast CONSPIRACY of heads; breathing together & struggling to be free. On January 24, 1970, we all have to "get it on for John"; the International Committee to Free John Sinclair and the Youth International Party will organize permanent coalitions to SERVE THE PEOPLE. The energy generated around ROCK 'N' ROLL benefits, smoke-in/teach-ins, petitions and Legalize MARIJUANA rallies across Woodstock NATION on January 24 should be used to unify the life culture, and to make the coalitions strong. Everyone in every city in our Nation is asked to give a benefit. Every band and poet is asked to talk about John's case and to donate a part of that night's earnings toward his fight for FREEDOM. It has been three years since John's bust AND six months at involuntary servitude in Marquette maximum security prison. JUSTICE is expensive under this system, and funds are urgently needed to end pot-prohibition. January 24 is FOR BROTHER JOHN Sinclair and all other political prisoners. We demand an IMMEDIATE end to marijuana prohibition, and amnesty for all political prisoners.

Please let us know what you are planning to do so we can help bring it together.

Contributions can be sent to the International Committee to Free John Sinclair, P.O. Box 444, Planetarium Station, New York, N.Y. 10024.

For more information, subscribe to the Youth International Party News Service, 1520 Hill St., Ann Arbor, Michigan 48104. [313] 761-1709.

[Includes John Sinclair's Prison letters, information from the Ann Arbor White Panther Tribe, catalogs of posters and buttons and literature and records, the UP Rock 'n' Roll Co., Rejuvenation News, and membership in the CONSPIRACY.] *Rates are $10 for 6 months, $15 for one year. Issues are twice per month.*

Name...
Address...
City......................State................Zip......
Check one: 6 mos...........1 year........Xtra.......
POWER TO THE PEOPLE!!!

FREE JOHN
FREE ALL POLITICAL PRISONERS - FREE MARIJUANA

JOHN SINCLAIR BENEFIT POETRY READING
Gary Snyder Michael McClure Laurence Ferlingetti Lew Welch Drummond Hadley
BERKELEY COMMUNITY THEATRE WED JAN 28 8pm
$2.00

The police. They were worse after the riot; they were trying to get back at people. By this time, the hippies were a well-defined stratum of society because, like black people, you could see the hippies. They had long hair, they looked different, and they probably had some marijuana on them so they were fodder for arrest—walking targets. You saw a hippie walking down the street, if you were a cop you stopped them and shook them down to see if you found some drugs on them. It got worse and worse and then they killed Martin Luther King, and they put Detroit on a "preventive curfew," they called it. You couldn't go out after eight o'clock at night. Well, we went out after eight o'clock at night to make a living in the rock 'n' roll business. We just thought, if it's going to be like this, if they're just going to shut the fucking city down and not let people out, we better get out of here because we can't live like this. We have to be able to move around at night.

JEFFREY BLANKFORT
San Francisco Express Times, San Francisco Good Times

I was the first person to buy a gas mask in the Bay Area because I was also an activist, I wasn't just a photographer, and I got a gas mask when they were cheap. So in Berkeley when they came over to drop the tear gas on the campus, everybody ran but me because I had my gas mask on. Suddenly, I realized I'm all alone and there was a row of maybe thirty or forty highway patrolmen and cops standing maybe about thirty or forty feet from me, and they were taking turns throwing tear gas canisters at me, trying to hit me like target practice. Anyway, one landed at my foot, and I did get a little whiff. I realized I better get

Berkeley Barb, vol. 5, no. 5 (1967). Sign hung outside the Sinclair-founded Detroit Artists' Workshop as a show of solidarity with the rioters during the uprising in the summer of 1967. Photo by C.T. Walker.
Opposing page: *San Francisco Express Times*, vol. 1, no. 5 (1968).

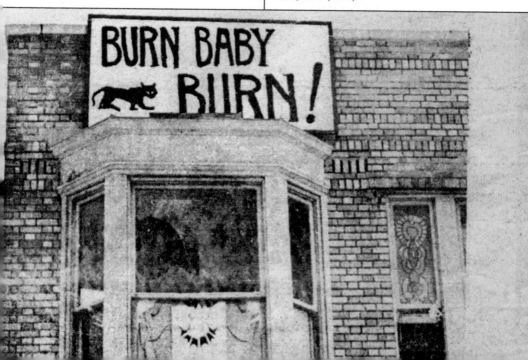

SAN FRANCISCO
EXPRESS TIMES

Vol. 1, No. 5 February 22, 1968 Bay Area 15c (*Other California Cities 20c, Out of State 25c*)

THE YEAR OF THE COP

haight '68

They're Giving It . . .

They Gon' Get It

full text of carmichael oakland speech p. 6 / alan watts p.

out of there because there was no one to see me if they decided to beat me up. So I ran and got out of there. I actually still have the gas mask and the helmet from those days.

JUDY GUMBO ALBERT
Berkeley Barb, Berkeley Tribe

I remember the days in Lincoln Park the week before Chicago: the sun was shining, we were painting signs, people were smoking dope, even making love. I didn't think anything bad could possibly happen. I should have been more clued in. A Native American guy by the name of Dean Johnson had been killed. Abbie [Hoffman] put out a leaflet: WARNING . . . LOCAL COPS ARE ARMED AND CONSIDERED DANGEROUS. I remember one of the first marches I went on was a protest march [against] the fact that Johnson had been killed. We all claimed he was a Yippie, and in fact he was. There was this other guy who was actually,

I think, a friend of Paul Krassner's, a black guy named Jerome Washington, who was a member of the Black Stone Rangers, and he was actually working with the Stones to try to define which turf was safe and which wasn't because of the Chicago gangs. This biker dude, Robert Pierson—who was an undercover cop, but of course we didn't know it— volunteered to be Jerry's bodyguard. All those things could have been clues to us had we had the hindsight we have now, which of course one never does. Maybe I was just a naïve Canadian and everybody else knew, but I thought, "Oh man, this is going to fun."

San Francisco Express Times, vol. 1, no. 33 (1968). Good vibes in Grant Park. Photo by Jeffrey Blankfort.
Opposing page: Liberation News Service, no. 117 (1968). Robert Pierson, a.k.a. Bob Lavon, was the biker/undercover cop that infiltrated the Yippies as Jerry Rubin's volunteer bodyguard during the week of the Democratic National Convention in Chicago. Here, LNS/MA runs the headline from the issue of *Official Detective Stories* that ran his report. It's unlikely that Pierson received anything close to the $10,000 that Abbie Hoffman claimed *Esquire* was willing to pay for the story.

OFFICIAL DETECTIVE STORIES

Combined with Actual Detective

EXCLUSIVE!

BEHIND THE YIPPIES' PLAN TO WRECK THE DEMOCRATIC CONVENTION

By ROBERT L. PIERSON
Investigator, State's Attorney's Police,
Cook County, Illinois

In the underground press, Abe Peck (editor of the Chicago *Seed*) and a number of other people were concerned about violence. They were putting out the message, "Don't come to Chicago, there's going to be violence." There was a big split between him [Peck] and Abbie and Jerry and the rest of us over his stance. Now, I have to say, Abe lived in Chicago; he was local, and he knew more than we knew.

Right at the end, all of the rock groups Abbie had invited dropped out . . . except for Phil Ochs and the MC5. I remember once all of us were sitting around at a meeting. I was almost too intimidated to speak up, but I had this idea. Stew and Eldridge were friends, and I'd met Eldridge in Berkeley. I said, "Well, why don't we invite Eldridge?" Everybody thought that was a great idea. Stew and I—and the undercover cop Robert Pierson, who volunteered to come with us—went to this bar in Chicago to call Eldridge. The phone booth looked like one you'd expect Superman to use; it was wood with a glass door in a dingy bar. We call Eldridge to see if he can come. He can't, but the Panthers decide to send Bobby Seale in his place. And so Bobby comes, speaks in Lincoln Park and ends up being one of the Chicago Eight. He is chained and gagged in the courtroom for demanding to act as his own attorney, and Pierson goes on the stand during the trial and testifies against Bobby. I sometimes wonder if I was, in some minor way, a catalyst for the entire chain of events because of my idea. What can you do?

Rat Subterranean News, vol. 2, no. 14 (1969). Caption reads: "Five police arrest high school student for insulting a parent." Photo by David Fenton.
Opposing page: *Berkeley Barb*, vol. 6, no. 15 (1968).

HERE'S A LITTLE SOMETHING FOR MOTHER'S DAY

FUCK THE DRAFT

Send for five posters ($5) and we'll send a sixth one free to the mother of your choice. Please send my sixth (free) poster to:

- ☐ Mrs. Lady Bird Johnson
- ☐ Mrs. Shirley Temple Black
- ☐ Lieutenant General Lewis B. Hershey
- ☐ General William Westmoreland
- ☐ Madame Ngo Dinh Nhu
- ☐ Mr. J. Edgar Hoover
- ☐ Mrs. Richard Hughes
 (other specify)_____

Single poster $2, two for $3, five for $5.
Send cash, check or money order.

The Dirty Linen Corp.
Dept. B
G.P.O. Box 2791
New York, N.Y. 10001

NAME_____

ADDRESS_____

CITY_____ STATE_____ ZIP_____

HOWARD SWERDLOFF
New York High School Free Press, John Bowne Was a Pacifist

The schools in those days were not very sophisticated about dealing with adolescent rebellion. The way they dealt with us was they repressed us. So of course that just encouraged us further. They were totalitarian institutions, the high schools in New York, which was an odd thing because these organizations were being run by liberals, by and large. Nonetheless, their relationship to us was extremely repressive, and no signs of dissent were tolerated. That included symbolic dissent, such as wearing peace buttons, or having long hair, or wearing jeans, all of the things which now the schools have become much more sophisticated in dealing with. So everything we did brought down some kind of reaction from the schools. You didn't have to do much to find yourself in opposition, and you didn't have to do much to have a lot of allies with the other students. It was more about being young, in some ways, more than it was about anything else. Of course there was the draft, which was looming in the background, and in some neighborhoods kids were starting to come home in coffins from Viet Nam. I certainly had that experience where I grew up. Friends of mine who had dropped out of high school and joined the Army, or been drafted, had been killed in the war. You were starting to feel the real effects of this. Of course, all the countercultural stuff that's very familiar to everybody now, that was the backdrop. There really was a generational conflict with authority. They did all the wrong things in reaction to us, and it just encouraged us by doing that. I was in trouble with the authorities constantly. The other thing is the media was fascinated with us, so we were being covered in the newspapers on a regular basis. *The New York Times* featured a big story about me where they called me the "Little Lenin" of the high school.

They would confiscate the papers, they would suspend us from school, they would break into lockers looking for papers, they would take away papers from students who were carrying them. It was just a totalitarian response. The New York Civil Liberties Union basically had a full time job with us.

New York High School Free Press, no. 8 (1969). Caption reads: "200 high school students sat-in at Columbia U. last week, demanding open admissions. HS FREEPHOTO by Miriam Bokser (LNS)."

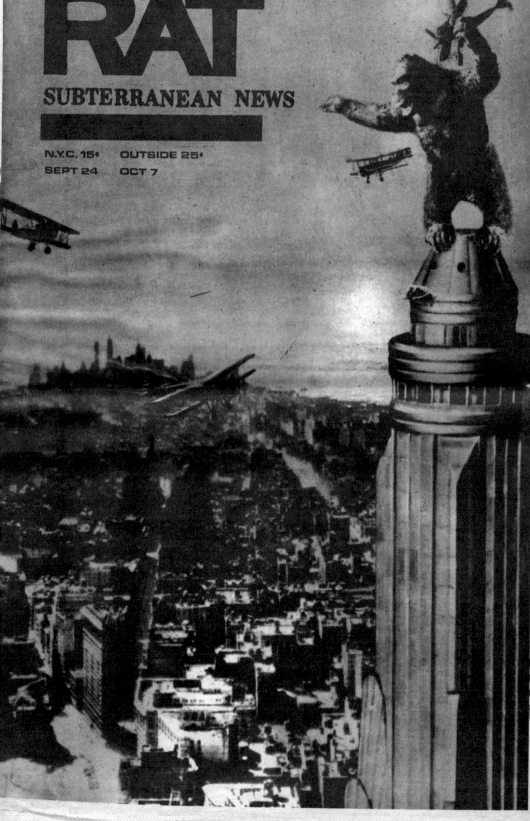

RAT

SUBTERRANEAN NEWS

N.Y.C. 15¢ OUTSIDE 25¢
SEPT 24 OCT 7

PEOPLE BURN OUT, AND PEOPLE BURNED OUT

The End

The unrelenting repression of the Nixon years (1969–1974) exacerbated the loss of editorial focus and hastened the decline in readership that began with the factionalism engendered by the rise of identity politics. The increasingly militant rhetoric that started to show up in the underground press tended toward the absurd, and the further that the content drifted to the fringes, the wider the gulf between the newspapers and the community they purported to represent became. Coming out of a period of nonstop frenzy, a generation that once radiated boundless creative energy and a sense of limitless possibility seemed, by the early seventies, to be fatigued, confused, and disillusioned. A deathly pallor descended and rigor mortis set in—the underground press was dead in the water.

ALICE EMBREE
Rag, NACLA,
Rat Subterranean News

The atmosphere in New York was incredibly tense. I read something that Bob Pardun had written, about how when Jeff and I came back from New York one time: we wouldn't talk to anyone in a house, we would only talk walking down the street. The level of paranoia was just palpable in New York at the time. Partly I came back to Austin because it was familiar turf, it was more laid-back, and it was sort of a place to find my bearings again. And it also felt like, "Well, if we're going to have a revolution, I want to know my way around town a little better than New York City." It was an incredibly tense period to live through. People talk about 1968, just the sequence of events that happened that were huge trajectory changes—Martin Luther King's assassination, Robert Kennedy's assassination, the strike at Columbia, Mexico City. The world was in total upheaval . . . the Tet Offensive, lest I forget because that practically started the year. That's not a recipe for long life. It's hard to live in that kind of adrenaline all the time. You can do it for short periods of time, and then you kind of have to get your bearings again, just your human bearings. People burn out, and people burned out.

BEN MOREA
Black Mask, The Family
(Up Against the Wall/Motherfucker)

It was an evolution. It was 1969 and I had been doing this ten years. I personally felt like my productivity and my role was severely hampered. I felt earmarked for elimination, and that was happening a lot. I was on my way to Chicago. At the time I was traveling with my girlfriend, who then had a blue Volkswagen car. I wasn't going to Chicago in that car but that's what I was driving around in in New York. So I kept getting calls that the police had my picture, and they were stopping all blue Volkswagen cars and were approaching them armed, as if they were waiting for something to happen, or provoke something, or claim something had happened. After the third call like that, I took a detour; I didn't go to Chicago. And that was it. I went into the mountains for five years, on horseback.

HOWARD SWERDLOFF
New York High School Free Press,
John Bowne Was a Pacifist

I got thrown out of school. In December 1968 I got expelled from school. I had the Civil Liberties Union representing me, and they negotiated a diploma for me from the school. As long as I didn't go back, they were willing to give me a diploma. So in January of 1969 I was a high school graduate. Some of us just quit and never went back, and years later had to go and get GEDs and go on to college. I ended up working in a manufacturing job for thirty years, and when I was forty-five years old I went back and got my B.A. and my master's degree.

All of us have different stories. We had to figure out what to do after high school, and it was difficult. Nixon was elected in 1968, and the repression got

Butch Cassidy and The Sundance Kid: A Lesson

See Butch run.

See Sundance run.

See Butch and Sundance run together.

Now see them split from their gang.

See Butch and Sundance square-off alone against the pigs.

See Butch and Sundance die.

LIBERATION NEWS SERVICE

#469 October 4, 1972

more intense. The New Left took a turn toward terrorism and increasing sectarianism. We were feeling quite alienated from all of this, so it was a very rough time. Some people did find things to do, they went to work in different neighborhoods in Chicago, organizing working class youth, or in Buffalo. Other people worked on the antiwar movement full time, which is what I was doing for a couple of years. Then things got a little bit loony on the left in the movement, and it basically became a time of emotional distress. Some of us had cut off our connection to our futures. What had been planned for us in the social hierarchy, we had cut ourselves off from those possibilities and were looking for what to do with our lives. There was this period of three or four years of absolute intensity that just stopped—and there we were, high and dry. I was twenty years old and quite confused about what to do with my life at that point. It was hard to do anything that could compete with the intensity of those years. The seventies was a rough decade for a lot of us; I think that was pretty generalized. All of these relationships that we had, that crossed all kinds of ethnic and racial and class boundaries, started to disintegrate. People started going back to their "roots," and all of a sudden it mattered whether you were white or black or Jewish or Italian or male or female. This identity politics that arose in the seventies was the opposite extreme from what we all had done in the sixties when none of this mattered, or seemed not to matter.

JUDY GUMBO ALBERT
Berkeley Barb, *Berkeley Tribe*

I went on my own trajectory after Chicago. I would come back and write occasionally for the *Tribe*, but I was also doing a lot of work with the North Vietnamese and the antiwar movement, which resulted in Nancy [Kurshan], Genie Plamondon, and me going on a trip to Viet Nam in 1970 so we could see for ourselves the human consequences of the war. I was working more on the national stage at that point, than I was at the *Tribe*. When you talk about the decline of the underground press, the *Tribe* lasted for about three years after the period we discussed. The *Barb* went on for seven or eight. Do you know why? The sex ads. We at the *Tribe* were ideologically pure, and of course we would not take sex ads.

JEFFREY BLANKFORT
San Francisco Express Times, *San Francisco Good Times*

In 1970, when I was in London, Liberation News Service asked me to go to Jordan and Lebanon to photograph the Palestinians. It was actually a young man named David Fenton, who at the age of seventeen was the youngest photographer to ever have a photograph in *Life*. David asked me if I had a problem being Jewish going to Lebanon and Jordan. I went there as a journalist, but it turned my life around. I've been actively fighting for Palestinian rights ever since, and most of the writing I do is around the Israel Lobby issue.

When I went to the Middle East

Liberation News Service, no. 469 (1972).

for LNS I was going to work with George Cavalletto and Sheila Ryan, who were two of the founders. They were going to write a book on the Palestinian struggle, and I was going to do the photographs. All of us became disenchanted with Yassir Arafat, but we decided we wouldn't talk about it at the time, because that was the last thing the Palestinians needed. They never got the book written, but I provided photographs. Anyway, so I come back and I'm staying with LNS people in New York, and I'm wide awake and we're talking, and I ask them, "What happened to the movement?" And everyone started looking around at each other and started talking about how it was necessary to find our inner self, to liberate our self first, the individual first. I said, "Oh God, I can't believe I'm hearing that from you." Then I went over to LNS to print pictures that I had taken in Lebanon and Jordan, and they were having their meeting. At that time, a young black man and a young black woman, who had been kicked out of the Panthers by Huey Newton when the purges had begun, wanted to join the LNS collective, which was all white. And, I wish I had tape-recorded this conversation, one woman said, "I'm not ready to work with a black person." The young black woman was only looking for an associate position, a half-time position—and these weren't paid positions—just to be a part of the collective. So I'm standing in the doorway listening to this disgusting discussion, and I said, "The easy solution, folks, just call yourselves the White Liberation News Service and be done with it."

JEFF SHERO NIGHTBYRD
Rag, Rat Subterranean News

I remember one night in New York . . . a girl in the Black Panthers was dating a guy who was a son of one the assistant chiefs [of police], and so sometimes she could overhear if there was going to be a raid or something, so we knew there was going to be a raid on Black Panther headquarters. I had Afeni Shakur hiding in my house on the Lower East Side, and she was, I don't know, second in command of the Harlem chapter. At any rate, we're sitting there, I'm from Texas and own a couple of guns, and I said, "This is just nuts. We have two pistols and eight people here, and if the police try to hold us, they're going to bust in with real firepower. This is symbolic resistance—this is not real resistance." At some point the left's rhetoric got so detached from reality. And so I'm printing stuff saying, "The Streets Belong to the People." And I'm sitting on the doorsteps of St. Marks, "I don't even like these streets. I don't want to fight for these streets. These aren't my streets." And I knew enough about guns to know that that was really elevated, macho, ineffective language, but desperation was pushing the whole society. It was stunningly bad, and as people got more frustrated there were more divisions, of course, within our own ranks.

One of the powers of the whole movement was that people, for a decade, felt hope. We're going to build a society, and it's not going to be racist. We're going to be in touch with things. There was a revolution in food, and

Rat Subterranean News, vol. 2, no. 27 (1970). Photo of Afeni Shakur by Barbara Rothkrug. Following page spread: *Rising Up Angry*, vol. 1, no. 10 (1970).

Revolutionary Wall-Posters, near Barry & Belina

WHERE YOU'RE <u>DO</u>

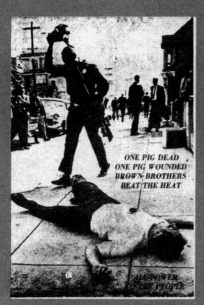

Pig gets a message from the People

Some brothers and sisters say they're for the revolution,
Some say they want to do it, but not enough people in t
Others say they dig the revolution, that they're for the pe

ALL OF THESE EXCUSES COME OUT OF CONFUSIO
all through the world are making the revolution by taking
We've all got to carry out revolutionary acts; we've all go

In action, in struggle against all pigs and hollow headed b
to be done next; we clear up our confusion and the confu
Action overcomes fear. It prepares us to escalate the stru

SO DIG! There are more people than pigs! Understand
burn and crumble! And the people all over the world are

The time has come today. There's no reason to hold bac
level you're prepared to handle. Always study, prepare a
next higher level. Doing it now, not waiting, we will gain
for bigger things. RIGHT ON! Here's some beautiful stu

**ONE PIG DEAD
ONE PIG WOUNDED
BROWN BROTHERS
BEAT THE HEAT**

ALL POWER
THE PEOPLE

Enemy dead in battle with "Los Siete"

Direct hit on R.O.T.C.

RISING U

ER
AT—
T!

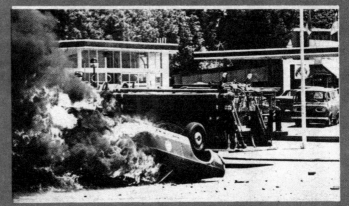
But "cocktails" are better than rocks

know what to do.
borhood or school are hip to it yet.
t the pigs will always win.

FEAR. People all over the city and
ionary actions to make it happen.
t.

humps, we figure out what needs
ong our brothers and sisters.

bleed and die! We know buildings
their fight against all kinds of pigs!

do what must be done at whatever
for revolutionary actions at the
fidence and knowledge necessary
done around America and the world.

DIG IT! DO IT!

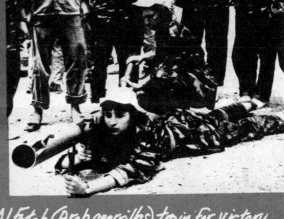
Al Fatah (Arab guerrillas) train for victory.

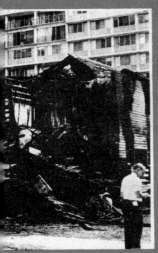

Vietnamese army of ALL the people fights for freedom

ding

there was certainly an environmental revolution that grew out of it. There was certainly a sexual revolution on lots of levels, from women's rights on to sexual tolerance. And a lot of it was successful. I think about it in a different way, I was twenty-four, twenty-five, twenty-six years old and, in New York, serious commentators were asking me how we should run America—and our critique was pretty damn good. We were very good at describing the problems in the society, economic segmentation between the rich and the poor, the underclass, racism, environment, all kinds of things. Our foreign policy critique was basically good. If we had to say what we should do, all we could fall back on, because we had nothing, was old Marxist solutions, which, for lots of reasons, were already proven not to work. If one had visited Russia, it wasn't the kind of society you wanted. I visited Russia and met the young Communists in Russia. Well, hell, they were the fraternity and sorority kids in the United States; they were playing by all the rules. They weren't rebellious at all, and if you raised an issue like homosexuality, well wait, you're gay-baiting and people go to prison. "We're dealing with that issue, but the time isn't now." Well, that didn't make the gay people feel too happy. They had lots of racism in Russia. It's not endemic to Communism, but when you concentrate the political and economic power in the same hands, it usually corrupts. I've always been a "little-d" democrat. We had no vision of where it should all be, and so we latched on to crappy old Marxism that didn't work.

At any rate, the underground press fails toward the end of the sixties, early seventies because it no longer reflected its own communities, and it started taking on a dull and boring rhetoric that wasn't the imagination that made the underground press attractive in the first place.

ABE PECK
Seed, Rat Subterranean News

We had a split with the Yippies and Tom Hayden. If you go back and really read David Farber's book [*Chicago '68*] around the convention, or even read my book [*Uncovering the Sixties: The Life and Times of the Underground Press*], you can see just how a lot of people were making this up as we went. SDS wasn't going to be there, then it was going to be there; the New York Yippies were going to bail out, then they decided to come anyway. Anyhow, I eventually wrote a piece saying if you're coming to Chicago, be sure to wear some armor in your hair. I was saying come, but it's not going to be incense and peppermints. That was a piece that created a lot of intense arguing later on and so in that sense the fear around the 1968 convention was a real debate—there were arguments about what was going to happen there. There was a theory that if we got enough people there, the cops would have to leave it alone. So the organizing venture was to get a hundred thousand people there. I went for that because I was looking for Woodstock a year early, without knowing that there was going to be a Woodstock. The reason I bring the split up is that we didn't necessarily consider ourselves in lockstep with the movement, or movements at the time. But by late 1969, early 1970, I think we were in lockstep with the movement.

The *Seed*'s readership was a mix of hardcore (a lot of people who were just freaking out, just getting into things, just

leaving home) and a lot of disenchanted liberals. When we got super-militant, I think we certainly lost a lot of people along the way. By 1970 we started hectoring our readers, as opposed to being their embodiment. The number of papers that we sold certainly shrunk, but there were some people, of course, that evolved with it. By the end of it, I wrote a couple of things that I read when they came out, and I said, "I don't believe that. I wrote that for the sake of the movement." And that's when I kind of left.

I became the, kind of, opposite, of who I had been in 1967. I became much more militant. I endorsed types of violence that I personally wouldn't commit. In some ways that was what got me out of it because I still believe in that whole initial thing, which is what the Buddhists call "right action." If I wasn't going to do it, and I was sending other people out to do stuff that I personally wouldn't do, then I call bullshit. It was personal bullshit. And that was the beginning of the end for me, that was in 1970.

I think this is pretty replicable. You had the initial flush of, "Wow, there's other people just like us. We're gonna write about it, and we're gonna bear witness." And also not just write—some of the best work in the papers was art or underground cartoons—but, "We're gonna express this stuff, then we're gonna be increasingly conscious about it." Then some people saying, "Oh, we have allies around the world, it's not just six streets and an office in New York or Austin or Chicago. Our allies are the Viet Cong, the SWAPO, all the causes of anti-imperialism around the world." Or, if you were of a different strain, the millions of longhairs that suddenly were appearing. Woodstock was an example of

that. I went to Woodstock from Kansas, and as we drove east, suddenly you just saw more and more longhairs. It was amazing! We had never seen that. So you wanted to be a part of something bigger. If you were totally into it, then you had the longhairs and the anti-imperialists. You were part of a giant movement, you know. So it was very reassuring, in a way, that you did have these things to express. It wasn't the original peace and love thing, and that's what a lot of people really wanted.

The paper was a bell curve: it started small, got pretty big, then it was the end. By 1972 or 1973, it was really just a couple of guys and an office full of dogs and dog crap. Just as there was a year of discovery before I joined the paper, I was discovering a lot of stuff, and I was freaking freely. I wasn't living with my parents anymore, everything was possible and everything was promise. My mind was expanding, all that good stuff. The other side of that is what I call the "bad year," because, for whatever reason, you're kind of out of it. You're not going into the paper anymore; you're not going into whatever's left of SDS anymore; you're in some faction of SDS, and someone just blew up a building and killed themselves or robbed a truck or whatever, and you just can't do it anymore. And I don't want to speak for the SDS people, I'll just speak for myself, but it's just like, "I'm out of this and what do I do? I can't write these kinds of pieces anymore because they're not for me, but at the same time, I can't go back and get that job . . . I didn't even like that job driving the company car and selling textbooks the first time. I don't want to go and write for something straight because

Following page spread: *Rat Subterranean News*, vol. 2, no. 23 (1969). Skip Williamson.

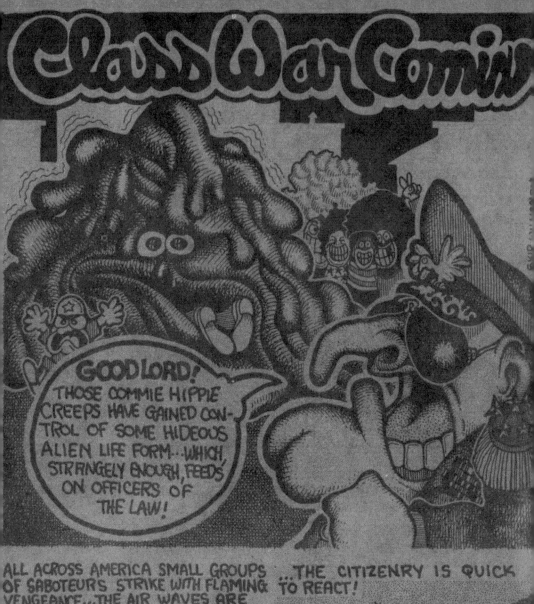

Class War Comix

GOOD LORD! THOSE COMMIE HIPPIE CREEPS HAVE GAINED CONTROL OF SOME HIDEOUS ALIEN LIFE FORM...WHICH, STRANGELY ENOUGH, FEEDS ON OFFICERS OF THE LAW!

ALL ACROSS AMERICA SMALL GROUPS OF SABOTEURS STRIKE WITH FLAMING VENGEANCE...THE AIR WAVES ARE ELECTRIC WITH RAGE...

ROVING BANDS OF GODLESS ANARCHISTS STRUCK FOR THE FIFTH TIME THIS WEEK TODAY...WITNESSES SAID THE YOUTHS APPEARED TO BE UNDER THE INFLUENCE OF DRUGS...

KRAP RADIO

...THE CITIZENRY IS QUICK TO REACT!

THROUGHOUT THE COUNTRY CONCERNED PARENTS QUESTION THEIR CHILDREN...

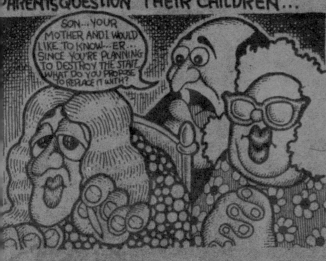

THE PRESIDENT DECLARES A STATE OF NATIONAL EMERGENCY AN REASSURES THE PEOPLE VIA TEEVEE...

...MEANWHILE, SHREWD REVOLUTIONARIES ORGANIZE THE WORKING CLASS...

AND THE AUTHORITIES QUESTION VARIOUS DISREPUTABLE SUSPECTS

BUT NO ONE KNOWS HOW IT'LL END...EXCEPT FOR THIS GUY... AND HE AIN'T TALKING!!

that's bourgeois journalism. Or I don't want to go down and have a day job." I never thought I wasn't good enough to do that . . . I thought it was lame, maybe. It was never even on my radar to go work for the *Chicago Daily News*, which is interesting because I eventually did go work for the *Chicago Daily News*.

I was kind of stuck in the middle between not wanting to work in the underground press anymore, but not wanting to be in straight society in any form. And I'll tell you a quick story. My solution was to leave the country with the woman I was living with and travel for five months. I wrote a letter to my friend and I said, "Marshall, I've made a decision. I'm going to move back into society a little bit, but I have terms, and here are my terms: the job has to be redeeming, hours should be flexible, and it should have a social construct to it." I gave him five or six terms and I said, "I'm going to be back in Athens in about a month. If you could write to me I'd really appreciate your thoughts." I get to Athens, and I go to the post office box and there's a letter from my buddy Marshall, and he says, "I really thought long and hard about your letter, and if you hurry back, Marshall Fields is hiring Santa Clauses." And that was a knock on the head.

I started freelancing. I certainly wrote things that were a little different than other people might have wrote, but I wasn't writing balls-to-the-walls outré stuff; I was trimming my sails a little bit. The big thing for me was getting a job at *Rolling Stone*, which some people had denounced as stealing the thunder of the underground press. By the time I was there in 1975, it was, to paraphrase A.J. Liebling, "Better than anything hipper, and hipper than anything better."

PETER SIMON
Cambridge Phoenix, Real Paper

My career was on that upwardly high trajectory to work in Boston as a newspaper photographer and eventually get a job with the *Boston Globe* or become an Associated Press stringer or full-time photographer. But then I discovered that all my negatives would become property of the publication that would hire me full time. I didn't like that idea at all; I wanted to retain rights to my own work. Then, I could have stayed with the *Cambridge Phoenix* or the *Real Paper*, but they didn't pay very well. So I decided to move, with Ray Mungo and college hippie friends, to Vermont and start my own commune, which was called Tree Frog Farm. That was a real turning point, because at that point I eschewed material possessions, a career, a fast-paced city lifestyle, ambitions to become Mr. Photographer of the Year . . . I just thought, "Fuck that. I just want to live with the cows and the plants and the hens and my friends and just chill out in the country."

ALLEN YOUNG
Liberation News Service, Gay Sunshine, Gay Flames

I stayed in LNS as I became involved in the Gay Liberation Movement. I actually came out to people and told them I was involved. My actual coming out, in a sense, was when I wrote about a demonstration, a gay demonstration, that I went to. I didn't say that I was gay when I wrote the article, but I think people probably realized at that point that I was. And when people started asking

Seed, vol. 8, no. 8 (1972).

A WORKER READS HISTORY

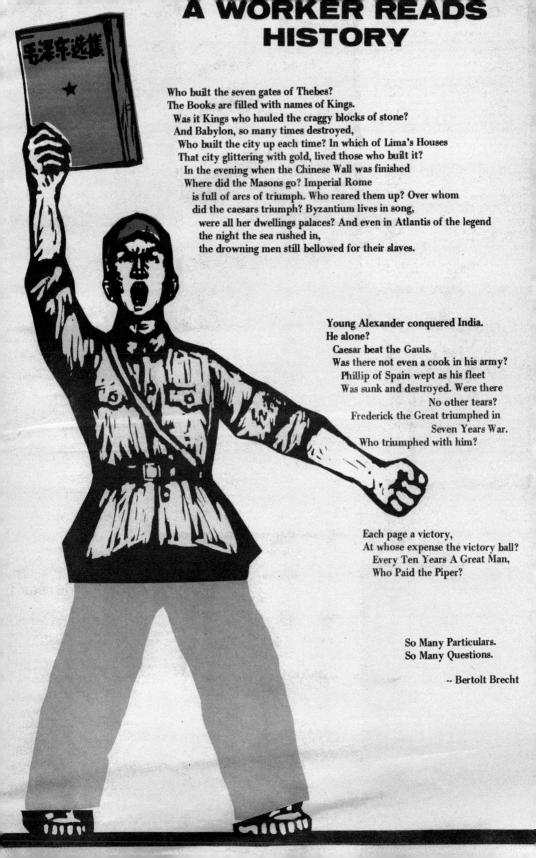

Who built the seven gates of Thebes?
The Books are filled with names of Kings.
 Was it Kings who hauled the craggy blocks of stone?
 And Babylon, so many times destroyed,
 Who built the city up each time? In which of Lima's Houses
 That city glittering with gold, lived those who built it?
 In the evening when the Chinese Wall was finished
 Where did the Masons go? Imperial Rome
 is full of arcs of triumph. Who reared them up? Over whom
 did the caesars triumph? Byzantium lives in song,
 were all her dwellings palaces? And even in Atlantis of the legend
 the night the sea rushed in,
 the drowning men still bellowed for their slaves.

Young Alexander conquered India.
He alone?
 Caesar beat the Gauls.
 Was there not even a cook in his army?
 Phillip of Spain wept as his fleet
 Was sunk and destroyed. Were there
 No other tears?
 Frederick the Great triumphed in
 Seven Years War.
 Who triumphed with him?

Each page a victory,
At whose expense the victory ball?
 Every Ten Years A Great Man,
 Who Paid the Piper?

So Many Particulars.
So Many Questions.

-- Bertolt Brecht

GAY LIBERATION FRONT

Drawing by Suzanne BeVier

FAG RAG
GAY SUNSHINE
Stonewall 5th
Anniversary Issue

SUMMER 1974 · ONE DOLLAR

me, I said I was. I think, if anything, I was being drawn into the idea that I needed to spend more time with gay people and less time with these straight radicals. And so I began to contemplate leaving LNS.

I decided I needed to live with other gay people, and I moved into this commune, a gay collective, on Seventeenth Street. I think that took place in late June 1970. My life at that point became round-the-clock gay politics, and I just basically drifted away from LNS. I don't know if drifted away . . . there was a certain point when I really left. There was a time where I was still involved, then I just quit, totally left. It was more like I was moving on. I started writing for *Gay Sunshine*, which was a gay paper that was launched in San Francisco in 1970, probably. Then I started living in a gay commune, and we put our own little magazine called *Gay Flames*—I wouldn't call it a magazine, maybe a newsletter.

In April of 1971 I was starting to get really disillusioned with the politics of gay liberation, which was turning somewhat dogmatic. People were getting sort of extreme in their views. They were getting very preoccupied with how gay men differed from lesbians. There was a lot of fighting between the gay men and the lesbians. There was fighting between more effeminate gay men who were criticizing more masculine gay men for masculine privilege and masculine attitudes and masculine dress. It became very arcane, if that's the right word, politically, and they were also very critical of the newest strains in the gay movement that were more moderate, in the sense that they weren't promoting revolution. Many of the people in gay liberation were trying so hard to be part of the international socialist movement,

to juxtapose gay politics on top of all the other left-wing politics. So everything had to be integrated; everything had to be correct in gender and correct in race and correct in cultural issues, and it became very unpleasant. Everybody was criticizing everybody else and I became kind of sick of it. Plus, I started doing quite a bit of psychedelic drugs around that time—tripping on LSD and mescaline—and really enjoyed being in the country and appreciating nature. I was going through some personal changes where I just wanted to spend more time in nature, enjoy the outdoors, and get away from all of the heavy-duty political argument that was going on.

HARVEY WASSERMAN
Liberation News Service

There is continuity in the world. Almost all of the underground papers died off within ten years, which is why the news service finally faded. What I love about what happened is that the FBI succeeded in breaking up the news service. And what they succeeded, then, in doing, was winding up with another new news service that lasted ten more years and was perfectly good, a farm (Montague Farm is still going: there is a Buddhist community which now runs Montague Farm, the Zen Peacemaker Organization), along with the whole antinuclear movement. So my response to the FBI and to J. Edgar Hoover is, "Fuck you! We're still going."

Seed, vol. 5, no. 8 (1970).
Previous page spread, left: *Rat Subterranean News*, vol. 2, no. 29 (1970).
Previous page spread, right: *Fag Rag*, no. 9 (1974), joint issue with *Gay Sunshine*, no. 22 (1974).

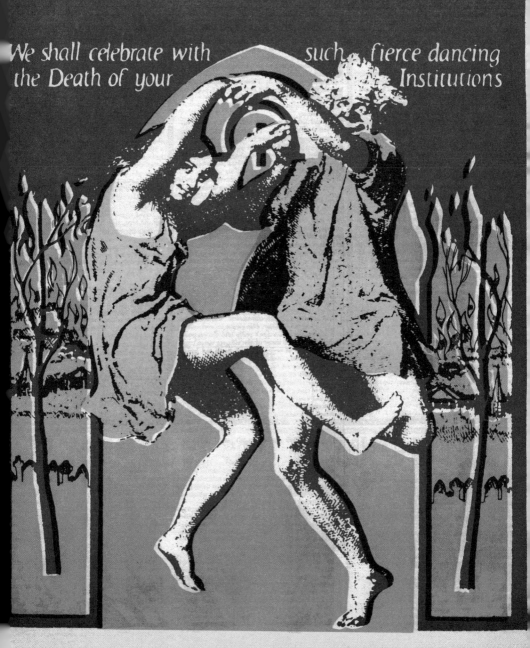

SEED

CHICAGO VOLUME 5 NUMBER 8 35¢

We shall celebrate with such a fierce dancing
the Death of your Institutions

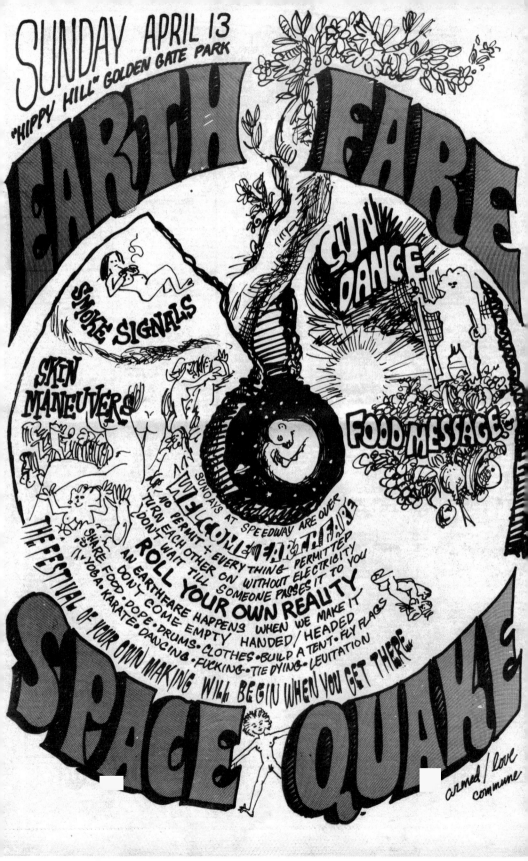

IT'S A TOTALITY
Legacy

 Sifting through the myths.

ABE PECK
Seed, Rat Subterranean News

Everything was different. All the underpinnings were different than they were in straight society. The policemen weren't our friends. We admired people of color as opposed to being suspicious of them or thinking they were inferior. And on, and on, and on. Good, bad, or indifferent, it was really just a totally different world.

I was fortunate to be involved in a time when speaking up was so compelling and also so much fun. The role of the papers in my life was [that it was] a place to stand and to make a stand. These were my people. I literally brought some friends out, but these were my new friends. These were people that I would struggle with; this was my tribe. I was going to the promised land with these people. I think that it was also a way to be expressive, less overtly as an editor, but sometimes as a writer. There was a saying, which I always believed, in the *Seed*, "Work is love made visible." That was one of my favorite hippie sayings, and I think we certainly had a love for the paper, and I think that when things were good we had a love for the movement and a love for the people and a love for peace and justice, initially, and then a love for more militant stuff later on. I think the paper was all-encompassing. If you would ask me then if I was a movement person or a *Seed* person, if I had to choose, I would have chosen the *Seed*.

JEFFREY BLANKFORT
San Francisco Express Times, San Francisco Good Times

The alternative press was an important contribution to the social movements at the time, and their absence is felt. It was a very holistic scene. Some people more into some aspects of it—some of them were into political, some were into music, some were more into drugs—but it was an amazing time. It was an amazing period in American history. I look back on it and it was a great time. You met great people, and it was possible to see change happen.

ALLEN YOUNG
Liberation News Service, Gay Sunshine, Gay Flames

I think it's important to point out, and I have made this point to people, that the underground press was a very important outlet for the ideas coming from the gay movement. Gay people were pretty much ignored by the establishment press in 1969 and 1970. They were just ignoring what we were doing—they didn't really understand it, and they didn't seem interested in it. Underground newspapers, with very few exceptions, were happy to publish material about the gay movement, publish the work of gay writers. They published personal ads for gay people to meet each other, which was actually quite important to us—it was a very important alternative to cruising in the bars or other places.

Berkeley Tribe, vol. 1, no. 18 (1969). Photo by Bil Paul.

My main point is the underground press provided a very important means by which the gay movement reached new people, and I think that's also one of the reasons that the gay movement had a strong left-wing bent to it in the early years, because that's where we were reaching people. We were reaching people and getting them interested in our movement through underground press papers, which had a left-wing tone to them already.

The underground press existed because of the failure of the establishment press. That's why it happened in the first place.

THORNE DREYER
Rag, Space City!,
Liberation News Service

It played a very, very significant role in building the new left and building the antiwar movement because it gave a forum. The underground press moved the mainstream media; it made them start covering things they weren't covering before.

One of the things that I think is very important is that we had a basic humanitarian vision in our roots, and I think it was the civil rights movement that gave us our core vision, and so we were egalitarian. We believed in something as opposed to just being against something. We thought you had to be both, and that was inherent in our whole concept. You had to fight the system, but you also had to have a positive alternative.

We were political from the beginning. We wanted to change the world. We didn't call ourselves Socialists, but we wanted to create a different kind of economy. We believed in putting an end to war, and we believed that we could succeed—it was imminent. We believed that the world was changing and felt this incredible sense of history, and it all got intertwined with the counterculture. Everybody all felt like they were changing the world—whether they were involved in the drug part of it or the political part of it. There were phenomenal changes happening. We were also delusional in lots of ways. We saw revolution—a total revolution—and our goals were so large that anything that happened would have fallen short.

One of the things that we always did in *Rag* and with SDS in Austin is that we tied things together; we thought that things were interrelated. We believed that the various issues that people were getting involved with on various levels were all interrelated—that it was all societal, structural, that it was all systemic, and that we had to change the system if we were going to change people's lives. And we very much believed that liberal change wasn't going do it, that it had to be basic radical change. I think one of the things that was important about what we did was that we created institutions. We created institutions that were reflective of what we believed, rather than being some kind of removed academics, and the underground press was the most significant of those.

Liberation News Service, no. 109 (1968). Caption reads: "Jerry Rubin proselytizing an unlikely constituency at the HUAC hearing. Actually, Rubin just told them his M14 is only plastic and they felt a lot better. It was one of the few light moments enjoyed by the capitol guards, however. They spent most of their time ripping off people's red, white and blue shirts and giving LNS and other unlikely media mites the bum's rush. Photo by George Cohen."

HARVEY WASSERMAN
Liberation News Service

The news service and the underground papers were nothing if not [infused] with a great a sense of humor, a total irreverence. We were not ideologues. We did not take ourselves seriously, and that was the great magic of the Sixties left, the New Left. We were not only political activists but comedians, and it was no accident that our great leader was Marshall Bloom, who was just a wild and crazy guy . . . and guys like Abbie Hoffman, Jerry Rubin, and Paul Krassner. My two older brothers in my life—I never had a brother in my family—were Marshall Bloom and Abbie Hoffman.

For example, people were terrified of the House Un-American Activities Committee, and when Abbie and Jerry were dragged in front of HUAC, what did they do? They showed up in costume and did a comedy routine, and the whole committee collapsed. After terrifying people for decades, it took these two twenty-something guys to come in there shirtless, screaming and yelling, to turn the committee to dust. So that was our great genius and the genius of the news service. You go back and read this stuff and a lot of it is very funny.

JEFF SHERO NIGHTBYRD
Rag, Rat Subterranean News

My stepfather was an Air Force Colonel who thought that we should bomb the Vietnamese back to the stone age (nuke 'em, and all that kind of stuff) and called me "the little communist," but I was basically a conservative, I thought.

I started going down to Mississippi, and in the freedom centers there we were working with SNCC. People, young blacks, were the most heroic people I had ever seen, far transcending anything that a person could imagine. Brave, ingenious, inspiring. That transformed my idea of possibilities, and I think every white person that worked in the southern movement at all was just transformed by the possibility, and it gave us enormous hope and we thought we could do anything. We could organize the University of Texas campus. We could end the war. We can change all these policies. After I'd won best journalist in the southwest for my reportage for Selma, Alabama, where I was in the famous King march, we started *Rag*. It's what inspired me to go into New York, where I knew no one, with five or ten dollars in my pocket and just crash on couches and raise the money to start the paper [*Rat Subterranean News*]—make it work. I'd seen people do much more difficult things in the Deep South. I wasn't getting my life threatened by the New York liberal intelligentsia. The worst they could say was, "No! We're not giving you any money for this *Rat Subterranean News* paper." And that has resonated through my entire life, because I saw that people could do just astonishing things.

People think the Sixties were a failure, but I think they changed a consciousness. Women's rights was initiated and came out of the movement. The general society was materialistic and believed that it could dominate nature. The hippie political experience was that we were part of nature and had to learn to live and coexist, and that lead to the environmental movement. We tried to talk about personal freedom and

we talked a lot about sexual freedom, that people's sexuality exists within a rainbow, the whole rise of gay rights, battles that first started in New York and permeated throughout. And partly the idea that government shouldn't be in your bedroom, and it shouldn't be able to tell you what to do with your body. The abortion rights movement is an extension of that. So in lots of areas we were successful.

ALICE EMBREE
Rag, NACLA,
Rat Subterranean News

The importance of *Rag* and the underground press movement was that it was the connective tissue; it spread the news of what was happening from here to other places. It brought the news of, say, People's Park or whatever was going on in Berkeley or New York, back. Through the Liberation News Service it was shared, it became common news, and I think it was a huge organizing instrument.

It was worldwide. We felt connected to the students in Mexico—enough to do a pamphlet, go down and talk to them. We felt connected to the Zengakuren in Japan, and then the French. There was a level of protest—not just here, but all over—that was just huge and mind-boggling.

BILL AYERS
Osawatomie

I think that one of the things that every insurgency develops is its own ability to communicate with itself, and that was true of the *Federalist Papers*. It was true of the abolitionist movement. It was true of the suffragettes. It was true in the labor days. It was true in the Sixties, and the underground press played that role [then]. I was very close to the *Fifth Estate* in Detroit, the *Berkeley Barb* and the *Berkeley Tribe* were important, New York City's *Rat*—these were all papers that were important to me. The underground press in the earliest days was important because here we were participating in the development of an alternative culture, and the underground press helped give that shape, meaning and amplification. I'll never forget Dr. Hippocrates, Eugene Schoenfeld. What was so great about Schoenfeld was that it was modeled on some phony advice column. It was called "Ask Dr. Hip," or something like that, and so people would write in with their drug problems, their venereal disease problems, their questions about sex—all these things were suddenly subject for open conversation. I just thought it was absolutely liberating, not only the open discussion of sex and drugs, but the open discussion of having a view of the world that was against the mainstream view. I think the underground press became, for many of us, affirmation, provocation, amplification.

HOWARD SWERDLOFF
New York High School Free Press,
John Bowne Was a Pacifist

In periods of tremendous social stress, all kinds of possibilities come to the fore, and they are wonderful times. You really feel like you have history in your hands, and you feel a tremendous solidarity with your fellow human beings. Of course the other side of the coin is that you have

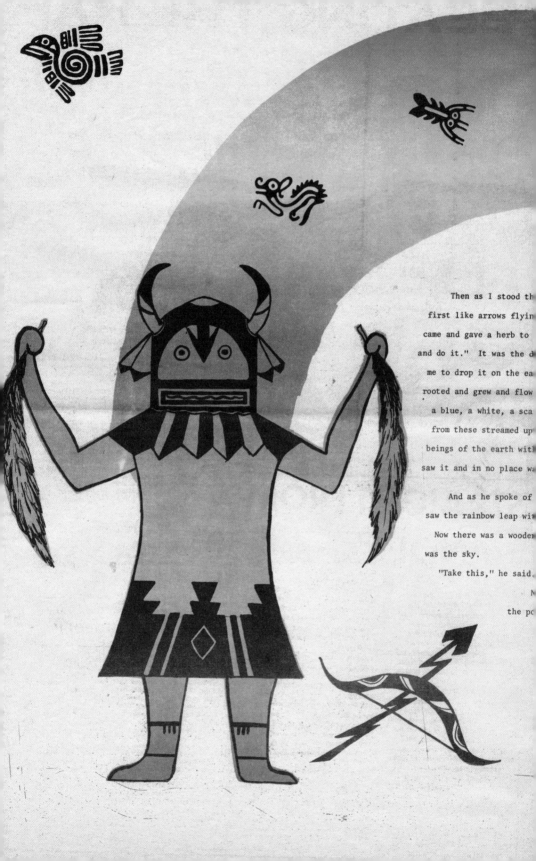

Then as I stood th

first like arrows flyin

came and gave a herb to

and do it." It was the d

me to drop it on the ea

rooted and grew and flow

a blue, a white, a sca

from these streamed up

beings of the earth with

saw it and in no place wa

And as he spoke of

saw the rainbow leap wi

Now there was a woode

was the sky.

"Take this," he said.

the p

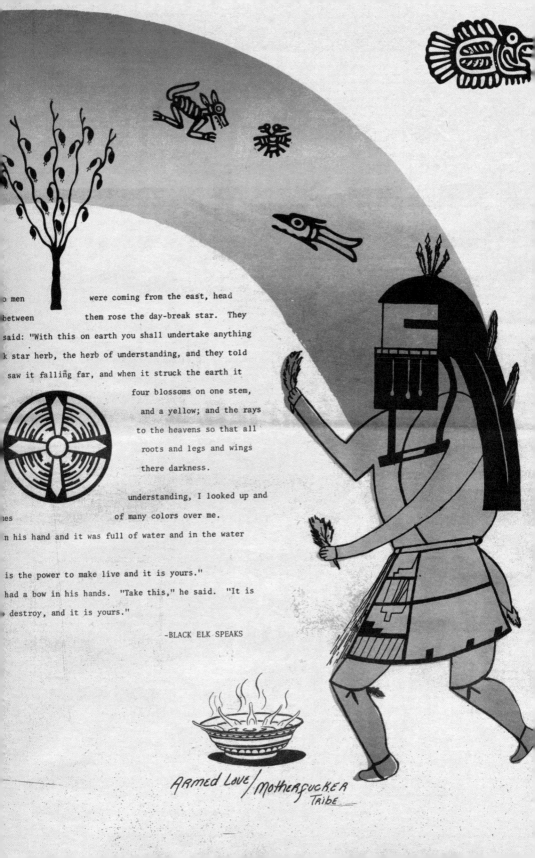

o men were coming from the east, head
between them rose the day-break star. They
said: "With this on earth you shall undertake anything
k star herb, the herb of understanding, and they told
saw it falling far, and when it struck the earth it
 four blossoms on one stem,
 and a yellow; and the rays
 to the heavens so that all
 roots and legs and wings
 there darkness.

 understanding, I looked up and
ues of many colors over me.
n his hand and it was full of water and in the water

is the power to make live and it is yours."
had a bow in his hands. "Take this," he said. "It is
destroy, and it is yours."

 -BLACK ELK SPEAKS

ARMED LOVE/MOTHERFUCKER
Tribe

a sense of power that is bigger than it really is. History is more complicated than what a few people decide they're gonna do with it. It's the conjunction of millions of personal stories and personal motivations that come together and create large historical events. But we were . . . in 1970 we would sit around and smoke pot and debate who were gonna be the leaders of the American Revolution, and what was next. We were kidding ourselves.

AL GOLDSTEIN
Screw, Gay, Bitch, Gadget,
Mobster Times, Cigar

The first issue, I was reviewing fuck films. How many publishers would do it? Larry Flynt wouldn't. I made seventeen porno films where you would see my dick and I'd eat pussy and get a blow job, but I felt, "I'm the publisher of *Screw*, I should do it." Hefner wouldn't do it. I wasn't ashamed. I think it [*Screw*] was honest. I'm not ashamed of one issue of *Screw*. Every fucking issue is like a child that went to Harvard, I mean because it had my intelligence. Now [Jim] Buckley was smart, too. He never tried to censor me; I never tried to censor him. We both were stealing from the government. He never robbed me; I never robbed him. But he got tired of being arrested after seven years. I had my twenty-one arrests and Jim wanted it to stop. So I bought him out for, I think, $1.2 million or $1.3 million. By the way, with my third wife I started a feminist publication called *Bitch*, and I had the first gay weekly in America called *Gay*. I think I'm the only guy I know who lost money with a feminist paper *and* a gay paper, but the world was open and we tried. And even though I lost (nothing made money but *Screw*), I was in there with a sort of open-door policy to new ideas. And the

rare thing for people in publishing . . . I'm a survivor. I did last thirty-eight years. I still don't know what I would do with the Internet, but I put up a good battle, and what I have is pride.

JOHN SINCLAIR
Work, Change, whe're, Fifth Estate, Warren Forest Sun, Ann Arbor Sun, Guerrilla

I watched the underground press unfold, so to speak. As a writer, I didn't care about Simon & Schuster; I wanted to be in the *East Village Other*. That was my idea of the standard of excellence—the underground press.

It was so much fun. Nobody has any idea of what the revolution was during the Sixties—how much fun it was, how many people were involved in it, all the wonderful things that were done. They get little parts of the music, but only

the ones that were number one. They don't really get the whole idea. There was bands of ecstatic hippies on LSD dancing to music played by guys that lived down the street. That's what it was really about. They don't have any idea about these things because they don't want them to know about these things. Like the underground press, and how easy it would be to have an underground press—you could have a million papers today. Well, they kind of got 'em with the podcasts and the blogs, but nobody has any ideas. We had the ideas! We were focused on the things that young people cared about.

The South End, vol. 58, no. 5 (1969). Leni Sinclair photo of John Sinclair and the Trans-Love crew. Opposing page: *Screw*, no. 18 (1969). John Lennon and Yoko Ono in bed with *Screw*. Previous page spread: *Rat Subterranean News*, vol. 2, no. 18 (1969).

— Magdalene Sincl

BEN MOREA
Black Mask, The Family
(Up Against the Wall/Motherfucker)

It's all important: walking down the street, getting high on LSD, breaking into the Pentagon, cutting the fences at Woodstock, or half the other stuff we did that was illegal that I don't even want to talk about. It's all important. It's a totality. The art of it is as important as the word of it, to me. Those who are nonviolent pacifists and they want to try to change things, I'm all for it. That doesn't mean I have to agree that that's workable, but I think there's room for everybody. That's the lesson of the Sixties; everybody was out there. It wasn't just the crazies, like we've been called. It wasn't just us, it was everybody. It was all there, and I think that's the key: it takes it all. If you really want to change it, it's gonna take it all.

It [the underground press] was essential then. It meant connecting the dots. What happened in the Sixties, I wouldn't say couldn't have happened without the underground press, but the underground press was a vital part of it, period. You can't take it away.

East Village Other, vol. 2, no. 5 (1967).

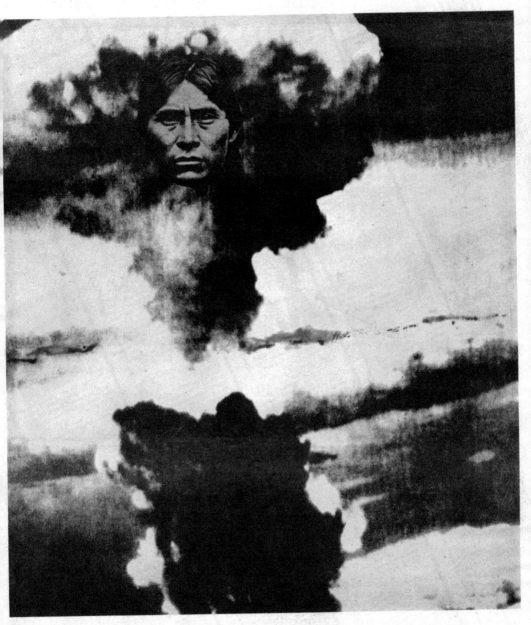

T..T..TH..THAT'S
ALL
FOLKS

WHEEL

AND

DEAL

Experimental

The synthetic corporation

FIND IT IN EVO

ABOUT THE INTERVIEWEES

JUDY GUMBO ALBERT

Judy Gumbo Albert, Ph.D., is an original Yippie. She worked at the *Berkeley Barb* and was one of the *Barb* staffers who left to found the *Berkeley Tribe*. In her later life, Albert was vice president of development for Planned Parenthood in Oregon, where she recycled the skills she learned in the underground press to write highly successful fundraising appeals. She coauthored *The Conspiracy Trial* (1970) and *The Sixties Papers* (1984) with her late husband and Yippie founder Stew Albert. She is the author of *Yippie Girl*, a memoir in progress about love and friendship among the Yippies and other romantic revolutionaries of the late Sixties. Contact Judy at Yippie Girl on Facebook or at her website: yippiegirl.com.

BILL AYERS

Bill Ayers was a prominent member of the Weather Underground Organization. Ayers and the Weather Underground were surprisingly prolific producers of literature, releasing regular communiqués and running a clandestine printing operation called the Red Dragon Press, which produced, among other things a newsletter called *Osawatomie*. In 1980 he, his wife (Weather Underground leader Bernardine Dohrn), and their two children came up from underground. Today he is a distinguished professor of education and senior university scholar at the University of Illinois at Chicago (retired) and founder of both the Small Schools Workshop and the Center for Youth and Society. He is currently the vice president of the curriculum studies division of the American Educational Research Association.

East Village Other, vol. 1, no. 24 (1966).

JEFFREY BLANKFORT

Jeffrey Blankfort is an American journalist and a recognized expert on the Israel-Palestine conflict. He was a contributing photographer at *San Francisco Express Times* (which became *San Francisco Good Times* in April 1969) and *Ramparts* magazine, covering the 1968 Democratic Convention in Chicago, the Olympic Games in Mexico City, the People's Park uprising in Berkeley and many other defining events and characters of the Sixties. (jeffblankfortphotography.com)

PAUL BUHLE
(Preface)

Paul Buhle is a (retired) senior lecturer at Brown University and author or editor of thirty-five volumes, including histories of radicalism in the United States and the Caribbean, studies of popular culture, and a series of nonfiction comic art volumes. Buhle was founding editor of the journal *Radical America* (1967–1999), an unofficial organ of Students for a Democratic Society; founder of *Cultural Correspondence* (1977–1983), a journal of popular culture studies; and founder and director of the Oral History of the American Left archive at New York University. He is the authorized biographer of C.L.R. James. From 2006 to 2007, he was one of the founding figures of the new Students for a Democratic Society and, more recently, a leader of the Movement for a Democratic Society.

EMORY DOUGLAS

From 1967 until the early eighties, Emory Douglas oversaw the layout and publication of *The Black Panther*, with his iconic artwork featured prominently throughout the paper, as the Black Panther Party minister of culture. He is currently enjoying a resurgence of interest in his artwork following the publication of *Black Panther: The Revolutionary Art of Emory Douglas* by Rizzoli in 2007, and has had major shows of his work at the Museum of Contemporary Art in Los Angeles and the New Museum in New York City. Douglas currently lives in San Francisco and continues to lend his talent, voice, and vision to the causes in which he believes.

THORNE DREYER

Thorne Dreyer is editor of *The Rag Blog* (theragblog.blogspot.com), director of the New Journalism Project and host of Rag Radio on KOOP-FM in Austin. He is a veteran of the Sixties New Left. He was active in SDS in Austin and nationally. Dreyer was founding "funnel" of *Rag* in Austin (the sixth member of the Underground Press Syndicate, founded on October 10, 1966), a member of the editorial collective of Liberation News Service in New York and a founding editor of Space City in Houston. He was general manager of KPFT-FM, the Pacifica radio station in Houston, where he hosted a popular talk show and worked as an actor, a public relations executive, a public information officer, a political consultant, a publisher, a freelance writer and editor, a union

booking agent, an event producer and as manager of a jazz club. Dreyer's coverage of the movement appeared in dozens of publications around the country, and his writing has been cited in more than fifty books about the Sixties, the media, and related subject matter.

ALICE EMBREE

Alice Embree was an early SDS member at the University of Texas in Austin, founding member of *Rag*, a member of *NACLA* (*North American Congress on Latin America*) and a contributor to *Rat Subterranean News* in New York. Today she is an Austin-based feminist, writer, and GI rights activist and is active with Code Pink in Austin and Under The Hood Café in Killeen, Texas. Embree is a contributing editor to *The Rag Blog* (theragblog.blogspot.com) and is treasurer of the New Journalism Project.

AL GOLDSTEIN

Al Goldstein cofounded (with Jim Buckley) the influential and long-running pornographic newspaper *Screw: The Sex Review* in 1968. A much-reviled figure on the left, but well-loved in the streets, Goldstein is also well known as the host and producer (with radio personality Alex Bennett) of the cult classic *Midnight Blue*, a New York leased–public access cable television series. In 2006, Goldstein released an autobiography, cowritten with Josh Alan Friedman, titled *I, Goldstein: My Screwed Life* (Thunder's Mouth Press).

BILLY X JENNINGS

Billy X Jennings grew up in San Diego and moved to Oakland in June 1968. He was Huey Newton's assistant and a member of the Black Panther Party from 1968 to 1974. He currently works as the Black Panther Party archivist, running the website itsabouttimebpp.com and working to preserve the true history of the Black Panther Party through education.

MICHAEL KLEINMAN

Michael Kleinman was a student at Stuyvesant High School in New York City, where he was a founding member of the underground high school newspaper *New York Herald Tribune*. He currently lives in Austin, Texas where, he owns and operates the chain of Planet K head shops.

PAUL KRASSNER

Paul Krassner is an author, journalist, stand-up comedian, and the founder, editor, and frequent contributor to the free-thought magazine *The Realist* (1958–1974). Krassner is the only person to win awards from both *Playboy* magazine (for satire) and the Feminist Party Media Workshop (for journalism). He was the first living man to be inducted into the Counterculture Hall of Fame, which took place at the Cannabis Cup in Amsterdam. He received an ACLU Uppie (Upton Sinclair) Award for dedication to freedom of expression, and, according to the FBI files, he was described by the FBI as "a raving,

unconfined nut." His latest book is an expanded edition of *Confessions of a Raving, Unconfined Nut* available at paulkrassner.com.

ART KUNKIN

The *Los Angeles Free Press* was founded in 1964 by Art Kunkin who, at the time, was a thirty-six-year-old unemployed tool-and-die worker and former organizer for the Socialist Workers Party, where he had served as business manager of the party paper, *The Militant*. The *Free Press* was one of the most immediate forerunners to the underground press and grew to be one of the most widely distributed alternative papers of the Sixties. The government lawsuit that followed Kunkin's publication, in the *Free Press*, of the names and home addresses of state narcotics agents precipitated a series of events that would ultimately lead to his bankruptcy, multiple ownership changes, and the end of the *Los Angeles Free Press*. For a short while afterwards, Kunkin was a professor of journalism at California State University, Northridge. Over the years he has dedicated his life to the study of metaphysics, and today he lives in the Joshua Tree area where he is a devoted alchemist.

BEN MOREA

A teenage delinquent and drug addict, Ben Morea in the late fifties, went looking for the Beatniks, discovered the Living Theatre, and developed a taste for, and got involved in, art and anarchism. A painter, rabble-rouser, and troublemaker, he was the main instigator of the Black Mask group, The Family (popularly known as Up Against The Wall/Motherfucker, and no relation to the West Coast Manson "family"), and the Armed Love communal movement. By the end of the Sixties, facing increased police attention, Morea "disappeared" into the rural communal movement. He continues to paint (and now blog at e-blast.squarespace.com) and galvanized by the current imperial wars, has reemerged to talk of the legacy and history of *Black Mask* and The Family and their relevance to the struggles today.

JEFF SHERO NIGHTBYRD

Jeff Shero Nightbyrd is a movement veteran, civil rights activist, author, early SDS organizer (and one-time SDS national vice president), and newspaper publisher. He was there in the early days of the influential Austin underground paper *Rag*, eventually moving to New York, where he founded the legendary New York underground paper, *Rat Subterranean News*. Shero Nightbyrd founded *Austin Sun* (1974–1978), which was a progenitor of the *Austin Chronicle*. He currently lives in Austin where he runs Acclaim talent agency.

ABE PECK

Once editor of the underground newspaper Chicago *Seed*, Abe Peck wrote *Uncovering the Sixties: The Life and Times of the Underground Press*, which *The New York Times* called the genre's "definitive" history. As a reporter, editor, and columnist for Chicago's *Daily News* and *Sun-Times*, he won two Illinois Associated Press awards. He was a critic

at large on WBBM-AM, Chicago. He is a former professor at the Medill School of Journalism/Northwestern University and remains involved as its first director of business-to-business communication, as professor emeritus in service, and as coeditor of *Medill on Media Engagement*. He and his wife Suzanne currently run Peck Consultants.

TRINA ROBBINS

Trina Robbins fought her way into the male-dominated world of underground comix. Her first fully fleshed-out characters and strips appeared in the late sixties in the pages of *East Village Other*. She left New York at the end of 1969 for San Francisco, where she worked briefly at the *Berkeley Tribe* and *It Ain't Me, Babe*. After putting together the first all-women comic book, *It Ain't Me Babe Comix*, she became increasingly involved in promoting and creating outlets for female comics artists through projects such as the comics anthology *Wimmen's Comix*. Robbins is considered the expert on the subject of early-twentieth-century women cartoonists, and is responsible for rediscovering many brilliant but previously forgotten women cartoonists in her books, *A Century of Women Cartoonists*, *From Girls to Grrrls*, and *The Great Women Cartoonists*. Her vast collection of original art by early-twentieth-century women cartoonists has been exhibited in Germany, Austria, Portugal, Spain, and Japan, as well as in the United States. She has produced collections of the work of some of these women: golden age cartoonist Lily Renee, comic strip artist Tarpe Mills, and the great Nell Brinkley. (trinarobbins.com)

SPAIN RODRIGUEZ

Buffalo native Manuel "Spain" Rodriguez was an early contributor to the fledgling *East Village Other* who published his seminal underground all-comic tabloid, *Zodiac Mindwarp*. It was while working as a full-time *EVO* staff member that Spain developed and introduced his popular character, Trashman, Agent of the Sixth International. He moved to San Francisco in late 1969 just as the underground comix movement was starting to explode and became a member of the original *Zap Comix* crew along with Robert Crumb, Victor Moscoso, Rick Griffin, S. Clay Wilson, Gilbert Shelton, and Robert Williams. He was one of the founders and prime instigators of the hugely important, though short-lived, cartoonist labor union, the United Cartoon Workers of America, and hasn't stopped working since. Ever prolific, his recent work includes the celebrated illustrated biography of Ernesto "Che" Guevara, *Che: A Graphic Biography*.

SKIP SHOCKLEY

In the early seventies, Skip Shockley joined the Texas branch of the Black Panther Party, rising to leadership. He is the author of *Mother's Son* and a retired nurse, disease intervention specialist, and health educator. He now lectures at local high schools and universities on HIV/AIDS prevention and on the history of the Black Panther Party's social programs. (skipshockley.com)

PETER SIMON

Peter Simon is a nationally acclaimed photographer, photojournalist, author, music historian, and instructor. Over the course of his nearly forty-year career, he has covered an eclectic range of subjects documenting the spirit of the free love and protest-filled Sixties; the greatest names in rock 'n' roll, reggae, and pop music; the scenic beauty of his beloved Martha's Vineyard; the action of major-league baseball; and stunning portraits of people from the everyday to the most celebrated personalities of our time. His most recent book is a collaboration with reggae historian and archivist Roger Steffens, *The Reggae Scrapbook*, a treasure trove of reggae ephemera that features a heavy dose of Simon's first-class Jamaican photography. He currently lives on Martha's Vineyard where he runs the Simon Gallery with his wife Ronni. (petersimon.com)

JOHN SINCLAIR

John Sinclair is an author, poet, and activist who mutated from small-town rock 'n' roll fanatic and teenage disc jockey to cultural revolutionary, pioneer of marijuana activism, radical leader, and political prisoner by the end of the sixties. He is the one-time manager of the band MC5 and leader of the White Panther Party from November 1968 to July 1969. Sinclair was involved in the reorganization of the Detroit underground newspaper *Fifth Estate* during the paper's growth in the late sixties. Sinclair also contributed to the formation of Detroit Artists Workshop Press, which published five issues of *Work* magazine. John worked as a jazz writer for *Downbeat Magazine* from 1964 to 1965 and was an outspoken advocate for the newly emerging free jazz avant-garde movement. He is currently based in Amsterdam and is making radio programs for RadioFreeAmsterdam.com and Detroit Life Radio and broadcasting them at TapDetroit.com every night at midnight Eastern Time. London publisher Headpress recently released an anthology of his writings, *It's All Good: A John Sinclair Reader*, as well as the John Sinclair–edited *Sun Ra Interviews & Essays*. You can find his recordings on No Cover Records and MoSound Records and follow his regular columns in the Detroit *Metro Times* and the *Michigan Medical Marijuana Report*. He also serves as the director for the Trans-Love Energies Compassion Club in Detroit. Keep up with everything he is doing at johnsinclair.us.

HOWARD SWERDLOFF

Once called "Little Lenin" by *The New York Times*, Queens native and former John Bowne High School student Howard Swerdloff was a cofounder and one-time president of the New York High School Student Union. The student union was instrumental in unifying and focusing the incredible explosion of student dissent that took place across the New York City school system in the late sixties. Swerdloff was also a key figure in one of the biggest high school underground newspapers of the period, the *New York High School Free Press*. After a career as a printer, today he is a professor of history at both the College of Staten Island and Montclair State University.

RON TURNER

Founded in 1970 by Ron Turner, Last Gasp is one of the largest and oldest publishers and purveyors of underground comic books in the world, as well as a distributor of all sorts of weird 'n' wonderful subversive literature, graphic novels, and tattoo and art books. (lastgasp.com)

HARVEY WASSERMAN

With Marshall Bloom, Ray Mungo, Verandah Porche, and others, Harvey Wasserman helped found Liberation News Service in 1967. *Harvey Wasserman's History of the United States*, written at the Montague/LNS Farm, was published (1972) with an introduction from Howard Zinn. A cofounder of the global grassroots "No Nukes" movement, he spoke and wrote (1975–1976) in Japan against Fukushima et al. He helped organize the Clamshell Alliance's first (1976–1978) nonviolent civil disobedience actions against the Seabrook nukes. In 1979 Wasserman joined with Bonnie Raitt, Jackson Browne, Graham Nash, John Hall, and others to help produce the legendary MUSE/No Nukes Concerts in Madison Square Garden. He coauthored *Killing Our Own: The Disaster of America's Experience with Atomic Radiation* (1982), which documented the radioactive death toll at Three Mile Island and elsewhere. As senior advisor to Greenpeace USA, he spoke to 350,000 semiconscious rock fans at Woodstock 2. In 2007 he helped found the nukefree.org campaign with Bonnie, Jackson, and Graham, still fighting to finally bury the lethal atom.

Overall, Wasserman has authored or coauthored a dozen books on history, energy, election protection, hemp, and spirituality. He is senior editor of the Columbus Free Press (freepress.org), born of the Sixties underground press, which exposed the theft of the 2004 presidential election in Ohio. His articles circulate widely on the Internet, including at former LNSer Thorne Dreyer's *Rag Blog* (theragblog.blogspot.com). Wasserman is father of five daughters, with three grandchildren (so far). His *Solartopia! Our Green-Powered Earth* is the first holistic vision of the sustainable world they will inhabit.

JOHN WILCOCK

Journalist and publisher John Wilcock was one of the five cofounders of the New York *Village Voice* in October 1955, eventually leaving to help found the *East Village Other* in 1965. While writing travel books for Arthur Frommer and coordinating the Underground Press Syndicate, he edited underground papers in London, Los Angeles and Tokyo and dispatched early issues of his own paper *Other Scenes*. In addition to the 2010 re-release of his classic *The Autobiography and Sex Life of Andy Warhol*, Wilcock recently published his own autobiography called *Manhattan Memories*. He currently lives in Ojai, California, and is still at it, publishing a monthly called *Ojai Orange*. Keep up with Wilcock at ojaiorange.com.

Old Mole, no. 13 (1969).

OLD MOLE

25¢ NUMBER 13 A RADICAL BI-WEEKLY BOSTON, MASSACHUSETTS MAY 9 – MAY 22

"They Ain't Our Equals Yet!"

Drawn by Maurice Becker, January 1917

WOMEN'S LIBERATION 1969
pp. 9–12

ALLEN YOUNG

Allen Young abandoned a promising career as a mainstream journalist at the *Washington Post* to join the fledgling Liberation News Service in 1967, where he became a frequent contributor and important leader. His departure from LNS in the early seventies coincided with his increasing involvement in the emergent gay liberation movement. He wrote numerous important articles for gay underground newspapers, and he coedited (with Karla Jay) the seminal anthology *Out of the Closets: Voices of Gay Liberation* and authored the groundbreaking exposé of homophobia in Fidel Castro's Cuba, *Gays Under the Cuban Revolution*. Since 1973, Young has been living in rural north-central Massachusetts, where he has a big garden, volunteers with the Mount Grace Land Conservation Trust, and writes a weekly column for the *Athol Daily News*.

Provo, vol. 3, no. 4 (1967).

INDEX OF NAMES
(page numbers in italics refer to illustrations)

Volume Five, Number Forty
Copyright/Atlanta Cooperative News Project
October 23, 1972

great speckled The·BIRd

20¢

25¢ outside Atlanta

"FOUR MORE YEARS!"

"FOUR MORE YEARS!"

"FOUR MORE YEARS!"

"FOUR MORE YEA

"FOUR MORE YE

*Black Mask & Up Against the Wall
Motherfucker: The Incomplete Works of
Ron Hahne, Ben Morea, and the Black
Mask Group*
Ben Morea and Ron Hahne
978-1-60486-021-4
$15.95

Founded in New York City in the mid-1960s by self-educated ghetto kid and painter Ben Morea, the Black Mask group melded the ideas and inspiration of Dada and the Surrealists, with the anarchism of the Durruti Column from the Spanish Revolution. With a theory and practice that had much in common with their contemporaries the San Francisco Diggers, Dutch Provos, and the French Situationists—who famously excommunicated 3 of the 4 members of the British section of the Situationist International for associating too closely with Black Mask—the group intervened spectacularly in the art, politics and culture of their times. From shutting down the Museum of Modern Art to protesting Wall Street's bankrolling of war, from battling with Maoists at SDS conferences to defending the Valerie Solanas shooting of Andy Warhol, Black Mask successfully straddled the counterculture and politics of the 60s, and remained the Joker in the pack of both sides of "The Movement."

By 1968 Black Mask dissolved into "The Family" (popularly known as Up Against The Wall Motherf**ker—the name to which they signed their first leaflet), which combined the confrontational theater and tactics of Black Mask with a much more aggressively "street" approach in dealing with the police, and authorities. Dubbed a "street gang with analysis" they were reputedly the only white grouping taken seriously by the Black Panther Party, and influenced everyone from the Weathermen to the "hippy" communal movements.

This volume collects the complete ten issues of the paper *Black Mask* (produced from 1966-1967 by Ben Morea and Ron Hahne), together with a generous collection of the leaflets, articles, and flyers generated by Black Mask, and UATW/MF, the *UATW/MF Magazine*, and both the *Free Press* and *Rolling Stone* reports on UATW/MF. A lengthy interview with founder Ben Morea provides context and color to this fascinating documentary legacy of NYC's now legendary provocateurs.

Excerpt:
"We are neither artists or anti-artists. We are creative men—revolutionaries. As creative men we are dedicated to building a new society, but we must also destroy the existing travesty. What art will replace the burning bodies and dead minds this society is creating?"
Ben Morea, *Black Mask* #3, January 1967

Diario de Oaxaca:
A Sketchbook Journal of
Two Years in Mexico
Peter Kuper
978-1-60486-071-9
$29.95

Painting a vivid, personal portrait of social and political upheaval in Oaxaca, Mexico, this unique memoir employs comics, bilingual essays, photos, and sketches to chronicle the events that unfolded around a teachers' strike and led to a seven-month siege.

When award-winning cartoonist Peter Kuper and his wife and daughter moved to the beautiful 16th-century colonial town of Oaxaca in 2006, they planned to spend a quiet year or two enjoying a different culture and taking a break from the U.S. political climate under the Bush administration. What they hadn't counted on was landing in the epicenter of Mexico's biggest political struggle in recent years. Timely and compelling, this extraordinary firsthand account presents a distinct artistic vision of Oaxacan life, from explorations of the beauty of the environment to graphic portrayals of the fight between strikers and government troops that left more than 20 people dead, including American journalist Brad Will.

Praise:
"Kuper is a colossus; I have been in awe of him for over 20 years. Teachers and students everywhere take heart: Kuper has in these pages born witness to our seemingly endless struggle to educate and to be educated in the face of institutions that really don't give a damn. In this ruined age we need Kuper's unsparing compassionate visionary artistry like we need hope." —Junot Díaz, Pulitzer Prize winning author of *The Brief Wondrous Life of Oscar Wao*

"An artist at the top of his form." —*Publisher's Weekly*

About the Author:
Peter Kuper is a co-founder and editorial board member of political graphics magazine *World War 3 Illustrated* and a teacher who has taught at New York's School of Visual Arts and Parsons The New School for Design. Best known for drawing *Mad* magazine's Spy vs. Spy comic since 1997, he has also illustrated covers for *Newsweek* and *Time* magazine. He is the author of the graphic novel *Sticks and Stones*, which won the New York Society of Illustrators gold medal, and his autobiography, *Stop Forgetting to Remember*. He lives in New York City.

Signal:01
*A Journal of International Political
Graphics and Culture*
Alec Dunn & Josh MacPhee, eds.
978-1-60486-091-7
$14.95

Signal is an ongoing book series dedicated to documenting and sharing compelling graphics, art projects, and cultural movements of international resistance and liberation struggles. Artists and cultural workers have been at the center of upheavals and revolts the world over, from the painters and poets in the Paris Commune to the poster makers and street theatre performers of the recent counter globalization movement. *Signal* will bring these artists and their work to a new audience, digging deep through our common history to unearth their images and stories. We have no doubt that *Signal* will come to serve as a unique and irreplaceable resource for activist artists and academic researchers, as well as an active forum for critique of the role of art in revolution. Although a full color printed publication, *Signal* is not limited to the graphic arts. Within its pages you will find political posters and fine arts, comics and murals, street art, site specific works, zines, art collectives, documentation of performance and articles on the often overlooked but essential role all of these have played in struggles around the world.

Signal:01 includes:
• The Future of Xicana Printmaking: Alec Dunn and Josh MacPhee interview the Taller Tupac Amaru
• The Adventures of Red Rat: Alec Dunn interviews Johannes van de Weert
• Hard Travelin': A photo essay with graffiti writer IMPEACH
• Mexico 68: The Graphic Production of a Movement: Santiago Armengod interviews Felipe Hernandez Moreno
• Adventure Playgrounds: A photo essay
• Designing Anarchy: Dan Poyner interviews Rufus Segar

Praise:
"*Signal* reads like a magazine in that it consists of a number of smaller, independent articles but the loose continuity of subject holds it together as a book. As a series, this is going to be a great resource. Dunn and MacPhee are filling a void in terms of political graphics; there's a lot of material for them to cover and this is solid start."
—Printeresting.org

Paper Politics:
Socially Engaged Printmaking Today
Josh MacPhee, ed.
978-1-60486-090-0
$24.95

Paper Politics: Socially Engaged Printmaking Today is a major collection of contemporary politically and socially engaged printmaking. This full color book showcases print art that uses themes of social justice and global equity to engage community members in political conversation. Based on an art exhibition which has traveled to a dozen cities in North America, *Paper Politics* features artwork by over 200 international artists; an eclectic collection of work by both activist and non-activist printmakers who have felt the need to respond to the monumental trends and events of our times.

 Paper Politics presents a breathtaking tour of the many modalities of printing by hand: relief, intaglio, lithography, serigraph, collagraph, monotype, and photography. In addition to these techniques, included are more traditional media used to convey political thought, finely crafted stencils and silk-screens intended for wheat pasting in the street. Artists range from the well established (Sue Coe, Swoon, Carlos Cortez) to the up-and-coming (Favianna Rodriguez, Chris Stain, Nicole Schulman), from street artists (BORF, You Are Beautiful) to rock poster makers (EMEK, Bughouse).

Praise:
"Let's face it, most collections of activist art suck. Either esthetic concerns are front and center and the politics that motivate such creation are pushed to the margin, or politics prevail and artistic quality is an afterthought. With the heart of an activist and the eye of an artist, Josh MacPhee miraculously manages to do justice to both. *Paper Politics* is singularly impressive." —Stephen Duncombe, author of *Dream: Re-Imagining Progressive Politics in an Age of Fantasy*

"For all of those who claim that poster art is dead in the age of YouTube and Blogs, *Paper Politics* will wheatpaste another message over your computer monitor. This exhibition and book is a testament to the vibrant trajectory of printmaking in the service of social change, including examples of earlier movements and artists as well as the graphics popping up right now. Obscure and familiar subjects are presented with wit, joy, and searing satire, guaranteed to snap your senses and challenge your opinions. It took a village to make this show, and the world will benefit from seeing it." —Lincoln Cushing, author of *Revolucion! Cuban Poster Art*

PM PRESS was founded at the end of 2007 by a small collection of folks with decades of publishing, media, and organizing experience. PM Press co-conspirators have published and distributed hundreds of books, pamphlets, CDs, and DVDs. Members of PM have founded enduring book fairs, spearheaded victorious tenant organizing campaigns, and worked closely with bookstores, academic conferences, and even rock bands to deliver political and challenging ideas to all walks of life. We're old enough to know what we're doing and young enough to know what's at stake.

We seek to create radical and stimulating fiction and non-fiction books, pamphlets, t-shirts, visual and audio materials to entertain, educate and inspire you. We aim to distribute these through every available channel with every available technology—whether that means you are seeing anarchist classics at our bookfair stalls; reading our latest vegan cookbook at the café; downloading geeky fiction e-books; or digging new music and timely videos from our website.

PM Press is always on the lookout for talented and skilled volunteers, artists, activists and writers to work with. If you have a great idea for a project or can contribute in some way, please get in touch.

These are indisputably momentous times—the financial system is melting down globally and the Empire is stumbling. Now more than ever there is a vital need for radical ideas.

In the three years since its founding—and on a mere shoestring—PM Press has risen to the formidable challenge of publishing and distributing knowledge and entertainment for the struggles ahead. With over 150 releases to date, we have published an impressive and stimulating array of literature, art, music, politics, and culture. Using every available medium, we've succeeded in connecting those hungry for ideas and information to those putting them into practice.

Friends of PM allows you to directly help impact, amplify, and revitalize the discourse and actions of radical writers, filmmakers, and artists. It provides us with a stable foundation from which we can build upon our early successes and provides a much-needed subsidy for the materials that can't necessarily pay their own way. You can help make that happen – and receive every new title automatically delivered to your door once a month – by joining as a Friend of PM Press. And, we'll throw in a free t-Shirt when you sign up.

Here are your options:

• $25 a month: Get all books and pamphlets plus 50% discount on all webstore purchases.
• $25 a month: Get all CDs and DVDs plus 50% discount on all webstore purchases.
• $40 a month: Get all PM Press releases plus 50% discount on all webstore purchases
• $100 a month: Sustainer. - Everything plus PM merchandise, free downloads, and 50% discount on all webstore purchases.

For those who can't afford $25 or more a month, we're introducing Sustainer Rates at $15, $10 and $5. Sustainers get a free PM Press t-shirt and a 50% discount on all purchases from our website.

Just go to WWW.PMPRESS.ORG to sign up. Your Visa or Mastercard will be billed once a month, until you tell us to stop. Or until our efforts succeed in bringing the revolution around. Or the financial meltdown of Capital makes plastic redundant. Whichever comes first.

PM PRESS • PO Box 23912, Oakland CA 94623 • 510-658-3906 • www.pmpress.org